DEDICATION

This handbook is dedicated to the following
generous donors who gave to the Trustee Initiative:

SELECTED WORKS

SEATTLE ART MUSEUM

Published by the Seattle Art Museum
Seattle, Washington

Printed in Japan.

Project managers: Helen Abbott and Patterson Sims
Editors: Helen Abbott, Lorna Price, and Paula Thurman
Design and production: Marquand Books, Inc.
Photography: All photographs by Paul Macapia except pp. 62 (81.108), 91, 92, 96, 97, 99, 100, 102, 104, 105, 139 by Susan Dirk; and by others where noted.

Cover: *A Country Home* (detail), 1854, Frederic Church, United States, gift of Mrs. Paul C. Carmichael, p. 110

Library of Congress Cataloging-in-Publication Data

Seattle Art Museum.
Selected works / Seattle Art Museum.
p. cm.
ISBN 0-932216-35-8 : $9.95
1. Art — Washington (State) — Seattle — Catalogs.
2. Seattle Art Museum — Catalogs. I. Title.
N745.A66 1991
708.197'772 — dc20 91-9704
 CIP

CONTENTS

ACKNOWLEDGMENTS

The printing of this publication was made possible by an extraordinary gift from Lyn and Gerald Grinstein. The research, writing, and photography were supported by generous grants from the National Endowment for the Arts and the Getty Grant Program of the J. Paul Getty Trust.

FOREWORD

In the fifty-eight years of its existence, the Seattle Art Museum has changed dramatically from the institution envisioned by Richard E. Fuller, its founder and primary benefactor. As a direct result of Dr. Fuller's leadership and generosity, Seattle quickly established itself as a major collector of Asian art, a treasure trove of exquisite jades and lacquers, Indian paintings, and sumptuous Persian objects. That distinguished museum was the forebear of the one celebrated by this publication, with its remarkable holdings in African art, the arts of the Northwest Coast, and American and European art.

The reasons for this happy evolution may be found in a wellspring of public and private generosity. When confronted in the 1980s with the dilemma of a museum whose collections were condemned to storage for lack of adequate exhibition space, the voters of Seattle seized the first opportunity to provide funding for new facilities from Robert Venturi's inspired design. This new building in turn made possible the acquisition and public exhibition of individual works of art and entire collections that reflect the generosity of benefactors whose names will forever be associated with the Seattle Art Museum. Fuller, Stimson, Frederick, White, Boeing, Wright, Davis, Hauberg, Isaacson, Klepser, and Falknor are but a few to whom we owe an enormous debt of gratitude for their gifts to this community.

The product of all this goodwill — a new museum reflecting the breadth and depth of our holdings and a reinstalled Asian art museum in Volunteer Park — constitutes an institution that now assumes its rightful place among the nation's pre-eminent art museums.

This publication serves to introduce the reader to a select group of treasures representing the range and quality of the museum's collections. Selected by the curatorial staff in consultation with distinguished experts, they describe holdings that do not conform to the traditional shape of the general art museum in the United States. The conventional Eurocentric view of the arts, which has defined so many of our sister institutions, has never held sway at the Seattle Art Museum. We flatter ourselves that the profile and therefore the experience of this museum is singular. This city on the frontier of the North American continent has always engaged the rest of the world in ways not shared by all. Its international perspective and Native traditions have formed an identity that makes Seattle and its art museum unique. We trust that your experience with us — and by extension with this volume — will be unusually enriching.

Jay Gates
The Illsley Ball Nordstrom Director

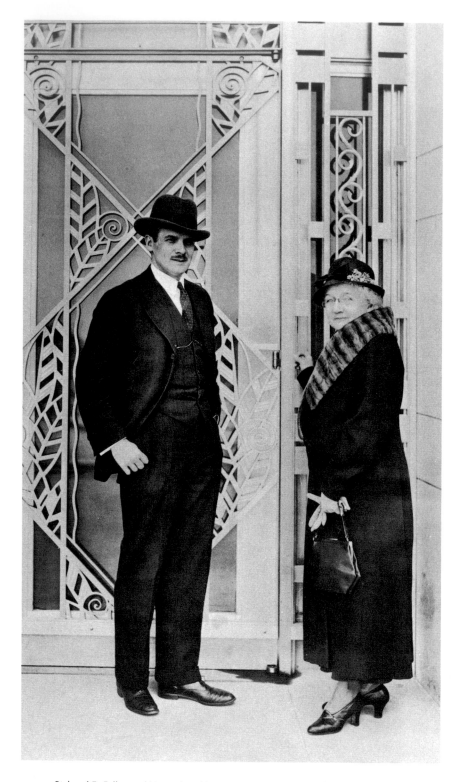

Richard E. Fuller and his mother, Margaret E. MacTavish Fuller, at the entrance to the Seattle Art Museum in Volunteer Park in 1933. The building was their gift to the City of Seattle. Photograph by Leonid Fink/*Seattle Times*

INTRODUCTION

The Growth of the Collection
of the Seattle Art Museum

A distinctive history surrounds the select group of objects illustrated and discussed in this publication. Ranging from ancient to very recent art, and made throughout the world, these works offer a succinct accounting of human culture and visual expression. Having begun with an emphasis upon Asian art, the Seattle Art Museum has matured into an institution with a global perspective. With the present breadth of its collections, the numerous donors who have made this growth possible, and the museum's newly expanded and renovated facilities, it is easy to forget that the origin and much of the history of the Seattle Art Museum may be traced to one reticent but dynamic man. The founding, directorship, and patronage of this museum from 1933 to 1973 by Dr. Richard E. Fuller (1897–1976) caused the museum to develop in a uniquely personal manner.

The Fuller Years

From the 1920s through the early 1970s, using for the most part his own and his family's funds, Dr. Richard E. Fuller assembled a collection of Japanese and Chinese art that secured a position of international importance for the Seattle Art Museum. Dr. Fuller also acquired works of art of other cultures for the museum; almost every aspect of the museum's current collection originated in his acquisitions. The range and quality of the museum's holdings, now numbering about 18,500 works, though small in comparison to many other fine art museums in comparable cities in the United States, have earned it great respect.

Founded in 1931, the Seattle Art Museum opened in 1933. It was the outgrowth of a series of Seattle art institutions which date to the mid-1890s, when the city was less than fifty years old and its population was around 46,000. The museum's most immediate predecessors were the Seattle Fine Art Society, begun in 1908, and the Art Institute of Seattle, founded in 1928. The Art Institute's small facility for changing exhibitions was housed in a rented mansion, formerly owned by the Horace C. Henry family, on Seattle's Capitol Hill. This philanthropic family's choice collection of late nineteenth- and early twentieth-century paintings initiated the Henry Art Gallery of the University of Washington in Seattle.

In 1931 the Art Institute was reorganized and renamed by Dr. Fuller, who was its president. Already an inspired civic benefactor, Richard E. Fuller was the board's youngest and most generous member. He saw "no future for the deficit operations of the Institute [and] conceived, with my mother's enthusiastic support, the idea of donating jointly from our greatly shrunken inheritance $250,000 for the purpose of constructing an art museum in Volunteer Park, on the crest of Capitol Hill." The site was in the public park closest to the center of the city, amid a residential neighborhood overlooking downtown Seattle, Puget Sound, and the Olympic Mountains. Following the guidelines of the Metropolitan Museum of Art in New York City's Central Park, the city of Seattle agreed to service and maintain the building if the Fullers and the museum would be responsible for its construction, operation, and art.

The Fullers, in fact, spent $325,000

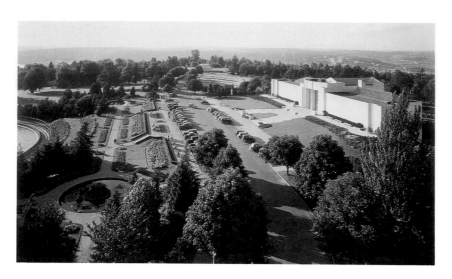

The Carl F. Gould-designed Seattle Art Museum in Volunteer Park. The view in this photograph, taken in July 1936 (the building opened in June 1933), is to the northeast.

to construct the museum's symmetrical art moderne structure. Although Richard and his mother declined to have the museum named after the family, they did dedicate their collections as a memorial to Richard's father, Dr. Eugene Fuller, who died in 1924, and Richard's brother, Duncan, who died in 1930. The museum's architect was Carl F. Gould, who had brought Fuller onto the board of the Art Institute of Seattle and preceded him as president. Gould, trained at the Ecole des Beaux-Arts in Paris, left a legacy of buildings and students from his years as professor and head of the School of Architecture at the University of Washington, a career that had established him as the pre-eminent Seattle architect in the first half of the twentieth century. Using materials from the Northwest whenever possible, Gould, working very closely with Dr. Fuller, designed a building with an imposing exterior and intimate wainscotted, skylighted galleries best suited to display small objects and paintings of modest dimensions.

For the museum's June 1933 opening, the Fullers transferred their overflowing collection from their nearby house, which bordered on Volunteer Park. Spurred by trips to the Orient starting in 1880, Mrs. Fuller had instigated her family's collecting activity around 1915 by buying Asian, mostly Chinese, eighteenth- and nineteenth-century art. Her first purchase, as described by her daughter, Eugenia, was "a white glass snuff bottle, imitation pork fat jade... [acquired] in New York City's Chinatown." Mrs. Fuller went on to gather many more snuff bottles, jades, and small ceramics. In the 1920s her son Richard formed one of the premiere private collections of Chinese jades in the United States. Dr. Fuller's interest in stone sculpture may be attributed in part to his doctoral studies in geology. Throughout his career at the museum, he continued to teach and conduct research in geology at the University of Washington: his work on volcanos and their effects on the geologic evolution of the Northwest and elsewhere profoundly influenced the understanding of the development of both modern and ancient landscapes. Following the Fullers' early commitment, Asian art has since held a position of primacy in the museum's collection.

The staff of the museum originally comprised seven employees under Dr.

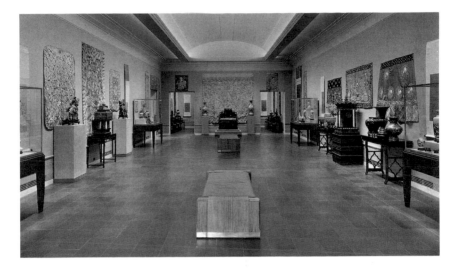

A 1933 installation of Chinese art in the newly opened museum in Volunteer Park. Early exhibitions reflected the strengths of the collection at the time, Asian art and works by Northwest artists. Photograph by H. C. Davidson

Fuller's unsalaried direction. They included Northwest artists Kenneth Callahan, Earl Fields, and in the late 1930s Guy Anderson and Morris Graves; one staff member, Dorothy C. Malone, remained active at the museum into the 1990s. There were frequently changing exhibitions and rotations of newly acquired objects and collections. Non-Asian art was represented by didactic presentations of framed facsimiles of pre-1900 European paintings. Starting with the opening, one-month long shows of local artists were held. The large Northwest Annual exhibitions of the region's living artists, begun in 1915 by the Seattle Fine Art Society, immediately became part of the museum's program. These exhibitions were held yearly under the auspices of the museum from 1933 to 1975; by that time numerous commercial galleries devoted to contemporary art had opened in Seattle, and the museum's curators opted for more selective one-artist and thematic group exhibitions of area artists.

From the start the museum reached out to the public through docent tours and lectures, public relations, and a library of slides and books. This activity helped to animate a small facility with a limited collection located in a residential neighborhood. In its first year, the museum had 346,287 visitors, an astonishing attendance given that the city's entire population at that time was around 365,000.

From 1933 until 1953, the painter Kenneth Callahan served as Dr. Fuller's advisor for regional and modern art. Manifesting a commitment to and patronage of its region's art exceptional among U.S. cities' fine art museums, Fuller and Callahan made numerous purchases from these small one-artist and big Annual exhibitions. Contemporary Northwest art, with a particular emphasis on a small group of painters including Morris Graves, Mark Tobey, Guy Anderson, and Kenneth Callahan, became the museum's second focus.

Drawing from their own funds, Mrs. Fuller, her son Richard, and on many occasions his sister, Eugenia, began an active program of acquisitions. "The Depression," as Richard later wrote, "was a favorable time to purchase." With money in hand, Dr. Fuller became a regular and welcomed visitor to galleries in this country, Asia, and Europe. He never hesitated to sell or trade works

that he had acquired to refine and upgrade the collection. Dr. Fuller staged several black-tie auctions at the museum to encourage local collecting and to refine the museum's and his own holdings. He set about, as Seattle historian Roger Sale has written, to make the museum's "taste a constant expression of his own, as though the museum itself were a work of art that would take a lifetime to complete.... A quiet person, he purchased quiet things."

Dr. Fuller aspired to have the museum hold a comprehensive collection of art from all over the world. In 1935 a major gift of prints, including etchings by Dürer, Rembrandt, and Whistler, and European drawings was bequeathed to the museum by the eminent Seattle banker Manson F. Backus. Contemporary European art was first acquired in 1936, beginning with a sculpture by Alexander Archipenko, who had taught at the University of Washington that summer. The first of the many earlier European paintings given by the Samuel H. Kress Foundation to the Seattle Art Museum arrived in 1937. By the early 1940s, facsimiles of European paintings were no longer needed for display. The Kress gift was followed by an additional donation, including two sculptures, by the foundation (through Samuel H. Kress's brother Rush H. Kress) in the early 1950s. This second gift was formally accessioned in 1961. These European works, along with a select group of paintings and drawings acquired by Manson Backus's son, Leroy, and left by him to the museum in 1948, formed by the early 1950s a respectable collection of pre-modern art of Europe and the United States. Selected examples of the art of Persia and of India had entered the collection by the end of the 1930s. Beyond Margaret Fuller, Dr. Fuller, and his sister, now Mrs. John C. Atwood, other donors of objects and acquisition funds slowly began to emerge, primary among them the Fullers' close friend

Mrs. Thomas D. Stimson. Mrs. Stimson, who was the museum's acting director in 1942 and 1943 when Dr. Fuller served in the U.S. Army, gave the museum the money to acquire numerous works of art, ranging from the paintings of living Northwest artists, to Peruvian ceramics, to the ancient art of Nepal, Korea, and China.

From the 1940s on, other individuals within the Seattle community, such as Blanche M. Harnan and Zoë Dusanne, set the stage for future collection growth with their respective passions for eighteenth-century European porcelain and the modern art of Europe and the United States. Harnan's activities incited an almost competitive collecting of porcelain within and between the three distinct "units" of devotees of the Seattle Ceramic Society, which she founded. Complete with lectures and barrels of china which arrived from dealers in New York and Europe, these intense and often fashionable gatherings blended post-graduate study and commercial zeal. From the mid-1950s on, the many gifts of Martha and Henry Isaacson established the museum's European porcelain holdings. The Isaacsons led the way as other donors—Mrs. Charles E. Stuart, Dorothy Condon Falknor, Mrs. Kenneth C. Klepser, Elizabeth Molitor, and the members of the Seattle Ceramic Society in honor of Blanche Harnan—made the museum a center for the appreciation and study of European porcelain.

Indicative of the central role that art dealers have played in bringing art and knowledge into the community, the well-traveled collector and gallery owner Zoë Dusanne helped bring modern European and American painting, sculpture, and drawing to the attention of the Seattle art public and key works into the museum's collection through the early 1960s. Through her friendship with the avant-garde collector Peggy Guggenheim, Dusanne was responsible for the addition of Jackson Pollock's *Sea*

Change and four other gifts from Guggenheim to the museum's holdings. Dusanne championed local artists while providing an international context for their work.

The museum's scholarly strength intensified in the aftermath of the 1943 visit to Seattle of Sherman E. Lee. Then in the U.S. Navy, Dr. Lee had been curator of Far Eastern Art at the Detroit Institute of Arts. Following his discharge from military service in Japan, where his responsibilities lay with overseeing that country's cultural properties, he joined the staff of the Seattle Art Museum in the autumn of 1948. Dr. Lee was assistant and then associate director of the Seattle Art Museum through 1952. He was drawn to the museum by Dr. Fuller, the Asian collection, and the opportunity to make acquisitions. During his four years in Seattle, Lee incited important purchases for the museum from Mrs. Donald E. Frederick, the widow of a Seattle department store owner, in the area of early medieval art. With the collector Norman Davis he attracted and selected additional gifts of earlier European art from the Kress Foundation, and at this opportune period, his invaluable contacts from his years in Japan brought to the museum many of its most treasured Japanese works of art. Lee cultivated an especially close working relationship with Mrs. Frederick, whose many gifts included such masterpieces of Japanese painting as the world-famous poem scroll by Kōetsu with deer by Sōtatsu. The museum focused on acquisitions of Egyptian art, which represent this ancient culture with distinction. Dr. Lee lectured at the University of Washington and established connections with students and faculty there, which have continued to be crucial to the intellectual life of the museum. He later became at the Cleveland Museum of Art one of the most esteemed museum directors of his time and one of the foremost authorities on Asian art in the world.

Starting in 1944 with a comprehensive loan exhibition of the art of India, ambitious changing exhibitions were routinely held at the museum. These shows reinforced the strengths of the museum's holdings, offered the public opportunities to see art of many different cultures, and stimulated collecting in new areas. This changing exhibition program became increasingly successful with such subsequent projects as Dr. Lee's 1952 *Japanese Art Treasures* and the Vincent van Gogh retrospective of 1959. These exhibitions heightened the museum's visibility locally, nationally, and internationally.

In the 1950s Norman and Amelia Davis became active partners in the growth of the museum's collection. Norman Davis became one of Dr. Fuller's closest associates and was the first individual to manifest the essential leadership and financial support that other members of the board of trustees would provide later in the museum's history. In 1954 he funded the addition of a second special gallery for the installation of the European and Kress Foundation paintings and gave the museum a choice group of ancient Greek and Mediterranean works, for which he underwrote the costs of installation in a special lower-floor gallery at Volunteer Park, prior to their placement at the downtown museum.

Sherman Lee's short tenure had also signaled the inception of the museum's professional curatorial department. Like Lee, subsequent curators have left their mark upon their cultural area, and acquisitions can be directly traced to their presence and preferences. Following Lee's departure, Dr. Millard B. Rogers was hired as assistant and then associate director. An authority on Asian art, he remained on the staff of the museum full time through 1961 and as advisor until 1972. Rogers was succeeded by Edward B. Thomas. Then from 1967 to 1973 Thomas N. Maytham was associate director of the museum

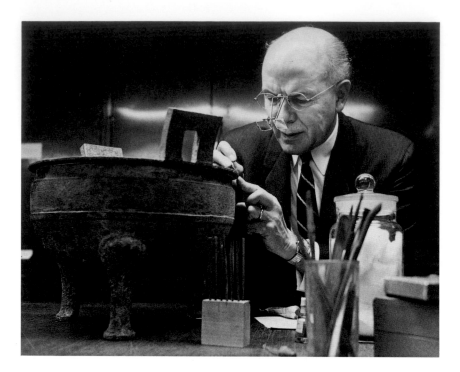

Dr. Fuller in 1964 examining a Chinese bronze *ding* in the museum's collection.
During his tenure as director of the museum, from 1933 until 1973, Dr. Fuller was
involved in all major aspects of the museum's activities. Photograph by Paul V.
Thomas

and took a special interest in building the holdings of U.S. and European nineteenth-century and modern art. Yet it was not until the arrival of the Asian expert Henry Trubner in 1968 and William J. Rathbun in 1971 that a curatorial division truly emerged.

In the 1960s and 1970s the museum routinely joined in partnerships with institutions in Japan, New York, and elsewhere for traveling shows. The cultural temperature of the city rose dramatically after the highly successful 1962 Seattle World's Fair in the Seattle Center. The presentation there, under the leadership of Norman Davis (who had been suggested by Dr. Fuller), of an international loan exhibition of artistic masterpieces and a lively contemporary show gave the community a heightened artistic awareness and hunger. The public for art expanded, yet much of the collection of the Seattle Art Museum reposed in storage, for only a small percentage could be displayed in Volunteer Park, away from the center of the city. Subsequent to the 1962 fair, in 1964 and 1965, two of the fair's pavilion buildings at the Seattle Center were combined to create a large branch facility for the museum. Through 1987 the Seattle Art Museum Pavilion, as it was known, was an active site for modern art and other large and small changing exhibitions. But even with this addition to its exhibition space, people in the community began to envision the possibility of a bigger and more centrally located permanent facility for the museum's collections and programs.

These needs eclipsed even Dr. Fuller's ambitions. He remained deeply committed to the Volunteer Park building. However, due to neighborhood resistance, the building, to which two more gallery spaces had been added in 1955, could not be further enlarged. Several options were explored, and the

merits of a downtown location were evaluated. Through the early 1970s, the museum had essentially remained the product of the interests and vision of one very generous and far-sighted man. In an autobiographical sketch he wrote a few years before his death, Dr. Fuller went so far as to characterize his leadership with as much wit as candor as a "dictatorship." Functioning as both benefactor and staff, patron and curator, he sought works of art that, as he expressed it, "reflect the creative talent of each period, and which in geological terms, serve as index fossils for their specific time and culture."

In 1973, approaching his seventy-seventh birthday and in his fortieth year as director, Dr. Fuller retired from the museum. He died three years later. Hardly Seattle's wealthiest citizen, Dr. Fuller was nonetheless the community's leading philanthropist. Respected by all for his brilliance, generosity, and vision, he laid the most solid of foundations for the next, shorter and more fluctuating chapters of the museum's history.

After Dr. Fuller

After 1973 the museum slowly developed its present broadly based management and increased public support and membership. Over the next fifteen years, given much greater responsibility, the members of the enlarged board worked with the staff and four different museum directors — Willis Woods, Arnold Jolles, and acting directors Bagley Wright and Bonnie Pitman-Gelles—to advance the museum professionally. Issues such as conservation of the collection, improved storage, and the expansion of audience through publications, public relations, and educational programs were thoughtfully addressed. The collection was re-catalogued, and by the end of the 1980s, collection data was computerized. A downtown site for the new building was finalized, funding requirements were calculated, strategies were devised, and special staff was hired to raise the needed funds. With the most ambitious financial goals for any cultural project in the Northwest's history, over the next fifteen years much of the attention of the staff and the museum's supporters was directed toward the new building and its attendant capital campaign. Even with the enormous funding needs for the move downtown, the development of the collection proceeded.

More private collectors emerged to help shape the collection. Many benefactors, such as Norman and Amelia Davis, the Backus family, the adventurous collectors of modern and Native American art Anne and Sidney Gerber (whose many gifts formed a framework for an appreciation of European and American modernism at the Seattle Art Museum), and others had previously donated works of art to the museum. However, from the mid-1970s on, museum supporters were more than ever encouraged to make purchases for and to give and bequeath art to the museum. Specific membership councils were begun, made up of collectors, artists, and enthusiasts connected to the curatorial departments the museum had established. There are now seven such councils, as well as a special contemporary art Collectors Forum. Specific councils exist for the art of Asia; contemporary and contemporary Pacific Northwest art; decorative arts; ethnic arts; African, African-American, and Caribbean art; and photography. Over the years, funds from these groups have purchased numerous significant works of art for the museum. But finally, it is the fascinations of specific donors, as much as the shared interests of the museum's affiliate support groups, that have caused the holdings of the institution in European porcelain, Korean art, Chinese painting and furniture, Indonesian and Japanese functional textiles, Northwest studio glass, post-1945 American art, and Northwest Coast

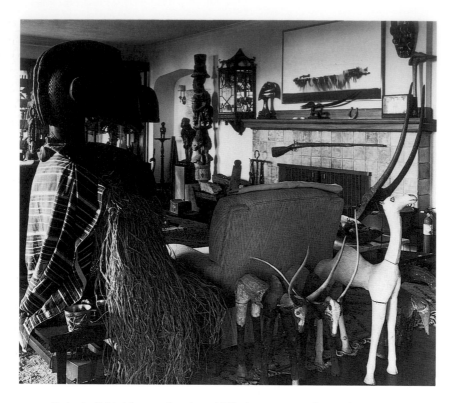

Katherine White's home in Seattle, in 1979. A passionate collector of African art, Katherine White filled her surroundings with the objects she so much admired. Photograph by Paul Macapia

Native art to burgeon dramatically.

Perhaps more than any other single factor, the 1978 Seattle venue of *Egyptian Masterworks of Tutankhamen* exhibition, brilliantly managed by a specially hired staff and hundreds of volunteers, forever altered the museum's definition and profile. The show attracted nearly 1,300,000 visitors, and the large surplus of funds generated by the admissions, the rise of museum memberships to 21,000, and the sale of catalogues and other products gave the museum a new solvency and raised aspirations. The Tutankhamen exhibition's popularity and financial success fueled the plans and preparations for a downtown facility and made the city government aware of the need.

Indicative of the expansion of the museum, the curatorial staff grew as never before. In 1981 Michael Knight, a young scholar of Chinese art, joined the curator of Japanese art, William Rathbun, and Senior Curator Henry Trubner in the department of Asian art. New areas of collecting outside Asia and contemporary Northwest art were emphasized, and appropriate curatorial staff was added. As the first curators of modern and contemporary art since Kenneth Callahan's departure in 1953, Charles Cowles (from 1975 to 1980) and then Bruce Guenther (through 1987) added many twentieth-century paintings, sculptures, photographs, and prints to the collection. They regularly included art made outside the Northwest in their programs. In 1978 the painter Mark Tobey, in recognition of the long support of his art by the Seattle Art Museum and the patronage of the Seattle Art Museum benefactor John Hauberg and his wife Anne Gould Hauberg, bequeathed to the museum an important group of his own works and

his eclectic art collection, ranging from Asian textiles to drawings by his contemporaries. European decorative arts, textiles of all cultures, and ancient and Native art of the Americas were given greater prominence within the museum's acquisition and exhibition programs.

The 1980s commenced with an extraordinary donation and purchase of African art, yet another realm of collecting initiated by Dr. Fuller. In 1968 he had put together a survey exhibition entitled *Tribal Arts of West Africa,* borrowing heavily from the New York dealer-collectors Nasli and Alice Heeramaneck, with whom he had worked closely since the early 1950s. They subsequently donated eighty-four examples of African art to the museum. Their gifts became the core of a small collection that grew modestly in the 1970s. But it was one woman, who lived in Seattle for barely one year, who brought about an unprecedented shift in the museum's collecting focus to cultures outside Europe and Asia.

In 1979, the collector Katherine C. White came to Seattle with the intention of opening a private viewing gallery to display her more than 2,000 works of African, ancient American, and Oceanic art. Her prowess as a collector of African art had become legendary during the previous two decades. She was renowned for her "omnivorous eyes," a persistence for tracking down scholarly opinions about works of art, and her skill with the Hassselblad camera she used during trips to Africa. She traveled constantly to see other public and private collections, and she built up a comparative slide reference base that served her well in choosing new acquisitions. She also challenged the limited notion of African art as consisting of only masks and figurative sculpture by collecting textiles, decorative arts, and household and functional objects. Even before White moved to Seattle, her exhibition plans were encouraged by

the museum's trustees and curatorial assistant Pamela McClusky at the Seattle Art Museum, then doing research on the museum's nascent African holdings. She has since become associate curator for African art.

Within a year after Mrs. White's relocation to Seattle, a debilitating illness took her life. Shortly before her death, she finalized the arrangements for the transfer of her collection to the Seattle Art Museum. Through the immense generosity of the Boeing Company and Mrs. White's gift, Seattle became the recipient of one of the most comprehensive holdings of African art in the United States. Instantly the museum became as well known internationally for African art as it was for the arts of Asia. A decade later the new museum building finally provides for a substantial portion of the Katherine C. White collection to remain on permanent view.

The 1980s brought other additions to the collection. The large, designated bequest in 1980 of Mrs. Charles E. Stuart instigated the formation of a Decorative Art Department, the hiring of Julie Emerson as assistant curator, and a new impetus for acquisitions in this area. In 1983 the collector of contemporary Northwest art Mary Arrington Small specified that her generous bequest to the museum be used for "museum acquisitions." Her funds were divided among the different curatorial departments; several of the resulting purchases are featured in this publication. In part making use of this fund, photography, a new aspect of the collection, was vigorously pursued from 1981 on. Like many other American museums around that time, the Seattle Art Museum began to seriously collect and exhibit photography. Under the leadership of assistant and then associate curator of photography Rod Slemmons, a special subcommittee of museum trustees, artists, and collectors tightly defined their objectives. They

Robert Venturi's model of the Seattle Art Museum. The new building is located on University Street between First and Second avenues, in downtown Seattle. Photograph ©Robert Pisano

used as their point of reference the examination of the commonly held idea that there have been two basic uses of photography, as document and as artistic expression. Approximately 1,400 photographic prints by nearly three hundred mostly U.S.-based artists have since been acquired to address and examine these aspects of the medium.

Moving Downtown

The appointment of Jay Gates as director in the spring of 1987 brought to Seattle a youthful but seasoned museum professional, with experience at the major museums of Cleveland, Saint Louis, and Kansas City and the directorships of the art museums of Memphis and the University of Kansas, Lawrence. Gates immediately embarked upon purchases of a significant ancient Chinese bronze bell (acquired in honor of Henry Trubner at the time of his retirement) and the *Portrait of Madame Brion* (1750) by the French painter Jacques-André Joseph Aved. The acquisition of the Aved, along with the purchase at auction of John La Farge's composition of colored glass *Peonies in the Wind with Kakemono Borders,* underscored the need to strengthen the museum's representation of earlier European and American art and the institution's new willingness to commit major funds for the acquisition of art. Gates and Patter-

son Sims, associate director for art and exhibitions and curator of modern art, who came to Seattle from the Whitney Museum of American Art in New York in late 1987, encouraged closer relationships with local and national collectors and cultural institutions in the region and elsewhere. In the summer of 1990, partly funded by the Samuel H. Kress Foundation and serving a joint teaching appointment with the University of Washington, the museum's first curator for European painting, Chiyo Ishikawa, was hired. A curator of Northwest Coast Native and ancient American art, Steven Brown, joined the staff in 1990 in anticipation of the gift by John Hauberg in early 1991 of over two hundred carvings and other works of Northwest Coast Native art. This collection's great strength in Northern ceremonial art and Northern Vancouver Island dramatic masks made it outstanding among this area's private collections. The works of a number of well-recognized Native artists of the nineteenth and twentieth centuries are included in the collection, as well as several documented eighteenth-or very early nineteenth-century objects. Hauberg's donation built upon his earlier gifts of Northwest Coast Native art and important examples of Mesoamerican metalwork and ceramic figures. By 1990 the curatorial staff con-

sisted of specialists in nine different areas. It more truly reflected the breadth of the collection and the specifics of its installation both downtown and in Volunteer Park.

From the late 1980s on, the director, the curators, and the board-based committee on the collection examined offers of gifts with heightened discretion and sensitivity to the needs of the collection. Selective deaccession provided some funds and opportunities to trade for collection improvement. Through the Christensen Fund, important collections of African art of the Kuba people of Zaire and Japanese functional textiles of the late nineteenth and twentieth centuries were placed on long-term loan. The earlier gift of Bagley and Virginia B. Wright's comprehensive collection of over one hundred Japanese textiles added a new dimension to their multifaceted support of the museum, as it became known that these nationally recognized collectors of the art of post-1945 Europe and the United States had developed a comparable fascination with the arts of Japan. With the promised gift of the Manring collection of Indonesian textiles in mid-1990, the museum began to realize its aspiration to be a major center for the study and appreciation of textiles. The Wrights' gifts of Japanese and modern art and the donation of the Hauberg collection of Northwest Coast Native art were made in anticipation of the completion of the downtown building and the conversion of the Volunteer Park facility into a center for Asian art. Mr. and Mrs. Wright and John Hauberg demonstrated once again their utmost commitment to the museum. As long term trustees and presidents of the board of trustees, they have personified the combination of connoisseurship, public service, and true generosity that has effected the continued growth of the museum's holdings.

The installation of the permanent collection galleries downtown and plans for the dedication of the Volunteer Park facility to Asian art dictated many additions to the collection. Donors and collections that had been virtually unknown or inaccessible emerged. For example, the nineteenth-century modern art gallery of the new museum building clearly required additional paintings and sculptures: with the timely support and advice of Seattle collectors Ann and Tom Barwick, in three years six works materialized. Building upon previous holdings and with Frank S. Bayley III as benefactor, the museum realized it had sufficient important art of Korea to devote rooms to the art of this culture both downtown and in Volunteer Park. Over an initial three-year period, the Sarah Ferris Fuller Fund helped the museum gather the essential elements for the creation of a Chinese scholar's studio in the downtown facility. The Urasenke Foundation of Kyoto designed and underwrote the costs of a Japanese teahouse in the downtown galleries. Key to the installations of the museum's Asian as well as its African, Oceanic, and Native art of the Americas at the downtown museum was the support of the National Endowment for the Humanities. In such partnerships with government, private foundations, and private collectors, acquisitions and their presentation are assessed and attained.

Dr. Fuller's original commitment to the contemporary art of the Northwest was not forgotten. From 1986 through 1990, with a substantial research grant from the Henry Luce Foundation, a twentieth-century Northwest art research curator, Barbara Johns, and Vicki Halper, assistant curator of modern art, in conjunction with a Northwest art subcommittee of collectors and other experts, oversaw the addition of more than twenty-five acquisitions of historic and contemporary Northwest art. These purchases and gifts anticipated the two galleries in the downtown museum dedicated to the accomplishments of the region's artists.

In the late 1980s, Elaine Henderson of San Francisco began to add Colonial American silver to the English silver given by Mr. and Mrs. Walter A. Buffington; this silver complemented the museum's holdings of porcelain, nurtured during this period by major bequests and donations from several of the early members of Blanche Harnan's Seattle Ceramic Society.

New Opportunities for Growth

Since 1973, under the leadership of five successive directors, a more methodical and publicly based acquisition program has been formulated. The community and private collectors have had to be persuaded of the vital role they can and indeed must play in the growth and expansion of the museum and its collection. In the late 1980s, substantial government grants were received for loan exhibitions and to underwrite the museum's presentation and interpretation of its collections, but governmental support does not include large sums of money for acquisitions. With the notable exception of the Boeing Company's gift of funds to purchase the Katherine White collection, most corporate funding has been dedicated not to acquisitions but to the support of exhibitions, operating costs, and building construction. Though relatively small, the museum's endowed acquisition funds are the principal tools with which the collection is built. But it is gifts that have allowed substantial collection growth to occur. Major expansions of the collection necessitate private initiative and generosity and are usually achieved through constant requests for assistance from the director, the curators, and the development staff. Even with tax laws and a financial climate from the 1970s through 1990 that discouraged the donation of art, the museum has secured many, some major, works of art.

Following Dr. Fuller's acquisition and gift to the city in 1969 of Isamu Noguchi's *Black Sun* for installation in front of the museum's Volunteer Park site, the two largest and most public works of art associated with the Seattle Art Museum were added. In 1986 came the donation of Henry Moore's *Three Piece Sculpture: Vertebrae* (1968). Still located on the public plaza in front of 1001 Fourth Avenue in downtown Seattle, Moore's colossal bronze biomorphic abstraction was given to the museum following a public outcry when the property on which it is placed was sold. It was bought back with the help of the building's original owners and donated to the Seattle Art Museum, with the proviso that it be transferred to the museum's site within thirty years of its donation. In 1990, under the auspices of the Seattle Arts Commission's 1% for art program, the downtown museum's development authority, the Virginia Wright Fund, and PONCHO commissioned Jonathan Borofsky's giant *Hammering Man*. Selected by a six-member panel, Borofsky's 48-foot-tall laborer acts as the guardian-greeter at the museum's First Avenue and University Street entrance.

Art that the region's collectors have managed to bring here, they want to have remain. As a magnet for generosity, the museum has benefited enormously from its singularity within the community and region and, with a consciousness intensified in recent years, its location on the Pacific Rim. The surge of growth of the city in the late 1980s and 1990s has brought many art collectors to the area. With its new downtown facility displaying the breadth of its permanent collection and with its original building in Volunteer Park dedicated to the exhibition and study of Asian art, the Seattle Art Museum has grown to reflect the world's diverse cultures.

Patterson Sims
Associate Director for Art and Exhibitions
Curator of Modern Art

ANCIENT ART
OF THE MEDITERRANEAN
AND THE NEAR EAST

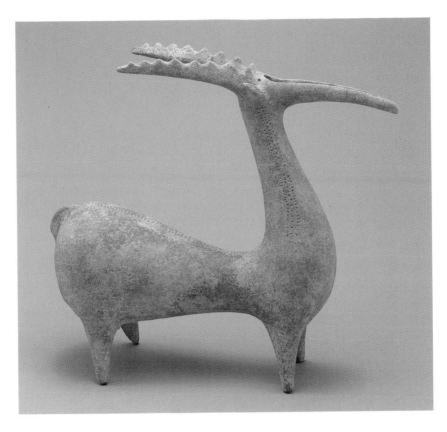

Rhyton
9th–8th century B.C.; Amlash
Red pottery; h. 11 in. (27.9 cm)
Eugene Fuller Memorial Collection, 68.8

This stag rhyton, or drinking vessel, is a handsome example of Amlash pottery and dates from the ninth to the eighth century B.C. The people known by this name, mostly farmers, lived in an area to the southwest of the Caspian Sea, the areas of Mazanderan, Gilan, and Daylam in present-day Iran.

The arts of these people came to be systematically known from a series of excavations begun in 1961, although farmers in the area had come across artifacts earlier. The material came from megalithic tombs at several sites; however, the town of Amlash gave its name to all of the arts of the entire area. Gold and silver vessels and bronze statuary of human figures were found in these tombs, but pottery is the medium in which most scholars believe the Amlash artists excelled.

Containers shaped in various animal forms are the hallmark of the gifted Amlash potters. Ducks, ibexes, horses, rams, birds, humped oxen, boars, and stags all were cleverly shaped to hold liquid as freestanding forms with small tapering legs. Each animal was appropriately stylized to dispense liquid. This stag has an elongated nose which serves as a channel for pouring or drinking. In addition, the potter has taken specific care to highlight its features, finely incising its antlers and applying puncture decoration.

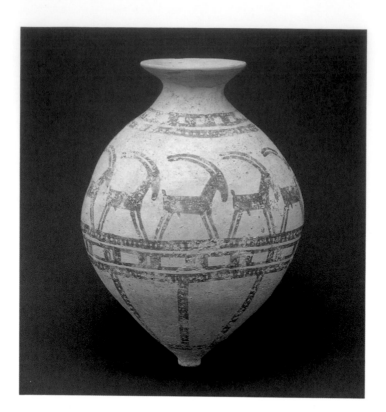

Jar with Frieze of Ibexes
8th–7th century B.C.; Iranian
Buff-colored pottery with painted decoration; h. 7 in. (17.7 cm)
Eugene Fuller Memorial Collection, 61.36

This jar with its ibex frieze is a fine example of the ceramic arts found in Luristan from the eighth to seventh century B.C. What distinguished the pottery of the Luristan ceramists from that of the Amlash of approximately the same period was their use of painting, although in time, painted ornamentation became relatively rare.

We know the arts of the Luristan nomads mainly from their megalithic tombs, which seem to have been placed at a distance from areas of habitation. The tombs contained a great number of bronze, iron, and silver objects, most often pertaining to horses, by which the arts of Luristan are often characterized. Objects found in tombs show no signs of wear and therefore seem not to have been in daily use, suggesting that objects actually used by the individual were not used for interment.

This ibex jar is exceptional because it represents a lesser-known medium in the arts of Luristan. The relative scarcity of Luristan ceramics is due to chance. The peasants who first opened the graves were more interested in the metal objects because of their immediate market value than in these ceramic wares which have rarely survived modern tomb-robbing. The ibexes represented on this jar allow us to see that the art of animal depiction of the potter and of the artist in bronze were closely related.

Bas-Relief Fragment
7th century B.C., Assyrian
Stone; 14 x 15½ in. (35.5 x 39.3 cm)
Eugene Fuller Memorial Collection, partially donated by Hagop
Kevorkian, 46.50

The four soldiers striding in line depicted on this fragment most probably were part of the wall ornamentation of a royal palace in Nineveh. Wall reliefs began to be an important part of palace architecture late in the long history of Assyria. They are known first from the palace of Ashur-nasir-pal II (883–60) in the capital city of Kalhu, and continued to be placed in royal palaces as a major pictorial record for more than two hundred years, through the reign of Ashurbani-pal (669–26).

Originally stone bas-reliefs were erected as dados in significant rooms within the palaces, such as reception halls, and they were enhanced with color. Ashur-nasir-pal's use of stone, a permanent and expensive material, contrasted sharply with the practice of earlier Assyrian kings, who decorated their palaces with brick and painted plaster.

The subject matter of all of the bas-reliefs can be divided into two major categories: kings and gods on the one hand, warfare on the other. While their general subject matter remained fairly consistent for more than two hundred years, the mode of the depictions and their scale changed over time. In the later years, the height of the reliefs was increased and more complex scenes were depicted, such as assaults on mountain fortresses and battles in swamps. The conventions of showing depth as well as the style of headgear and shields of these warriors suggest a seventh-century B.C. date and their location in the city of Nineveh.

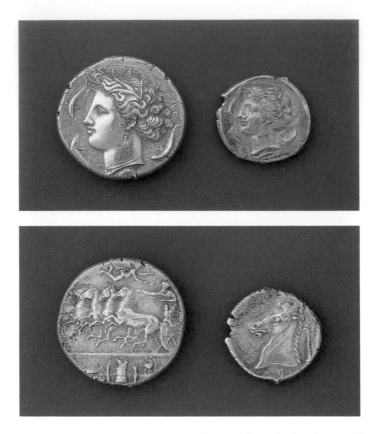

Decadrachm
c. 380 B.C.; Greek (Syracusan)
Silver; diam. 1⅜ in (3.5 cm)
Norman and Amelia Davis Classical
Collection, 56.231

Tetradrachm
c. 350 B.C.; Carthaginian
Silver; diam. 1 in. (2.6 cm)
Norman and Amelia Davis Classical
Collection, 56.226

Classical coins often appear as intact today as they did in antiquity. This is important, because in the main, artists created the dies that produced them, and no less aesthetic interest was lavished on coins than on sculpture.

One of the most prolific and talented die engravers was Euainetos. He was the creator of the motifs on the first of the two coins featured here, an imposing ten-drachma piece of Syracuse. Its obverse depicts the head of Arethusa, a water nymph, who, when pursued by the river god Alpheus, was rescued by Artemis. According to the myth,

Artemis brought Arethusa to Syracuse and there transformed her into a spring. To this day she still pours her waters into the surrounding sea, symbolized here by the circling dolphins. On the reverse appears a racing chariot, its driver being crowned by a Nike, a winged figure representing victory. This particular piece was struck under the rule of Syracuse's greatest tyrant, Dionysios I, and it may initially have been used to pay off the army of mercenaries on whom his power depended, and through whom he attempted to drive the Carthaginians from Sicily.

The Carthaginians, who had colonies in Sicily, adopted certain aspects of Syracusan coinage. They replaced the racing chariot with their own national device, the horse's head, but retained the head of Arethusa, as is seen on the four-drachma piece. But Arethusa's features have acquired a Semitic cast more in accord with Carthaginian tastes.

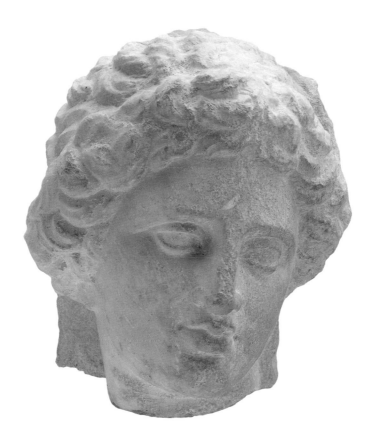

Head of a Woman from Tomb Monument
350–300 B.C.; Greek, Attic
Marble; h. 10 in. (25.4 cm)
Gift of Norman Davis in memory of his mother, Mrs. Annie Davis, 60.60

This fine classical life-size rendering of a woman's head is only a fragment of a large marble relief that was used as a funeral monument in fourth-century Athens. These reliefs were often shaped like aediculae in which family members were depicted bidding farewell to the deceased. The Davis head, therefore, represented either a family member or the dead person. Since such monuments were expensive, they marked the burial plots of wealthier citizens.

As is usual in Greek sculpture of this period, the artist has carved an idealized rather than representational version of the human female. Since such renderings were based on common models, many of the female heads created by fourth-century artists are strikingly similar. This one varies only a little, in its essentials, from that of the nymph Arethusa on the Syracusan decadrachm (p. 26).

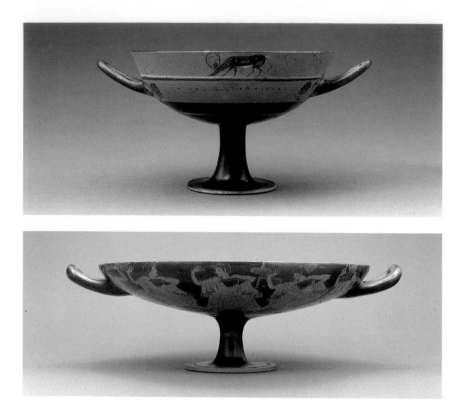

Kylix
550–530 B.C.; Greek, Attic
Xenokles
Black-figure ware, pottery;
4⁷⁄₁₆ x 8¼ in. (11.2 x 21 cm)
Norman and Amelia Davis Classical
Collection, 59.100

Kylix,
500–480 B.C.; Greek, Attic
Painter of the Paris Gigantomachia
Red-figure ware, pottery;
5⅛ x 16⅛ in. (13 x 41 cm)
Norman and Amelia Davis Classical
Collection, 59.30

The city of Athens was famous for pottery during the sixth and fifth centuries B.C., when large amounts of Attic ware were exported, especially to Italy. Both of these finely decorated wine cups were probably recovered from tombs located on Italian soil.

The smaller, more delicate specimen is of the black-figure type, featuring figures in black imposed on an orange-red background. Of particular interest is the autograph of its potter, Xenokles, which appears between the two handles. Xenokles or some other artist decorated the vessel with a bull and a deer on the bowl exterior, palmettes by the handle, and a hen and rooster inside to amuse the drinker as the wine was drained. Details on the figures were incised with a sharp instrument.

The red-figure style emerged in the later sixth century and became extremely popular. The reason for the change was surely that greater realism was possible by using a lighter surface for the figures, and painted rather than incised details. Red-figure vases often depict scenes from everyday life, as here. A lively Athenian drinking party is depicted on both the exterior and interior of the bowl. Inside, drinkers are shown playing *kottabos,* a game made possible by the large handles of these cups. The object was to make a wish, then seize a handle and fling the dregs of the wine at a target. If it were hit, one's wish was supposed to come true.

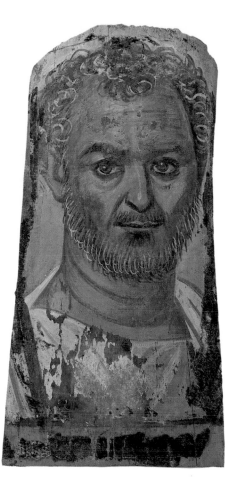

Funerary Portrait
2nd century, Roman Period, 31 B.C.–A.D. 395, from Mazghuna, Egypt
Wood, tempera, traces of resins,
gold leaf; 16⁵⁄₁₆ x 8½ in. (41.4 x 21.6 cm)
Eugene Fuller Memorial Collection, 50.62

During the Roman Period in Egypt, native and Roman customs were gradually assimilated. The persistence of the belief that rebirth depended upon preservation of the features of the deceased led the egyptianized Romans to adopt the practice of mummification. Mummies of this period were poorly prepared, although they were often wrapped with layers of narrow bandages that form elaborate geometric patterns. Rather than rely upon an idealized Egyptian-style mask, Roman tastes dictated that a lifelike portrait be placed over the face of the wrapped mummy and secured at its edges by the final layer of wrappings.

These portraits are Roman in style and composition, with the deceased shown, as here, in a nearly frontal position, rather than the standard Egyptian profile, and coiffed and bearded in Roman fashion. Since few of the subjects of these portraits are depicted as being old, and since some were originally framed, it is assumed that the paintings were done in the subjects' prime and hung in their homes during their lifetimes.

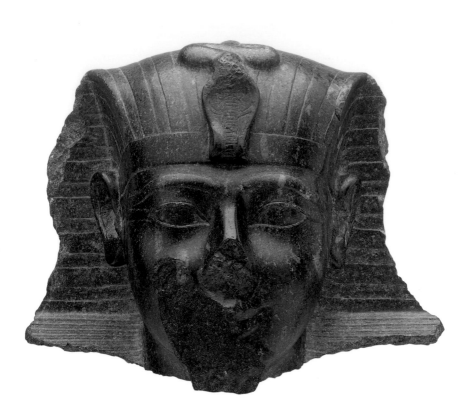

Head of a King
c. 1435 B.C.; Egyptian, 18th Dynasty, 1570-1293 B.C., from Armant
(excavations of Sir Robert Mond)
Black basalt; h. 11¾ in. (29.9 cm)
Eugene Fuller Memorial Collection, 52.70

The tradition of creating life-size or monumental statues of the king and the gods can be traced back to the very earliest period of Egyptian history. Such statues were placed in funerary or festival temples as effigies intended to partake of the rituals that were performed by the staff of priests. These figures, sculpted in imitation of an official sculptural representation of the king, were often royal commissions and, in many instances, were executed in the royal workshops.

Here a pharaoh, either King Thutmose III or Queen Hatshepsut, is shown wearing the striped *nemes,* the royal headcloth ornamented with the uraeus snake, symbol of kingship. The strap securing the false beard that associated the king with the god Osiris runs from ear to ear. Hard stone like this basalt was worked with simple copper saws and drills and smoothed with stone scrapers.

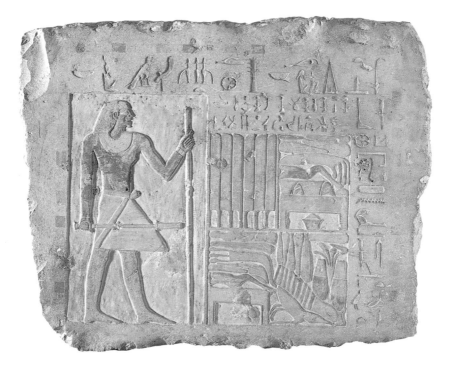

Stele of Chaywet
Egyptian, First Intermediate Period, 7th–9th Dynasty, 2250–2000 B.C.
Limestone, pigment; 22 x 22 in. (55.9 x 55.9 cm)
Thomas Stimson Memorial Collection and partial gift of Hagop
Kevorkian, 47.64

Among the major features of ancient Egyptian theology was the belief
that the needs of the deceased were much like those of the living, and
that preservation of the image, name, and titles of the deceased was
associated with existence in the afterlife. As a result, this stele from a
tomb chapel is incised with a representation of the tomb owner, the
mayor Chaywet, and with a hieroglyphic inscription requesting
funerary offerings of the staples of the ancient diet: bread, beer, oxen,
and fowl. Chaywet is shown standing behind a pile of offerings, which
include vegetables, a bird, and two offering tables with bowls heaped
with provisions and haunches of beef. In theory, the representation of
these supplies could substitute for actual offerings which Chaywet's
friends and family were expected to leave in the chapel. The deceased
is dressed in typical garb of the times — a heavily starched linen kilt
knotted at the waist; bracelets; a wide, beaded necklace; and a heavy
wig. His staff and scepter serve as symbols of his authority.

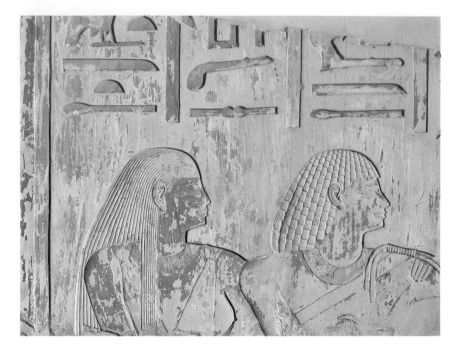

Relief from the Tomb of Montuemhet
c. 665; Egyptian, 25th–26th Dynasty, 780–525 B.C.; from Luxor, tomb 34
Limestone, pigment; 10½ x 13⅜ in. (26.7 x 34 cm)
Purchased from the bequest of Archibald Stewart and Emma Collins
Downey, 53.80

This fragment once decorated the vast underground chambers of the tomb of the Fourth Prophet of Amun, the mayor of Thebes, Montuemhet. This block formed part of a scene showing Montuemhet, embraced by his wife, Shepetenmut, as they receive funerary offerings which would have been shown to the right of this scene. They are shown in typical garb, with elaborately styled wigs and heavy necklaces. Shepetenmut wears a dress with plunging neckline and clasps or knots at each shoulder. The hieroglyphs above their heads are the last characters in their personal names.

As the mayor of Thebes, Montuemhet was responsible for surrendering the city, then the center of ancient Egyptian culture, to the Assyrian armies of King Ashur-bani-pal in 667 B.C. Montuemhet survived the Assyrian invasion and went on to serve Egyptian rulers of the 26th Dynasty. Toward the end of Montuemhet's career, it was considered fashionable to consciously imitate the earlier artistic style with its simple rendering of facial features and depiction of heavy, long wigs.

ART OF AFRICA

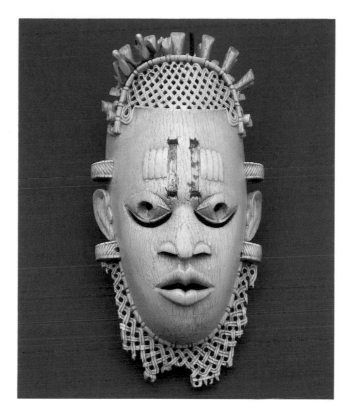

Belt Mask
16th century; African, Nigeria, Benin
kingdom
Ivory; h. 7 in. (17.8 cm)
Gift of Katherine White and the Boeing
Company, 81.17.493

In the sixteenth century, the Benin king-
dom was one of Africa's most pros-
perous urban civilizations. At its center
was a divine king or *oba,* who lived in a
palatial compound surrounded by an
elaborate court. Ivory carvers worked
exclusively for the *oba* and produced
many items of regalia, including a cor-
pus of pendant masks that capture the
formal gazes of royalty. A delicate female
face is rendered here, with an incom-
plete crown of pegs and a guilloche pat-
tern derived from Benin royal regalia
around her chin and forehead. Suspen-
sion pegs on the sides of her face
enabled the mask to be worn on the
oba's hip.

Until the late nineteenth century, the
oba's treasury was rarely seen beyond
the palace walls. In 1897, a British

punitive expedition confiscated thou-
sands of objects which have since been
located in museums and private collec-
tions in Europe and the United States.
Not much was revealed about the iden-
tity of this royal mask until 1977, when
the late Oba Akenzua II identified a sim-
ilar mask in the British Museum as the
face of Idia, the Queen Mother of a
remarkable sixteenth-century *oba*
named Esigie. One of the many innova-
tions credited to his reign is the estab-
lishment of the role of the *iyoba* (*iye:*
mother; *oba:* king), who lived in her own
palace and wielded great influence over
state policies and the cult of the royal
ancestors.

Today Akenzua's son, Oba Ere-
diavwa, is the thirty-eighth *oba* and
the spiritual and temporal leader of a
thriving metropolis. He continues to
patronize a guild of ivory carvers who
provide him with ivory masks to be
worn during ceremonies commemorat-
ing his Queen Mother.

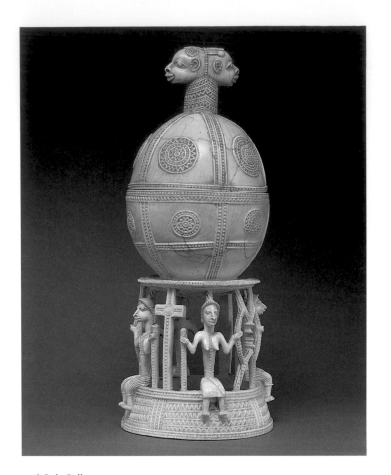

Salt Cellar
16th century; African, Sierra Leone, Sapi-Portuguese
Ivory; h. 12⅛ in. (31 cm)
Gift of Katherine White and the Boeing Company, 81.17.189

Both the Sapi and the Portuguese are given credit for this hybrid creation. It documents an inventive African response to a European suggestion made during the Renaissance, when Portuguese navigators circling the West African coast in the late fifteenth century sought "white gold," or ivory, but also found carvers whose skill was indisputable. Commissions were established using as models gold and silver chalices and salt cellars that followed the Renaissance preference for profuse and extravagant detailing. African carvers replicated such details in ivory to a surprising extent. This salt cellar may imitate a coconut cup mounted in metal strapwork decorated with minute granulation and incised borders. Beneath the sphere, a group of men and women wearing pantaloons and skirts are seated in an openwork circle. Their faces, like the two Janus heads at the top, stylistically identify the region of Sierra Leone the carvers came from.

Once placed on the dining table of a noble family during the Renaissance, the salt cellar would have accented the careful dispensation of salt, then a precious spice. As a conversation piece, it could have prompted discussion about discoveries of the newly explored continent.

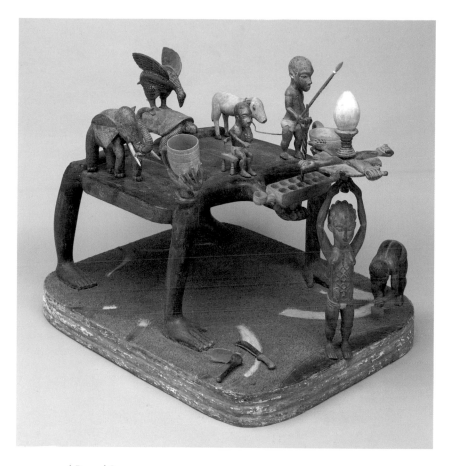

Figural Scene
African, Ivory Coast, Baule
Wood, paint; h. 23¹³⁄₁₆ in. (60.5 cm)
Gift of Katherine White and the Boeing Company, 81.17.239

Naturalistic details and explicit textures draw attention to this sculpture. An elephant's wrinkled skin is imitated by an ingenious pattern of crosscuts that leave a surface of tiny pyramids. The tortoise has a geometric maze incised on its shell and scales on its limbs, while the bird above has layers of lined feathers. A bony hand with distended knuckles grasps a decorated cup. Each creature and figure demonstrates the prowess of a master carver at work.

Fantastic images within this assembly include a human body splayed out to become a table, with a gameboard for a head. In front of the seated ruler, a woman holds up a circle of hands which twirls around a stationary egg. It may relate to a common proverb about how holding responsible office is like holding an egg in the hand (power must be grasped gently; held too tightly, it will break).

This combination of miniatures forms a cryptic assemblage. Collected without primary field documentation, this display can be admired for its inventive qualities but cannot be tied down to a definite meaning.

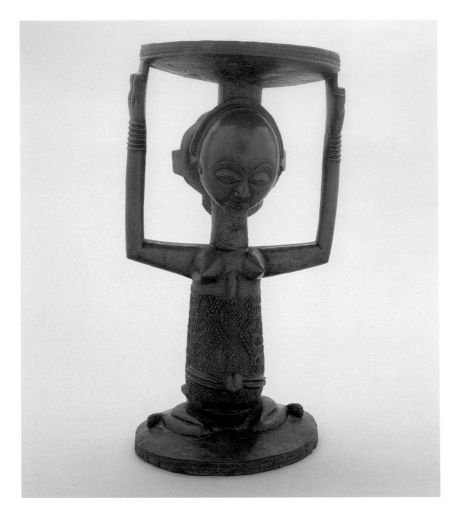

Kihona Stool
19th century; African, Zaire, Luba
Wood; h. 20 in. (50.8 cm)
Gift of Katherine White and the Boeing
Company, 81.17.876

Prestige furniture was an essential part of the Luba royal court in a kingdom which flourished from the seventeenth to the late nineteenth century. Stools, staffs, bowls, bow-stands, and cups were created for Luba leaders as insignia of their office. The stool, in particular, became a throne emblematic of the authority to hear disputes and to extend protection to outlying chiefdoms.

This stool has been identified as the work of a master carver who contributed furniture to the royal treasury. The hand of a master is evident in the degree that this woman's rigid stance seems natural and appropriate to her role. To confine her body between two circular discs, the carver has reduced her legs and hips to merge with the base and has extended the arms to form a tripod of vertical support. Two types of body art favored by this master are highlighted. The torso is covered with a herringbone pattern of relief representing the welted skin of a finely scarified woman. Her hair has been extended into a cross form on the back of her head, balancing a globular forehead and face with features compressed into the bottom half. Such subtle refinements transform a woman crouched beneath a seat into one posing with great dignity and strength.

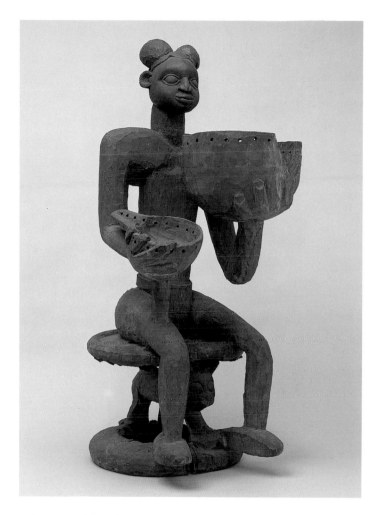

Chinda Retainer Figure
19th century; African, Cameroon, Kom
Wood, cloth fragments, nail;
h. 30⁷⁄₁₆ in. (77.3 cm)
Gift of Katherine White and the Boeing Company, 81.17.719

Royal palace etiquette is commemorated by this seated figure of a retainer offering bowls filled with delicacies. Retainers assisted the *fon*, or king, of the Kom kingdom by acting as emissaries and confidants. Within the inner sanctum of Kom royalty, this retainer figure would offer two ingredients useful to palace discussions. One hand held kola nuts, a stimulant offered as a gesture of hospitality, and the other held palm wine, an intoxicant.

Originally, this figure was covered from the neck down in a cloth casing sewn with glistening beads. With that covering removed, the faceted surface of an adzed carving of a lean, attentive figure is revealed. Despite the lack of beading, the retainer's distinguished status is evident in his attributes and attitudes. He wears the knobbed cap of a Kom nobleman and he sits on a leopard stool. Leopards are a prerogative of royalty, appropriate as a seat only for an esteemed associate of the *fon*.

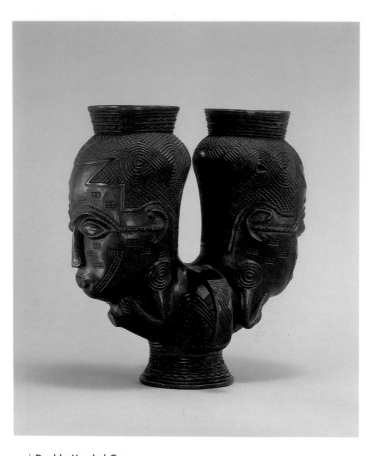

Double-Headed Cup
20th century; African, Zaire, Bashilele
Attributed to Niamandele (d. 1965)
Wood; h. 8¹¹⁄₁₆ in. (22 cm)
Gift of Katherine White and the Boeing Company, 81.17.827

Drinking palm wine from a carved cup was just one of many ways that the people of the Kuba kingdom showed their dedication to decorative artistry. Serious drinking on ceremonial occasions required complex etiquette and the finest cup a man could commission. Men competed with each other by owning distinguished cups supplied by master carvers.

This cup is identified as the work of an artist and leader who worked early in this century. Niamandele's talented hand is conspicuous in the cup's exacting symmetry and skillful proportions. Crisscrossed hair, interlocking motifs, and incised zigzags enliven the surface of the cup with minute linear patterns. Layers of such designs were known to cover Kuba clothing, pottery, boxes, weapons, and furniture, and established the Kuba as a culture with a genius for geometric design.

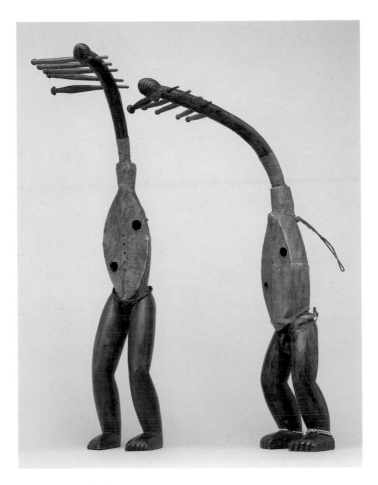

Female and Male Harps
20th century; African, Zaire, Ngbaka
Wood, skin, fiber;
h. 26¹¹/₁₆ in. (67.8 cm); h. 26½ in. (67.3 cm)
Gift of Katherine White and the Boeing Company, 81.17.882.2, .1

African sculptors often illustrate just how adaptable the human form can be. The complete human figure may function as a table, stool, spoon, or comb, as well as a wide variety of musical instruments. Bellies or torsos are reconfigured into platforms, scoops, or in this case into resonating chambers.

Humanoid harps are found in many areas of Africa, but full-figured harps are most often from Zaire. In this pair, long curving necks hold five pegs, which once supported strings of varying length and pitch. The strings were tied into the ovoid, hide-covered torso to create elliptical sound boxes. Slightly flexed legs enable the instruments to balance as freestanding sculptures that almost appear to dance together.

Such harps are not actually played for dance events but form accompaniment for professional musicians who recite stories. These male singers and narrators would hold the harps facing their bodies as they played and performed for hours on their travels in and out of the courts and towns in Zaire.

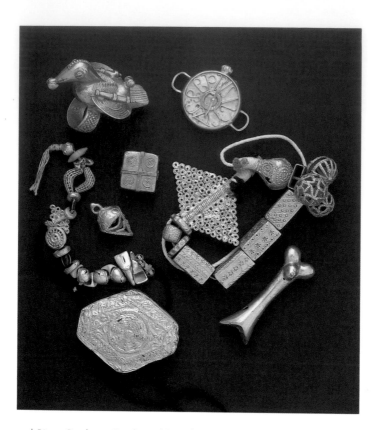

Rings, Pendants, Beads, and Bracelets
19th–20th century; African, Ghana, Akan-Asante
Gold, gold wash over silver core
Gift of Katherine White and the Boeing Company

Akan kings and chiefs have been adorned in lavish displays of gold jewelry for centuries. As early as 1482, a Portuguese expedition was met on the coast by an Akan official who was "covered with chains and trinkets of gold in many shapes, and countless bells and large beads of gold." This golden affluence is still seen today, particularly during ceremonies, when the wardrobes of Akan rulers exude artistic and symbolic wealth.

On great occasions, the visual complexity of a ruler's panoply is matched by the verbal intricacies of the Akan court. Gold jewelry is often selected to trigger the proverbs and metaphors that lace Akan speech. For example, the ring depicting a bird with cannons on its wings alludes to a proverb: "The courageous bird Adwetakyi sits on cannons," or, a brave man faces all odds; he is always ready to face the enemy. The cast gold version of a watch is a metaphorical indication of the power of the chief to control events, since he is in control of time. While this dazzling array of gold is apt to demonstrate power and prestige, it also conveys a wealth of other messages to an Akan observer.

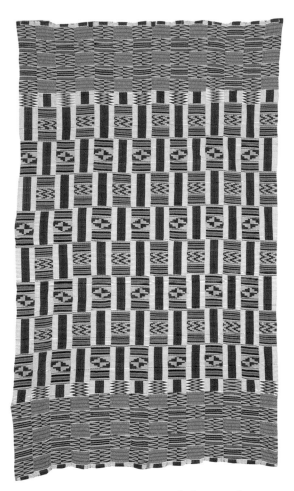

Regulated asymmetry, or off-beat phrasing, is an aesthetic explored in many West African textiles. *Kente* cloths, once made out of cotton with shimmering silk and today out of vibrant rayon, are among the best known examples of this tradition.

Weaving in strips is one basis for the complex phrasing of these cloths, as the weaver produces narrow three- to five-inch bands which are sewn together to form a complete cloth. When the weaver inserts inlays of richly colored geometric motifs, such as diamonds, steps, and chevrons, he must mentally calculate the larger composition of the cloth. The dazzling complexity of the designs is made all the more impressive by the mastery of planning required to coordinate each cloth. *Kente* is translated as "that which will not tear away under any condition." Individual *kente* are also given names; different patterns are given names as well, many alluding to proverbs or points of history. Two examples are: "Money attracts many relatives," and "An insect that purifies dirty water."

Only chiefs, royalty, and court officials once wore *kente* as a togalike garment. Today, it is a prestigious cloth that may be worn by anyone who can afford it. Foreign designers have also been adapting its dynamic patterning and applying it to printed cloths for years.

Bridal Cloak (Linaga and Nyoga)
20th century; African, South Africa,
Transvaal, Southern Ndebele
Hide, beads; h. 42 in. (106.7 cm)
Gift of Katherine White and the Boeing
Company, 81.17.1285

Ndebele women offer a lesson in creative self-determination. In answer to a century of political and social upheaval, they have provided a buoyant aesthetic profile. By composing regal beading and dynamic wall painting, they have encouraged their families to defy the severity of conditions in South Africa.

Major stages in a woman's life are acknowledged by sewing beaded garments. A bride is outfitted in the most ornate ensemble of her life. This large beaded composition forms a cape around her shoulders with a train called Nyoga, or snake, as it slithers along the ground when she walks.

Compact shapes in vivid colors are hallmarks of both Ndebele wall painting and beading. This cape features a virtual crust of white seed beads serving as a background for sections with translucent and opaque glass beads. For the original owner, these colored blocks set up a symbolic matrix whose interpretation is now unknown. In the 1960s, images of light bulbs, airplanes, and swimming pools were incorporated into Ndebele art, despite the fact that most women were restricted to homelands where there was no access to such luxuries.

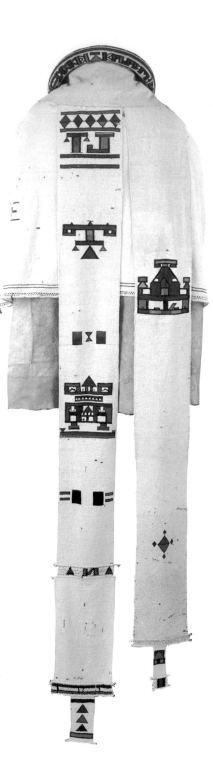

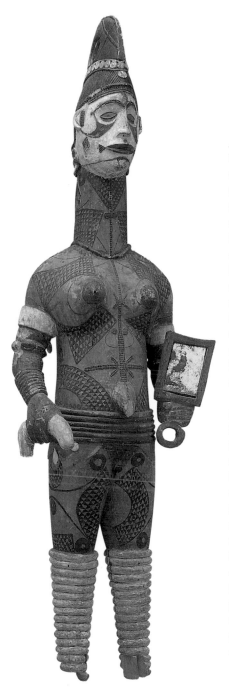

Female Figure
20th century; African, Nigeria, Igbo
Wood, pigment, mirrored glass;
h. 50 in. (127 cm)
Gift of Katherine White and the Boeing
Company, 81.17.525

An alluring Igbo maiden who is ready to become a bride is faithfully portrayed in this sculpture. While she holds a mirror that satisfies the Western notion of cosmetics — from the neck up — her body attests to an exploration of cosmetology from head to toe. Complex patterns rendered in a blue-black stain derived from indigo have transformed her body into a canvas. The textured bands that interrupt these minute lines delineate the ivory and brass armlets, anklets, and waist bands of a wealthy woman. Her coiffure, stiffened with pomade and braided into minute rows, has mirrors and disks of shell added to it.

Two clues identify her status. Rows of rectangular marks, once commonly cut into women's skin before marriage, form a raised line down her torso. Her stout stomach refers to a particular time in an Igbo woman's life when she was secluded, well fed, and educated by female tutors who prepared her for married life. In a parade to announce the conclusion of this time of learning, brides-to-be would exemplify the concepts of female beauty seen in this sculpture. Erect carriage, precise attention to jewelry and body painting, and a calm expression are indications of the inner poise and creativity sought in a well-educated Igbo woman.

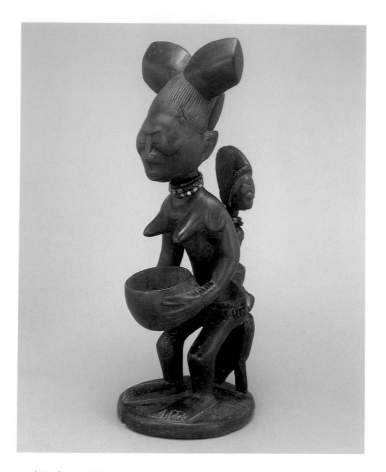

Mother and Child Figure
19th–20th century; African, Nigeria, Oshogbo, Yoruba
Wood, glass beads; h. 16¹⁵⁄₁₆ in. (43 cm)
Gift of Katherine White and the Boeing Company, 81.17.594

Extreme composure is obviously required in order to do as this mother does: sit on a mudfish, give generously with both hands, and support an alert baby on her back. What may not be obvious is her devotion to Shango, the thunder god, whose bolts issue from her head to signify his presence. Shango, as wild and tempestuous as she is benign and thoughtful, is saluted in various Yoruba praise songs:

> *Storm on the edge of a knife.*
> *He dances savagely in the courtyard of the impertinent.*
> *If you do not offer him a seat, he will sit on the top of your nose.*

Female followers may entice Shango to refrain from violence and to focus his fiery energy on benevolent gestures. This devotee absorbs the splitting potency of his bolts but tames his force with feminine grace, showing how a woman can take on Shango's explosive power and wield it to intensify life. Once placed in a shrine, this sculpture's features have dissolved into a smooth and glistening surface derived from countless hands caressing this masterful mother.

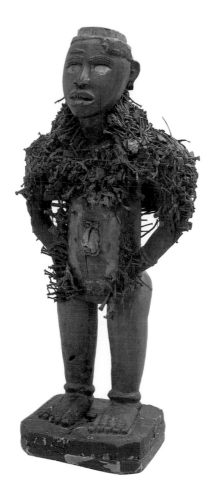

Power Figure (Nkisı Nkondi)
19th–20th century; African, Zaire, Kongo
Wood, iron, fiber, beads, string, glass, feathers, chalk; h. 31¹¹⁄₁₆ in. (80.5 cm)
Gift of Katherine White and the Boeing Company, 81.17.836

Vengeance is often assumed to be the motive for an African sculpture bristling with nails and blades. Interpreters have typecast such sculpture as "fetishes" for covert purposes, overlooking the Kongo rationale for their use. Revised interpretations now credit the Nkondi with a range of public roles including those similar to a judge, notary, and priest in their ability to deal with serious legal issues and moral dilemmas.

In prime muscular condition, this Nkondi stands in a posture called *pakala*, hands on hips. His stance is that of one ready and waiting to render complicated decisions. When agreements or oaths were sworn in his presence, a nail or blade would be hammered into his body to register a pact. This jolt would signal the Nkondi to be vigilant in watching over its longevity and validity. If a pact was not honored, the Nkondi would be empowered to cause harm. Hundreds of nails attest to the hundreds of Kongo citizens who consulted the Nkondi, seeking his disciplined judgment. Each nail was pounded in only a portion of its length and distinguished by an added bead, packet of medicine, hair, or string. Differently shaped blades also encode the precise history of a legal agreement, divorce, resolution, treaty, or trial. His massive mane of nails served as a public record of justice, not private hostility and revenge.

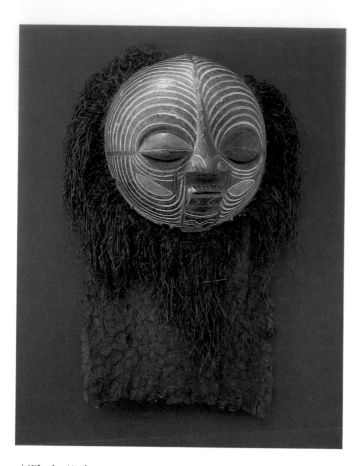

Kifwebe Mask
Prior to 1913; African, Zaire, Luba
Wood, raffia, bark, pigment, twine; h. 36¼ in. (92.1 cm)
Gift of Katherine White and the Boeing Company, 81.17.869

Bold lines and volumes converge in this mask full of dramatic geometries. A hemisphere forming the head is intersected by a triangular nose and square mouth and chin. Domed eyes with slit openings are surrounded by concentric grooves of white chalk. Each feature is conceived in dynamic sculptural terms that complete the impression of a commanding face.

This Kifwebe was first published in 1913 in a photograph taken in Zaire (then Belgian Congo) which shows this mask on a Luba dancer wearing a voluminous raffia and bark cloth costume. With the human body overwhelmed by a rough mane, the precision of the concentric circles is accented. Father P. Colle had collected the mask and deposited it in a missionary society, the White Fathers of Africa and Antwerp, who began lending it to large international exhibitions.

Kifwebe refers to a men's association that called upon masks to dance at the installations of chiefs, at funerals, and during visits by important dignitaries. Such vividly striated masks have been a popular form made for export from Africa, yet documentation of their meaning for the Luba remains unclear.

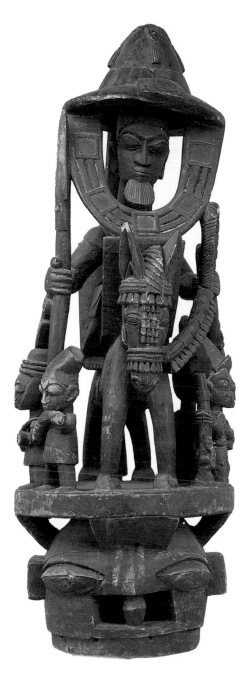

Epa Mask
20th century; African, Nigeria, Yoruba
Bamgboye of Odo-Owa (d. 1978)
Wood, pigment; h. 48¹³⁄₁₆ in. (124 cm)
Gift of Katherine White and the Boeing
Company, 81.17.579

Epa masks are spoken of as "the great ones, the great ones of the family that are now dead." At the bottom of each mask a potlike *(ikoko)* head is always portrayed with squared-off features. This *ikoko* head depicts the otherworldly face of the deceased, while a superstructure above supports a vision of the heroic person to be remembered. Praise names and dance rhythms would address and identify the individual being honored in an Epa performance.

One Yoruba master carver, Bamgboye of Odo-Owa, is credited with the creation of several monumental Epas. The central warrior here carries a spear, a sword, and an enormous pistol. At his sides, two attendants hold rifles as large as their bodies while musicians play *dun-dun* drums and a deer horn trumpet. Together they document the loud and impressive cavalcade created by a conquering hero on horseback. Bamgboye was born in the nineteenth century when Yorubaland sustained many invasions by riders on horseback. His Epa masks may have memorialized these invaders in order not to honor but to rouse the defense of Yorubaland against foreign aggression.

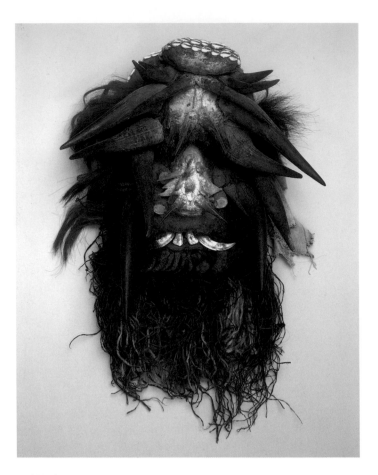

Mask
20th century; African, Ivory Coast, We
Wood, raffia, cloth, teeth, horns, feathers, hair, fiber, cowrie shells,
mirrors, wax, mud; h. 31⅞ in. (81 cm)
Gift of Katherine White and the Boeing Company, 81.17.193

Terrifying masks with dangerous and exciting potential are regularly
invited into We villages during a season devoted to masked festivals.
This mask festers from a bumpy humanoid red core and then sprouts
out in several directions with animal parts.

Enticed by songs and an atmosphere charged with confrontation,
the masker, or *gela,* charges into the village, wearing an enormous leaf
skirt and performs an explosive series of physical and spiritual feats.
In the course of ambushing villagers, the *gela* also conducts a
dialogue with elders over community problems that have arisen in the
last year. We commentators interviewed in 1987 said, "For us, ... the
mask is our supreme court. Once a masker has decided an issue, there
is no further recourse." This mask, collected in 1968, thus derives its
potency from a culture where masking continues to be a complex
community endeavor. By obscuring the human face with a weltering
mass of projectiles, it reverses the usual Western construct of man
controlling nature. Instead, it provides an indelible vision of how the
natural vitality of the forest may overwhelm and instruct man.

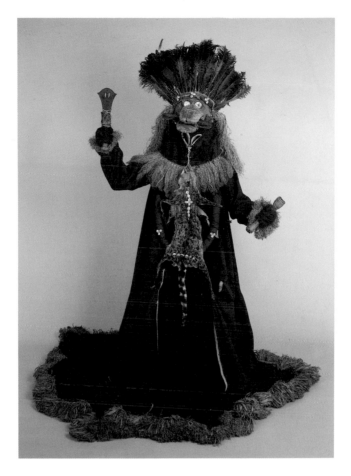

Basinjom Musk and Costume
1970s; African, Cameroon, Upper Cross River, Ejagham
Cloth, wood, feathers, porcupine quills, mirrors, herbs, raffia, cowrie
shells, rattle, eggshell, knife, genet cat skin; h. 85 in. (215.9 cm)
Gift of Katherine White and the Boeing Company, 81.17.1977

Basinjom is a masquerader who is equipped to denounce and humili-
ate negative people. An arsenal of clairvoyant and intimidating ico-
nography is gathered into Basinjom's costume. Feathers from a blue
war bird form a corona signifying strength. Mirrored eyes allow
Basinjom to penetrate into people's hidden thoughts. A rattle records
the sounds of evil. A crocodile's snout adds the impression of a
reptilian prowler. A genet cat skin puts the image of a nocturnal
predator out in front like a shield. Raffia surrounds the cuffs and
hems to bring a raw forest energy into place. Dark indigo and black
cloths swirl around the performer to foil the vision of potential
attackers.

Stalking through a village, Basinjom chases down signs of extreme
selfishness or deceit. When a suspect is found, Basinjom stops,
shakes, and recites the misdeeds of the person being scrutinized. So
publicly exposed and humiliated, the individual is forced to confess.
Through Basinjom, the Ejagham have established an imaginative way
to confront difficult personalities.

Crocodile Headdress
19th–20th century; African, Nigeria,
Cameroon, Cross River, Ekoi
Wood, skin, basketry; h. 29 in.
(73.6 cm)
Gift of Katherine White and the Boeing
Company, 81.17.507

Skin is an uncommon artistic medium with an ominous impact. In the Cross River region, wood masks covered with antelope skins have become a specialty of various associations and have spawned a style of aggressive realism that is unique in the world.

This forceful medium has been applied to a disturbing union—a crocodile face and a female coiffure. Crocodiles reside along the streams of the vast delta territory in the Cross River region.

A crocodile's long snout, reptilian eyes, and open mouth with teeth are all aptly portrayed. On the forehead, a hole probably once held a crown derived from British contact, whereas the coiled projections at either side are inspired by a young woman's hair style. Beneath, a basketry base brings the two images together.

The union of a crocodile and human image may derive from the Cross River concept of animal familiars. Persons of extraordinary abilities or unusual inclinations can attribute their actions to the persuading force of an animal who sought them out. In performance, the basketry base would have elevated the head to create a looming, if not alarming, apparition.

ART OF OCEANIA, MESOAMERICA
AND THE ANDES

These carvings are thought to have
been associated with specific indi-

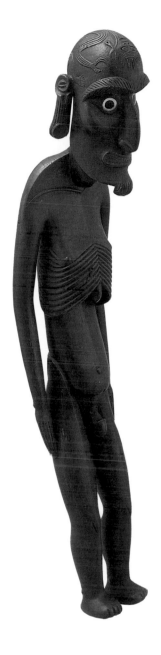

Wood Sculpture *(moai kavakava)*
Early 19th century; Easter Island
Toromiro wood, shark vertebrae,
obsidian; h. 19⅜ in. (49.2 cm)
Gift of Katherine White and the Boeing
Company, 81.17.1422

This ancestral figure was carved on Easter Island where, as elsewhere in Polynesia, a large pantheon of deities and ancestors dominated the mythology. Deities and ancestral spirits could inhabit a wooden sculpture, stone monument, or feathered image. This wooden figure of a male ancestor was carved by a specialist. It was kept in the house, carefully wrapped in bark cloth, and brought out and displayed only during important festivals that were linked to the production of food crops. At these times men cradled the figures in their arms, chanted to them, and danced with several such figures suspended around their necks. The ring protruding from the back of the figure was used to suspend it.

These carvings are thought to have been associated with specific individuals and were made when that person died. The deathlike features (deep-socketed eyes, clenched teeth, thin arms, and protruding rib cage and vertebrae) were common to all such figures. The relief carving on top of the scalp, however, was individualized and most likely represented the person who had died. After the mid-nineteenth century, these carvings were made mostly for trade to Europeans, and at this time the scalp-top figure disappeared from the carvings.

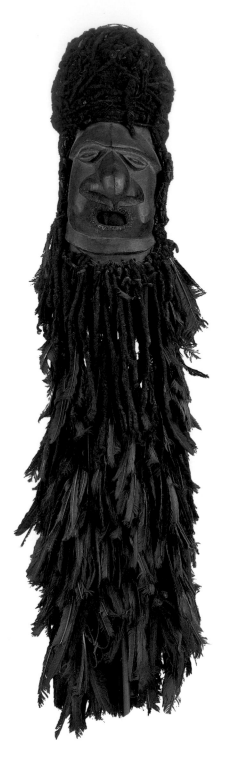

Mask
19th century; New Caledonia,
northwestern region
Wood, human hair, feathers, fiber
netting; h. 51 in. (129.5 cm)
Gift of Katherine White and the Boeing
Company, 81.17.1440

New Caledonia is an atypically dry Melanesian island where the hillsides are extensively terraced, and crops must be irrigated. The traditional New Caledonian universe was sustained by processes of sexual duality. Invisible feminine forces provided continuity and were symbolized by the sea, rain, moisture, and perennial plants. As a complement to them, more tangible masculine forces accounted for transience and were symbolized by land, dryness, annual plants, and people. Religious rituals, in which feminine forces were impregnated by masculine forces, were symbolic enactments of the perpetuation of physical and social life. Sculpture was the concrete representation of these unseen forces.

One distinctive type of sculpture was this mask, used ceremonially to invoke powers that brought rain and abundance. Carved in hardwood and painted black, a color which seems to emphasize its massiveness, these masks were made only in the northwestern district of the island. The mask is a sculptured element of an elaborate costume that completely disguised the wearer. The headdress is composed of a woven cylinder surmounted by a towering dome of human hair braided over a wicker framework. From the chin hang ropes of human hair representing a long beard. From the bottom of the mask falls a long mantle of feathers attached to fiber netting.

These masks are no longer produced. France annexed New Caledonia in 1853, using it as a penal colony, depleting it of its natural resources, and altering the customs of the indigenous people who, by 1900, had lost most of their traditions. Little traditional sculpture has been produced since that time.

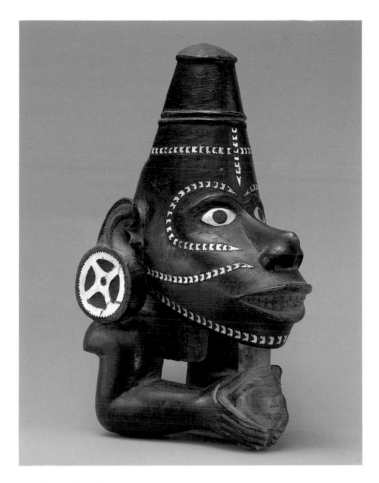

Canoe Prow Figure *(musumusu)*
19th century; Solomon Islands
Wood, mother-of-pearl; h. 10⅝ in. (26.9 cm)
Gift of Katherine White and the Boeing Company, 81.17.1443

In the central Solomon Islands of Melanesia, male craftsmanship and prestige were displayed in the carving of war canoes. The canoes were impressive in size, with hulls up to 100 feet long and prow and stern posts up to 10 feet tall. Canoe-carving was a high art form in which great pride was taken. The vessels were elaborately carved and exquisitely inlaid with mother-of-pearl. Long strands of white cowrie shells, secured along the prow from top to bottom, adorned them.

At the base of the prow, a small figurehead like this one was attached at the waterline. Dipping into the water as the canoe navigated the seas, this figurehead searched for hidden reefs and enemies and protected the canoe from spirits that might otherwise cause winds and waves to upset it. Cradled in its hands and clasped under its chin is a small head, possibly representing the enemy. The extensive shell inlay, as seen on the figurehead's face and ear ornaments, was typical of the central Solomon Islands, an area of great artistic productivity.

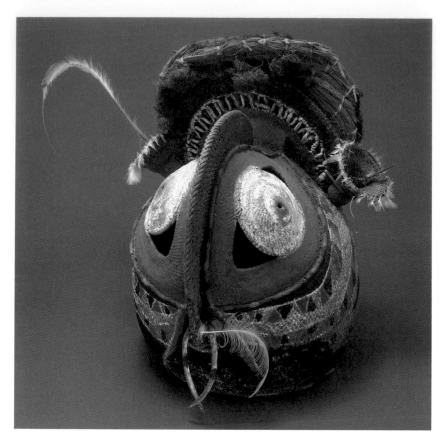

Yam Mask (baba)
20th century; Papua New Guinea,
Abelam
Wicker, pigments, natural fibers,
feather, boar tusks; h. 15 in. (38.1 cm)
Gift of Katherine White and the Boeing
Company, 81.17.1492

The Abelam of Papua New Guinea regulate their world by means of a yam cult. Yams, which can grow up to twelve feet long, are endowed with animistic qualities. When harvested, the largest are decorated and displayed prominently as an indication of the owner's virility. Because of their association with the yams they produce, cultivators do not eat their own yams but exchange them with other clansmen. Abelam society is also characterized by a series of graduated male initiation rites. A long cycle of ceremonies initiating men to the clan spirits, which are patrons of the clan's pigs, involves the making of basketry masks and carvings and the elaborate decorating of ceremonial house facades.

During initiation, when young men are shown the mysteries of the spirit world, they cover their heads with basketry masks like this one, and conceal the rest of their bodies with shredded *sago* leaves. Thus disguised, they dance and parade through the village. These masks are also worn by the largest yams at harvest festivals. For each initiation performance or harvest ceremony, the masks are freshly painted and decorated with orange berries and flowers. The masks represent piglike creatures, all assigned to particular clans. The only obvious reference to this imagery lies in the shape of the ears and the way they are set into the head. The Abelam make no masks of wood, only basketry ones. The fact that the masks are also worn by yams accounts for the use of basketry material, which easily conforms to the shape of the tuber.

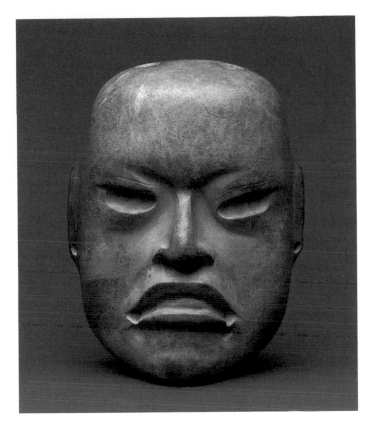

Mask
Olmec, Costa Rica, Middle Preclassic, 900–400 B.C.
Greenstone; h. 3¹⁄₁₆ in. (7.7 cm)
Gift of John H. Hauberg, 82.165

Throughout the history of Mesoamerica, from very early times up to the Spanish Conquest, ancient peoples held greenstone—jade, serpentine, or other types—to be the most precious material on earth. The first Mesoamericans to hold greenstone in such esteem, the Olmec may have been the New World's greatest lapidaries. From hard, unyielding stones they released pliant forms, including such supple representations as this tiny mask. Working with jade tools and using jade powder as the abrasive, the ancient lapidaries first drilled the stone at the corners of the mouth, the nostrils, and the eyes. The resulting almond eyes, broad nose, and strongly downturned mouth characterize much Olmec stone sculpture. Light incision, visible here on the eyebrows and on the protruding ears, was added last.

From their heartland sites in Veracruz, near the Gulf of Mexico, the Olmec developed extensive trading routes, which stretched from West Mexico to lower Central America. Scholars believe that the Olmec traveled such long distances to obtain their precious greenstone, which was then given final form back at the heartland sites. Many Olmec and Maya greenstone objects, however, have been recovered in Costa Rica, where there may have been a brisk secondhand business in valuable materials. This tiny mask was discovered along the Atlantic slope of Costa Rica in the 1960s.

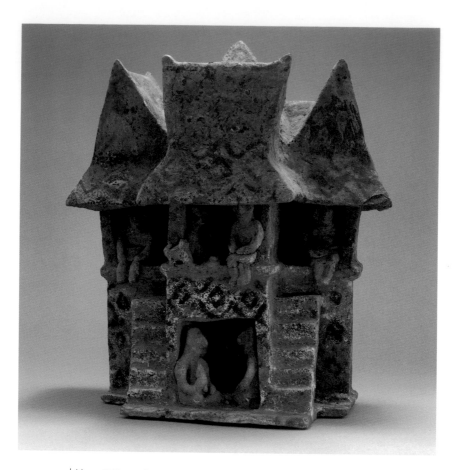

Nayarit House Group
West Mexico, Late Preclassic, 300 B.C.–A.D. 100
Terra cotta, polychrome; 14¾ x 12¾ x 8 in. (37.5 x 32.4 x 20.3 cm)
Gift of Katherine White and the Boeing Company, 81.17.1375

The people of ancient West Mexico buried their dead in shaft tombs, deep below the surface of the earth, with many ceramic offerings: pots; effigies of birds, humans, or animals; and, particularly in Nayarit, with animated ceramic sculptures of houses, ball courts, and village life. This example is a particularly fine one, with four separate thatched roofs housing the compound where several people and animals dwell. The lively geometric designs on the perishable roofs and house walls may indicate just what such living quarters looked like in ancient Nayarit. The several persons of this grouping prepare food, affectionately address one another, and play with animals, all surely aspects of domestic life in West Mexico.

Some scholars have seen in such "anecdotal" groupings a simple mirror of ancient life, a reflection of an unsophisticated peasant world. Others have inferred religious practices from the mortuary context and repeated imagery of West Mexican ceramic sculpture. The lower story of this house group, for example, may be a place for funeral preparations or even an entrance into a shaft tomb. Much religious ritual of ancient West Mexico probably focused on ancestors and the power they maintained in the world of the living.

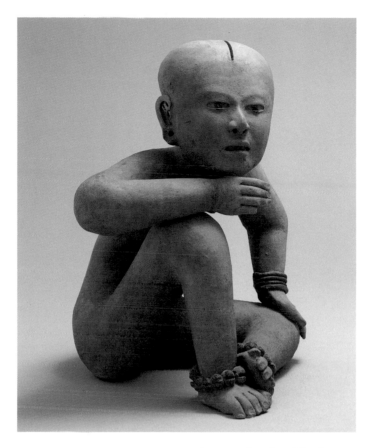

Seated Man
Mexican, Veracruz, Upper Remojadas I,
Early Classic, 200–500
Terra cotta; h. 13⅜ in. (33.9 cm)
Gift of Katherine White and the Boeing
Company, 81.17.1376

During the Classic era, thousands and thousands of ceramic figures and figurines were made in Veracruz, particularly in the hot coastal lowlands, in the regions of Remojadas and Nopiloa, among others, where they are recovered from graves and tombs. Few such works bear any archaeological provenance, and much of their dating is also conjecture. Most simple, large figures like this one have been dated to the Early Classic period, but the bell anklets worn by the figure may have been made of copper, generally not used in Mesoamerica until after 1200. Like this piece, most large Veracruz figures have been reconstructed from fragments. Seattle is fortunate, however, to have photographs

documenting that this piece was nearly complete when discovered in 1968.

Although the so-called smiling figures, with their ecstatic expressions, are most characteristic of Remojadas, there are many sober and naturalistic figures, like this one, from the region. This figure has a particularly beautiful and compelling face, perhaps an actual portrait of a handsome young man. The slit through the top of the head may have once held human hair, and the young man may have worn perishable garments.

After the figure had been fired, its maker applied a shiny black asphalt to bring out details. Locally called *chappote* by native inhabitants, this substance is a naturally occurring petroleum product, the only known use made of the abundant oil of Veracruz in pre-Columbian times. Used on the eyes, the black paint gives the work a penetrating stare.

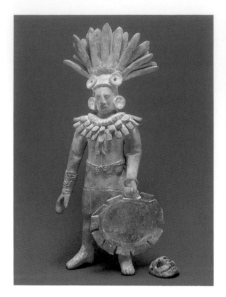

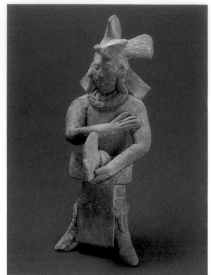

Standing Warrior Figure with Jaguar Mask
Maya, from Jaina Island, Campeche, Mexico, Late Classic, c. 600–900
Terra cotta, traces of polychrome;
h. 10⁵⁄₁₆ in. (26.2 cm)
Gift of John H. Hauberg, 81.108

Ballplayer Wearing Yoke and Hacha
Maya, from Jaina Island, Campeche, Mexico, Late Classic, c. 600–900
Terra cotta, traces of polychrome;
h. 8 in. (20.3 cm)
Eugene Fuller Memorial Collection, 55.107

Maya craftsmen along the Campeche coast and on the neighboring islands made lively figurines during the Late Classic period. Thousands were taken to Jaina Island and the adjacent Campeche coast for interment with the noble dead. Jaina figurines are an animated mirror of elite Maya life, including warriors, ballplayers, dwarves, and elegant women. Many of these figures are also whistles, ocarinas, or rattles — musical companions for the dead. Both mold-made and hand-modeled, the figurines here have heads pressed from molds and bodies and costume details worked by hand. Splashes of tenacious bright blue pigment, added after firing, often survive, as on this ballplayer figure.

The Maya ballplayer wears the paraphernalia for that game, the horseshoe-shaped yoke with an *hacha* at its front. Despite the clumsy form of his hands, the ballplayer's face and that of his *hacha* are elegantly formed, and the small circle on the *hacha's* cheek indicates the glyph *ahau* (lord). He wears a bird at the front of his headdress and crosses one arm across his chest in a gesture of respect. The rear section of the player's loincloth has been extended to form a tripod support and a whistle. Although Maya athletes competed in the ball game as a sport, they also played the game as one of the central rituals of kingship, in which the stakes were life and death.

The Jaina warrior wears a loose-fitting sleeveless jacket called a *xicolli* with a great ruff of feathers, cloth, or vegetal pods as a collar. Other warriors also prepare for war in similar great feathered headdresses. The warrior stands with a shield in his left hand, ready to put on a skull mask, which would give him the appearance of the skeletal death god. Ballplayers often bind a forearm just as this warrior has prepared his right arm, so we may suppose that he will engage in the ball game, perhaps in the guise of the death god, after combat.

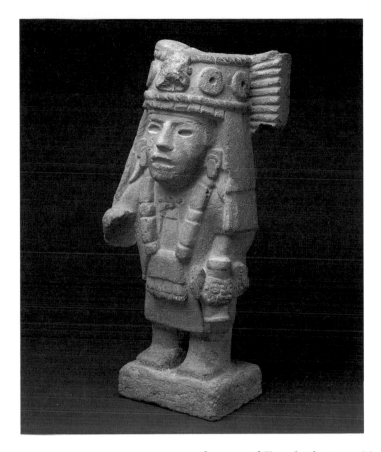

Priest with Tlaloc Effigy
Aztec, from Tenanzingo, Mexico,
Late Postclassic, 1400–1521
Volcanic rock; h 18½ in. (46.9 cm)
Eugene Fuller Memorial Collection,
52.150

In the fifteenth and sixteenth centuries, the Aztec adorned their shrines with stone statues of deities and their priests. Huitzilopochtli, the tribal cult god, reigned supreme among the Aztec, but even within the most sacred precinct of Tenochtitlan, the capital, Huitzilopochtli shared his shrine with Tlaloc. Worship of Tlaloc began long before the Aztec achieved power in Central Mexico, and their recognition and manipulation of this most ancient god of the pantheon, god of water and earth, both guarantor and destroyer of fertility, lent legitimacy to the Aztec and their own gods.

Reputedly from Tenanzingo, a town to the west of Tenochtitlan (now Mexico City) and near Malinalco, a larger Aztec settlement, this figure represents an attendant of Tlaloc and probably once graced an altar in a building dedicated to him. From the figure we gain some sense of the simplicity and rough-hewn appearance of provincial Aztec sculpture, and we can also see how the attendants of this deity may have looked.

Wearing the simple sleeveless jacket of priests, this sculpture bears a representation of Tlaloc — perhaps his image on a water jug — in the crook of his left arm. Here, Tlaloc's typical goggle eyes are created by twisted snakes that meet to form his nose above a fanged mouth. Tlaloc's bearer wears a headdress with jade diadems, symbolic of the blue-green preciousness of water, and a paper fan associated with many fertility deities and their priests.

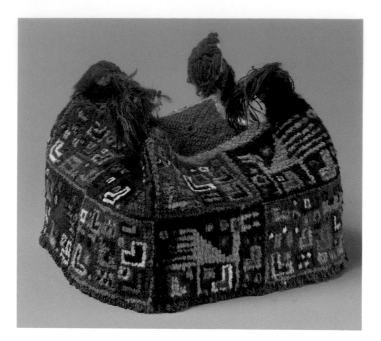

Tasseled Cap
Peruvian, Wari, Middle Horizon, 700–1000
Pile weave on knotted base, alpaca and cotton; h. 4½ in. (11.4 cm)
Gift of Jack Lenor Larsen, 76.51

At the time the Spanish conquered the Inca empire, Europeans were astounded by the varied and sophisticated textiles of the Andes. Cloth held great value, and some special weavings made for the royal family were more precious than gold. In a realm without coinage or currency, cloth could function as a means of exchange. Made of highland camelid fibers (alpaca and vicuña) or cotton grown in rich irrigated coastal river valleys, or a combination of both, Andean textiles reveal to us today an ancient world of attire and status.

Some Andean textiles have survived from the time of contact, but pre-Inca garments have been preserved in the world's driest desert, the narrow coastal strip that runs between the Andes and the Pacific Ocean, particularly south of modern Lima, Peru. Ancient mummies are found fully attired, frequently wrapped in dozens of finely woven garments. This cap once probably adorned such a mummy.

Dominators of an earlier realm nearly as large as that of the later Inca, the Wari wore a characteristically square hat of cut pile in lively colors. Here birds alternate with geometric designs, perhaps abstractions we can no longer decipher. Both the uncut loops along the lower border and the four complete tassels indicate an unusually fine state of preservation.

NATIVE ART OF
THE NORTHWEST COAST

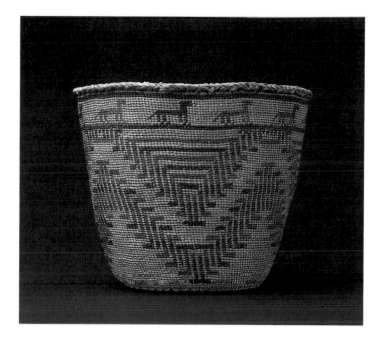

Twined Basket
Late 19th century; Twana (Skokomish),
Hood Canal, Washington
Red cedar bark, beargrass, cattail leaf;
h. 8 in. (20 cm)
Gift of John H. Hauberg, 86.91

Native peoples, their culture rooted in the earth and the visible realizations of its life and vitality, embrace in their daily existence the abundant materials that our living planet has created. Basketry, the interweaving of natural materials into specifically functional containers, is but one of the ancient traditions that manifests a simple but all-encompassing cultural philosophy: to use with care, respect, and joy that which the earth has provided.

Weaving techniques such as coiling, twining, twilling, and plaiting, common throughout the world, have everywhere been adapted to regional availability of appropriate materials. The Native weavers of Puget Sound and the Northwest Coast are no exception. Intimately familiar with the forests in which they have made their homes, they have selected local materials such as inner barks, roots, or grasses; refined individual techniques; and traditionalized basket shapes and designs within tribal groups. They have produced basketry styles that proclaim their uniqueness as tribal entities, their historic kinship with related language families, and their extraordinary ability to integrate form, beauty, and function.

A small border pattern of wolves appears here about the basket rim, standing alert as if testing the air with their noses, their tails angling down behind them. Below, geometric forms divide the basket surface into a pattern of interlocking opposing triangles, an ancient and rhythmic design seen throughout the southern coastal area, frequently relief carved in wood. The diagonal movements are here ingeniously composed of parallel, right-angle line elements, defined by color on the straight horizontal-vertical twining grid. The name of this complex pattern has been reported as "salmon gills" by Skokomish weavers of this century.

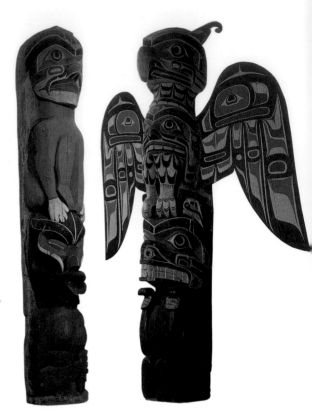

Interior Houseposts
c. 1916; Kwakwaka'wakw,
Gwa'yasdams Village, Gilford Island,
British Columbia
Hemasilakw (Arthur Shaughnessy,
1884–1945, Nam'gis Band)
Western red cedar, iron fastenings,
modern paints (restored 1969);
h. 14 ft. (4.2 m)
Gift of John H. Hauberg, 82.168.1,
82.169.1

Traditional Kwakwaka'wakw houses are built around a framework of massive cedar log beams and posts. These grand, split cedar board-covered buildings are still being built among the Kwakwaka'wakw, today primarily for ceremonial performances. They once housed large extended families, with the interior partitioned off for individual family groups around the central fire area. This house frame comes from the John Scow family of Gwa'yasdams Village, who dedicated the original house in an elaborate potlatch in the year 1916. The images from the rear of the house are the Kolas, similar to a thunderbird, above, and the Nan, or grizzly bear, below. From the front of the house, the Man Who Announces the Names of the Guests is positioned above the Dzunu'kwa giantess.

Hemasilakw, the carver of many large monuments and houseposts, had a distinctive and flamboyant personal style. His work contributed significantly to the overall tone of early twentieth-century Kwakwaka'wakw art, and his influence continues to be seen among the present generation of artists. Typical of Kwakwaka'wakw sculptural style, Hemasilakw has fastened additional wood to the main log for the beaks and noses, wings, and other extended appendages. Freed from the limitations of the cylindrical log, the composition is given increased dimension and a heightened dramatic character. Painting the sculpture with a white background had become the norm among Kwakwaka'wakw artists of the early twentieth century. In the muted light of the house interior, the added contrast behind the more traditional colors further enhances the bold and energetic nature of the southern coastal painting style.

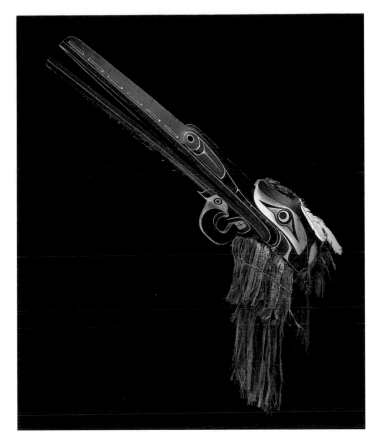

Huxwhukw Mask
c. 1938; Kwakwaka'wakw,
Gwae Village, Kingcombe Inlet,
British Columbia
Hihlamas (Willie Seaweed,
c. 1874–1967, Na'kwaxda'xw Band)
Western red cedar, cedar bark, eagle
feathers, leather, twine, enamel paints;
l. 63¾ in. (160 cm)
Gift of John H. Hauberg, 91.1.2

One of the three main types of people-eating birds from Kwakwaka'wakw Hama'tsa ritual mythology is the Hux-whukw, whose long, straight beak possesses skull-crushing power. Spiritual brothers of the untamable people-eater Baxbakwalanuksiwe' (Cannibal from the North End of the World), these loud and awe-inspiring images appear during the 'Tseka, or Winter Ceremonial, dramatizations in the form of masked dancers as part of the complex taming ritual of the Hama'tsa initiate.

The Hama'tsa is a dancer gone wild, imbued with the primal, voracious spirit of Baxbakwalanuksiwe', whose power is also realized by dancers wearing the masks of Raven (Gwakwamhl) and Crooked Beak (Galokwamhl) as well as the Huxwhukw. This chaotic power is drawn out of the initiate by traditional rituals involving songs, dances, and other customs whose roots lie in shamanic healing.

Accompanied by a syncopated, slowly paced song which announces the entrance of each masked dancer, as many as four of these supernatural birds perform in the Big House (Walas Gukw) at once. To see these striking figures, cloaked in shredded cedar bark as they stalk and crouch and whirl about the firelit house, is to feel and experience part of the ancient and powerful message of renewal within these dances and rituals. They represent spiritual power, called up from the mythical past and reenacted in the continuing cycles of the Native world.

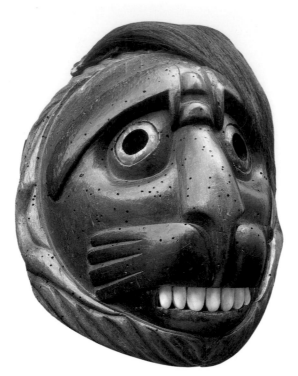

Nuhl'amahl Mask
Early to mid-19th century;
Kwakwaka'wakw (Gwa'tsinuxw or
Gusgimukw Band) Northern Vancouver
Island, British Columbia
Wood, horsehair, opercula, copper;
h. 10⅜" (26.4 cm)
Gift of John H. Hauberg, 91.1.27

The Nuhl'amahl (Foolish, or Reckless, Dancers) are the characters who enforce tradition in the ceremonial house, calling attention to mistakes and breaches of custom by wild, frenzied actions. They are contrary figures, not without elements of humor, who display great sensitivity to their exaggerated noses, usually the most prominent features of their carved faces. The traditional form of the masks, often hung with hair or rimmed with twisted cedar bark, incorporates sagging eyebrows, diminutive eyes, grinning mouth, and sometimes the depiction of mucous flowing from the large nose.

Kwakwaka'wakw artists, prolific in their mask-making and representations of mythical or unusual figures, have always been quick to experiment artistically with new inspirations that appear in their world. When vessels of the fur trade began to appear on the coast in the late eighteenth century, the Kwakwaka'wakw artists saw images visually similar to the Nuhl'amahl carved on the ships' cat-head timbers and elsewhere. They were lions to Euro-American eyes, but certain carvers of those early days realized an adapted version of what they saw, creating an innovative Nuhl'amahl image. Only those features pertinent to the Nuhl'amahl were incorporated — the swirling mane as twisted cedar bark, the upper lip whiskers as running mucous, and the prominent, blunt nose. A very small number of these old, unusual masks survive in various museums. From a Native point of view, the use of a Euro-American image to represent a rule-enforcing character, known in English as the Fool Dancer, is perhaps not without significance.

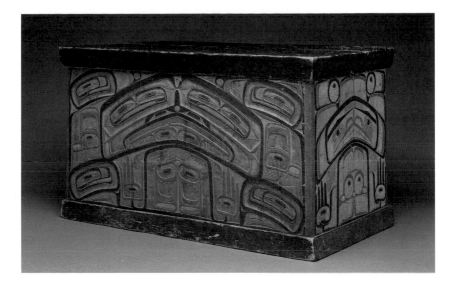

Bent-Corner Chest
Early to mid-19th century; Bella Bella (possibly Heiltsukw Band),
Milbanke Sound, British Columbia
Yellow cedar sides, red cedar top and bottom, Native and trade
pigments; 21¼ x 35¾ x 20½ in. (54 x 90.8 x 52.1 cm)
Gift of John H. Hauberg, 86.278

Masterpieces of wood technology, bent-corner boxes and chests belie
the relative simplicity of their manufacture in the classic perfection of
their design and craftsmanship. The sides are formed of a single
plank of wood. Three corners are bent, with the fourth being formed
by the joining of the plank ends.

Elaborately decorated chests were created to contain the cere-
monial heirlooms of clan and family, such as dancing blankets, rattles,
and headgear. This large and finely made chest was collected from the
family of the Tongass Tlingit chief Kian, though it probably did not
originate in that southeast Alaskan area. The style of the design work
suggests an origin in the Heiltsukw or Bella Bella territory of the
central British Columbia coast. The chest may have been relocated as
a result of trade, gifting, or possibly warfare.

The very thin formlines in black and red that weave across the
entire chest actually cover a small amount of the total painted surface,
a consistent characteristic of Heiltsukw two-dimensional art. This
leaves a large expanse of "background" area that is shallowly relief-
carved away. Most of these areas are enclosed within lines of either
black or red and make up the third-color, or tertiary, level of design,
painted a deep blue in this example. The layout of these designs
follows the most classic traditional arrangement for decorated chests,
and the design fields are visually symmetrical, balanced, and embel-
lished with intriguing detail. The formline patterns certainly do
suggest an animal image, and the numerous eyes give the viewer the
feeling of being watched. However, like the majority of structurally
similar traditional chest designs, this one is sufficiently ambiguous to
prevent making a positive identification of the creatures represented.

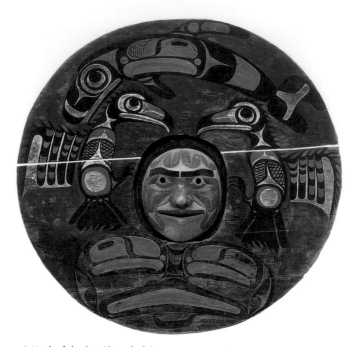

Mask of the Sun (Sinxalotla)
Second half of the 19th century; Nuxalk (Bella Coola), head of Dean and
Burke channels, British Columbia coast
Alder, red cedar; diam. 42¾ in. (108.6 cm)
Gift of John H. Hauberg, 91.1.95

The vigorous and imaginative nature of Nuxalk sculpture is well
represented in this large and impressive mask, probably depicting the
sun. Two wide planks of cedar make up the corona, on which are
painted a killer whale arching across the top, two ravenlike birds
flanking the central mask, and a formline face structure of undeter-
mined identity at the bottom.

The Nuxalk are a Salishan-speaking people who arrived at their
present coastal inlet location via the Bella Coola River from the
interior. Their art shows influences from Wakashan-speaking neigh-
bors both to the northwest and southeast along the coast. Certain
Nuxalk artists expressed their images in the formline tradition of the
more northern coastal groups, while others, like the painter of this
sun disk, seemed to prefer a less conventionalized form of repre-
sentation more like the style of their southerly neighbors, the
Kwakwaka'wakw.

Ethnographic records describe a masklike object such as this
being drawn sunwise across the rear of the performance house by
mechanical means, similar to the manipulation of puppets and other
movable images that are a part of the dramatic ingenuity of all the
Northwest Coast peoples. The humanlike image at the center repre-
sents one form of the being named Ahlquntam and comes from
within one of the substyles of Nuxalk sculpture, featuring rounded
forms, less aggressive features, and subtle junctures. The blue, form-
line-style shapes crossing the carved surfaces; the unpainted eyelids;
and the bulbous character of the face are typical of the overall Nuxalk
style of sculpture.

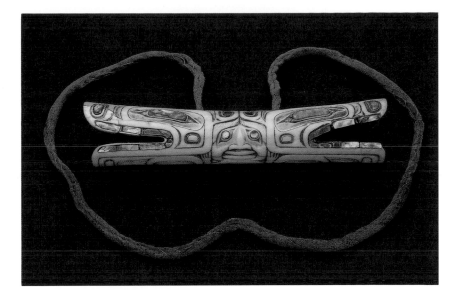

Soul Catcher
Mid-19th century; Tsimshian, Northern mainland, British Columbia
Bone, abalone shell, buckskin; l. 7¾ in. (19.7 cm)
Gift of John H. Hauberg, 91.1.83

A large number of these symmetrical bone pendants, known in English as "soul catchers," have been acquired from the Northwest Coast people, and most documented examples come from the Tsimshian. What little has been recorded about them describes their use as symbolic receptacles for the reclaimed souls of distressed persons recovered from the spirit world by shamans engaged to effect a cure.

In this elegantly balanced composition, the outward flaring, symmetrical form possesses an architectural strength, its very shape connoting harmony and stability. So designed, these objects become the most appropriate kind of "container" for disjunct souls recovered and returned from a state of chaos. As with most soul catchers, the flaring ends have been sculpted into animal heads, here resembling wolves, composed of two-dimensional formlines in the ancient and classic style of the northern coast. They may symbolize the clan identity of the owner. Pieces of jewellike iridescent abalone shell have been inlaid into the eyes, teeth, and prominent ovoid shapes, the deep blue color glowing against the warm-toned ivory surface.

A human face is relief-sculpted into the space between the two animal heads, a feature commonly seen in the center of soul catchers. With bulging cheeks, very angled eyes, and sloping eyebrows, this unusual face is connected to a human body, which wraps under the bottom of the cylinder. Its arms, legs, and feet can be seen on the other side of the pendant. Symbolically, perhaps this compact human figure portrays the shaman's situation — on the borderline between opposing forces, on the knife-edge that separates the mirrored worlds of life and death.

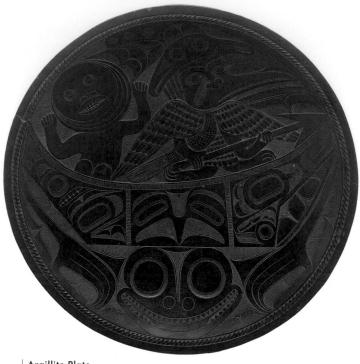

Argillite Plate
Late 19th century; Haida, Masset Village, Queen Charlotte Islands,
British Columbia
Tahaygen (Charles Edensaw, c. 1839–1924)
Argillite (carbonaceous shale); diam. 12 in. (30.5 cm)
Gift of John H. Hauberg, 91.1.127

A prolific and accomplished carver in all native materials, Tahaygen
was one of the most innovative and imaginative of the nineteenth-
century Haida artists, both in his sculptural style and his handling of
two-dimensional traditions. Argillite was one of his favored media,
and a great many examples of his work in the soft, black stone survive
today, nearly all in museums and private collections outside his own
culture.

Like many of his artistic contemporaries, Tahaygen called upon
the rich oral tradition of Haida mythology for his subject matter. He
often illustrated complex stories with a graphic and descriptively
pictorial approach that is a conceptual step beyond the style
employed in traditional representations within the Haida culture.
Following the devastating epidemics of the mid-nineteenth century,
surviving Haida artists, particularly those working in argillite, appear
to have been intent on recording enduring images to illustrate and
perpetuate the narrative style and cultural values of Haida mythology.

Tahaygen's exquisite craftsmanship is evident throughout the for-
mation of this plate. The tale represented concerns the sexing of
human beings, which Tahaygen also chose to illustrate on at least
three other known objects. Here Yeihl, the Raven-in-human-form,
sets off in a mythic canoe, having animated a shelf fungus to handle
the steering. His intent is to spear the rock chitonlike female genitalia
that cling to a certain sea-washed rock, and then return to bestow
their supernatural power upon the first human females.

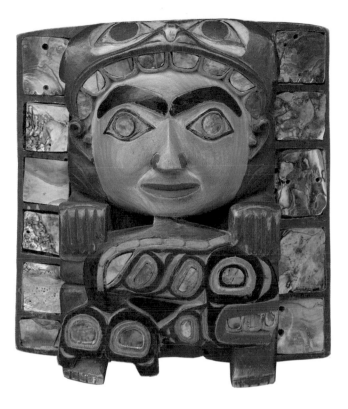

Headdress Frontlet
Mid- to late 19th century; Haida,
Hydaburg, southeast Alaska
Attributed to Albert Edward Edensaw
(Masset, 1810?-94)
Maple, abalone shell, Native and trade
pigments; h. 6¼ in. (16 cm)
Gift of John H. Hauborg, 91.1.82

A complex story-image is depicted with poetic simplicity in this striking headdress frontlet. Created to adorn the front of swansdown and ermine decorated dancing headdresses, the carved figures on frontlets derive from oral history, often from origin stories that are owned by particular clans or family lines. This work was attributed to Albert Edward Edensaw (Charles Edensaw's maternal uncle) by its last Native owner. The finely crafted carving portrays the tale of a man who captured and killed a powerful sea monster, known as Gonakadeit in both Haida and Tlingit stories. Wearing the skin of the monster enabled the man to swim deep in the sea, capturing many fish and even whales with which to feed his village.

Here the whole picture is compactly rendered in a deep and rich sculptural style. The central human figure in the story is portrayed in a crouch, his knees and elbows drawn in. Long-fingered hands delicately touch the profile body of a whale, rendered in two-dimensional design and held in front of the man's shins and torso. The man wears the skin of the Gonakadeit like a headdress, the monster's teeth forming a graceful arch of U-shapes across his forehead. The teeth are inlaid with pieces of iridescent blue abalone shell, acquired by Native trade from California, as are the man's eyes and prominent features of the whale. The monster's body and legs drape down behind delicately spiraled ear shapes, its feet resting on the man's shoulders, the claws curving alongside his full, rounded cheeks. Larger pieces of abalone shell decorate the rim of the frontlet, all of which combine to catch and brightly reflect the firelight of the performance house.

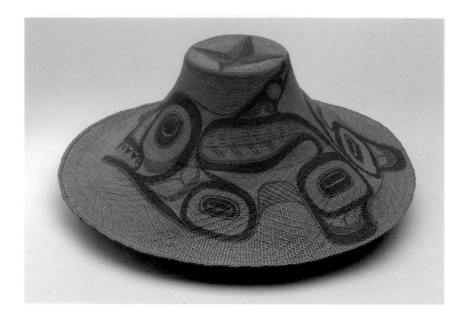

Spruce Root Hat
Late 19th century; Haida, Masset
Village, Queen Charlotte Islands,
British Columbia
Tahaygen (Charles Edensaw,
c. 1839–1924) painting; Isabella
Edensaw (1858–1926) weaving
Split spruce roots, Native and trade
pigments; diam. 17 in. (43.2 cm)
Gift of John H. Hauberg, 83.226

One of the most remarkable and highly refined of the fabric arts of the Northwest Coast is that of hat-weaving, practiced according to varying local traditions by all the coastal groups. Beyond their obvious utilitarian aspect, certain of the elegantly shaped hats became important and respected items of ceremonial regalia, based on the stature and history of their creation. Many, like this one, were woven and decorated for sale in the newly developing cash economies of the time.

In the more northern areas, peeled and split spruce roots are the weaving material of choice, being strong, flexible, and readily available (in certain locations). This hat, representative of a broad, intertribal tradition, contains a variety of weaving techniques. The upper crown is woven in three-strand twining, which produces a smooth, relatively even surface. The lower, flared-out area is done in a self-patterning "skip stitch" technique that creates a rhythmic, textured design of concentric diamonds encircling the rim.

Beautifully woven by Isabella Edensaw, the hat was then passed to her husband, Charles, for the painted decoration. He chose to represent an orca, or killer whale, and conceptually split the cetacean into two profiles, each of which gracefully swims around the body of the hat. The black primary formlines are sparely composed, like a visual haiku. Red secondary design shapes are limited, though the artist has bordered the whole perimeter of the whale with a fine red line.

As a rule, traditional Native art was unsigned, leaving only an artist's individual style to reveal his or her identity. A number of Haida artists, however, frequently painted geometric designs on the flat tops of woven hats. Tahaygen used this particular form of bicolored, four-pointed star on the top of his painted hats consistently enough for it to act as a signature, in function if not intent.

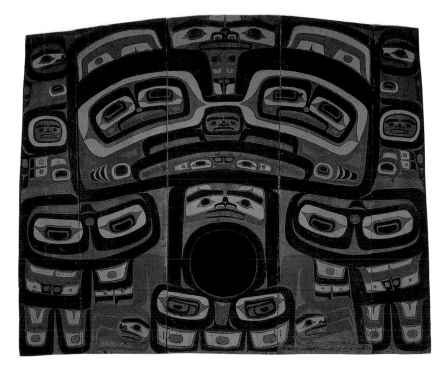

House Partition
Early 19th century; Tlingit, Gaanaxteidi
clan, Frog House, Klukwan Village,
southeast Alaska
Attributable to Kadjisdu'axtc II, of Old
Wrangell (c. 1750–1840)
Spruce boards, Native and trade
pigments, fiber ties; 8 ft. 9 in. x
10 ft. 9 in. (2.69 x 3.28 m)
Gift of John H. Hauberg, 79.98

Perhaps the most important political division within traditional Tlingit society is that of the house group. Each clan in a village occupied and maintained one or more houses, each with distinguished names perpetuated throughout their history. Today, in the most traditional villages, one's house group affiliation is still recognized, though the people for the most part live in modern, single-family homes and maintain their tribal houses mainly for ceremonial occasions.

The leader of each house group, or Hit'saati, along with his immediate family, traditionally occupied the section of the old-style dwelling located farthest from the door, across the rear of the house. This space was often partitioned off by an elaborately decorated wooden screen, such as the magnificent example illustrated here. Within this area the heirloom treasures of the house group were protected and maintained in accordance with their historical importance. This aged and highly respected painted screen once stood at the rear of successive historic incarnations of the Frog House, or Xixch'i Hit. Known as Yeihl NaXin, or Raven People Screen, its dignified and stately design represents an upright raven rendered in broad, sweeping black formlines, with the bird's legs and inner design areas in red. The original native paints were almost completely covered over by a repainting that took place about 1898.

Manifested in the painted image, the mythic progenitor of the house group presides over tribal gatherings as well as daily life. The hereditary position of the Hit'saati represents its human counterpart, and assumes great importance during ceremonial occasions as the reincarnation of the clan founder or ancestor. Emerging through the opening in the body of the Raven, he is reborn through the veil of the mythical past into the present.

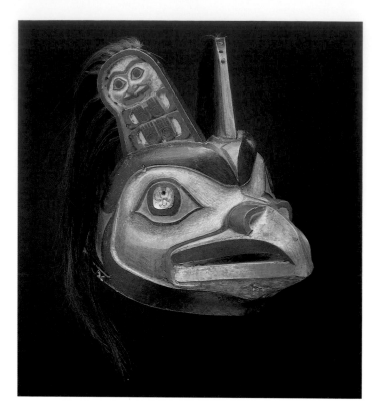

Events of grand and mythic proportions have been manifested and recorded by Tlingit artists in specific, emblematic works of art. Reproduced on occasion, when the deterioration of age deemed it necessary, certain of these wooden incarnations of history have attained considerable age. They were inherited literally through centuries by successive generations, along with their stories of origin, until the most recent decades when the forces of colonization overwhelmed the native continuum. A treasured few of these important objects remain today in Native hands.

Such a manifestation of the mythic era is this dramatic and noble head-piece, the *Raven Floating on the Nass Hat*. It represents not the common raven, but Nasssha.ki yeihl (Raven at the Head of the Nass), one of the two most ancient figures of Tlingit mythology. The seemingly dysfunctional shape of the beak tip is often a feature of this representation. Other manifestations of Nasssha.ki yeihl created by the Gaanax.adi use a strongly recurved beak like that often associated with the hawk or thunderbird image.

Set by its design in an alert, regal attitude when worn, the upward gesture of the head is beautifully balanced by the rising angle of its human-elaborated ears and the downward movement of pendant wisps of hair. The eye shapes and formlinelike structure of the main image and the formation of the human figures in the tall ears relate this head-piece to other major works by this remarkable artist. The abalone shell pieces inlaid in the eyes of the bird contain rare and intriguing detail, the fine engraving of inverted raven images.

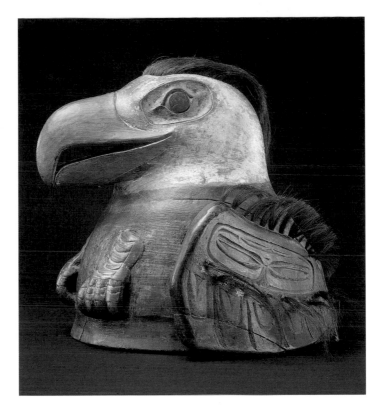

Eagle War Helmet
Late 18th or early 19th century; Tlingit,
Leneidi clan (Aanxaakhitaan), Angoon
Village, southeast Alaska
Spruce, human hair, brass buttons;
h. 11⅜ in. (28.9 cm)
Gift of John H. Hauberg, 91.1.72

The ancient Native style of warfare, as practiced by the Tlingit of southeast Alaska, involved combat between trained and armored warriors using such weapons as stone clubs, daggers, and bow and arrows. The unique wood-and-hide protective armor developed by the Tlingit was topped off by stout wooden helmets. Many, such as this venerable example, were elaborately carved. Functionally intended to ward off blows to the head, they increased the height and powerful appearance of the warriors as well. Certain esteemed helmets, kept as treasured family heirlooms, attained the status of clan crest objects, to be worn and displayed on ceremonial occasions. Family history tells us that this helmet was worn in the 1802 battle of Old Sitka, in which the Tlingit succeeded in temporarily driving Russian fur traders from their territory.

Here the shape of the helmet conforms with the body of an eagle, in an image at once very naturalistic and traditionally stylized. The head and beak are quite faithful to the eagle's true appearance, particularly in the shape of the upper and lower mandibles and the near-smile where the two come together. The eyesocket, wings, and tail are traditional stylizations, and the character of the two-dimensional forms is typical of very old Tlingit work. The stocky, thick quality of the wings and tail are a function of the object's use as a protective helmet. Many war helmets were made with the wood fibers arranged to run from side to side, so configured to prevent vertically splitting from a forward blow. On this example the front to back orientation of the wood fibers strengthens the wings and beak.

Chilkat Robe and Pattern Board
Early to mid-19th century; Tlingit, southeast Alaska
Mountain-goat wool, yellow cedar bark, commercial yarn, dye
pigments, spruce boards, Native paint; robe: 51⁹⁄₁₆ x 66¹⁵⁄₁₆ in.
(131 x 169.7 cm); board: 20⅞ x 37⅜ in. (53 x 94.9 cm)
Gift of John H. Hauberg, 83.229, 85.357

Production of highly refined and technically remarkable creations in
the fiber arts was traditionally the effort of women on the Northwest
Coast, and for the most part this custom remains. Their labor begins
with the seasonal gathering of materials, the time dependent on the
rising of the sap in spruce and cedar trees, or the shedding of the fine
winter wool of the mountain goats in the spring. For centuries, this
delicate, soft wool has been gathered in small tufts (or plucked from
prepared hides), spun into yarn, and woven into highly valued cere-
monial robes on the northern coast. The designs woven into the
earliest robes were geometric in character, and a precious few eigh-
teenth-century examples of these complex textiles were collected by
Europeans.

By the early nineteenth century, Native weavers had improvised
techniques to reproduce the curvilinear forms and small circles of the
traditional painting style in warp and weft. A design revolution
began, and over the next century countless formline patterns were
woven using the complex new techniques, to the exclusion of the old
geometric style. A combination of horizontal twining and vertical
braiding, the weaving is done on the simplest of looms, using tech-
niques most related to basketry. Nimble fingers alone separate the
warp strands, rhythmically twining and packing the weft yarns into
place.

Once the materials are prepared, the weaver looks to a pattern
board, usually painted by male artists, with something more than half
of the symmetrical design applied to its surface in the single color
black. From this, the weavers reproduce the design section by sec-
tion, measuring from the board for size and proportion of the indi-
vidual elements. Sometimes a number of robes or tunics would be
created from a single pattern board by various weavers, and now these
design "blueprints" are extremely rare. There exists today, however, a
fragile but unbroken line of weavers and apprentices that reaches
back to the earliest tradition.

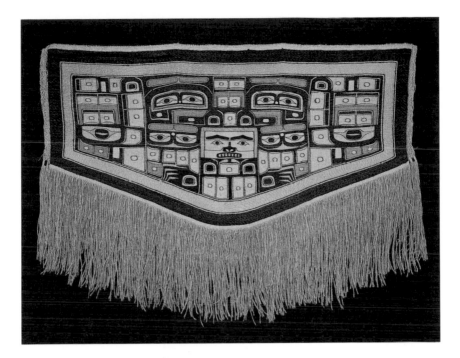

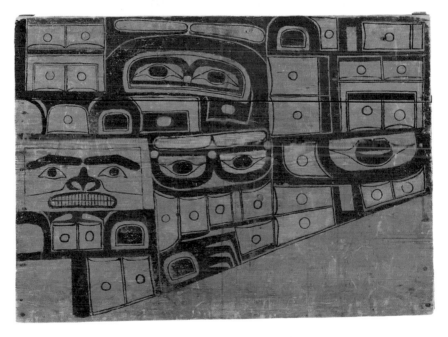

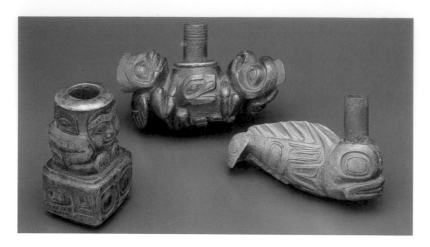

Wooden Pipes
Early to mid-19th century; Tlingit, southeast Alaska
Hardwoods (oak and walnut), iron, copper, Native pigments;
h. 4 in. (10.2 cm), 4⅜ in. (11.1 cm), 3½ in. (8.9 cm)
Gift of John H. Hauberg, 91.1.115, .116, .104

During the long era prior to the arrival of European trading vessels, Native people of the Northwest Coast cultured and grew a species of tobacco, now thought to be extinct. Pulverized in wood or stone mortars and mixed with the lime of burned clam shells, the substance was chewed and held in the mouth, rather than smoked. The tobacco plant, unknown in the Old World prior to the early seventeenth century, was domesticated by North American Native people and introduced to Europe by the first colonists on the eastern seaboard. European seamen of the eighteenth century introduced the habit of smoking tobacco in pipes of wood or clay to the Northwest Coast people, who largely switched over to the new technique. Imported tobacco continued to be used as was the native variety, in association with house raisings, important ceremonial occasions, and memorials, as well as for common consumption.

A great number of pipes incorporate trade materials brought to the area at the same time as the smoking concept. Firearms, such as the Hudson's Bay trade musket, provided useful materials for pipes, either when they ceased to function as weapons, or were altered by being shortened. Many Native pipes were made from the highly carvable walnut wood of musket stocks, and the large, smooth-bore barrels served as nearly indestructible pipe bowls, a factor which has contributed to the longevity of some very early pipes. The pipe stems were typically made of slim wooden shoots from which the pithy center had been burned out. Easily worn out, and therefore expendable, few of these have survived with their parent pipes.

These three Tlingit examples suggest the range of complexity and diverse images that are common to the old pipes. Pipes in general are some of the most freely expressive objects from the Northwest Coast. In this "new" medium, in which the Native artists felt unbound by traditions, they created an incredible variety of imaginative and sometimes very emotional miniature, functional sculptures.

ART OF EUROPE

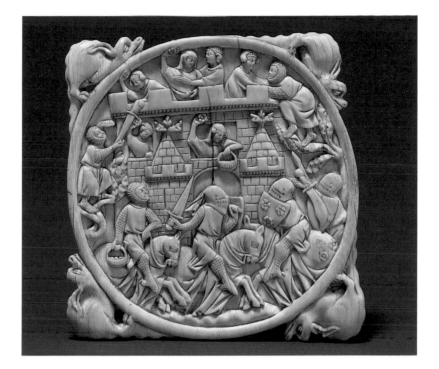

Mirror Case
c. 1330–60; French, probably Île-de-
France, Paris
Ivory; 4½ x 4¼ in. (11.4 x 10.7 cm)
Donald E. Frederick Memorial
Collection, 49.37

The turreted and crenelated castle is defended by ladies who hurl roses at knights, some of whom climb trees to surmount the battlements. One, at the left, surrenders his sword, hilt first, while another, at the right, is assisted over the ramparts by a lady. At the center, another lady, receiving an amorous caress, is about to pelt her attacker with a rose, but otherwise, like her companions, resists no more than decorum requires. Below, two mounted knights engage in a joust, apparently to win the favor of a lady, suggested by the roses emblazoned on the shield and caparison. The only weapon of the mounted knight, at the left, appears to be a basket of roses. The circular format of the mirror case is squared off by a crouching wyvern in each corner.

Storming the Castle of Love, an enduring late medieval theme, was an allegory of conquest. After a somewhat equivocal defense, the ladies yield their castle—that is, their favors—and elope with the knights of their choice. No literary source is known, and the closest resemblances seem to be with pageants and oral traditions. The preoccupation of the *Minnesänger,* in particular, with the conquest of love may account for the frequent representations of the Castle of Love in ivory, tapestry, manuscript illumination, and other media.

The absence of any hinge or connector indicates that this ivory formed the single-valved case for a speculum or mirror, probably made of polished metal. Locating the origins of this carving is somewhat problematical, as popular courtly themes became both stylistically and thematically conventionalized. Although comparable secular carvings have been attributed to Cologne, the symmetry of the composition, the lyrical but animated narrative style, and the exceptional refinement of the carving are all characteristics generally associated with Parisian workshops in the fourteenth century.

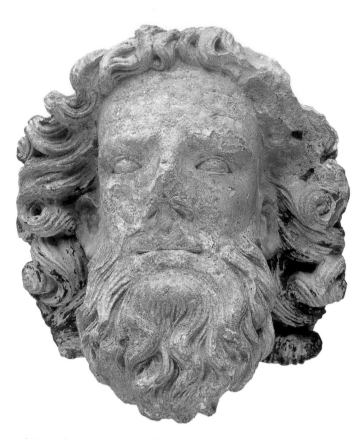

Head of a Saint or an Apostle
1225–30; French, Burgundy
Limestone; h. 13 in. (33 cm)
Gift of the Seattle Art Museum Guild, 51.233

The prominent forehead, carefully integrated facial contours, graceful curves of the beard, and the strictly frontal treatment of this head invoke an initial impression of thoughtful serenity. These calmer aspects of the physiognomy, undiminished by the surface mutilations, are countered, however, by the penetrating gaze of the eyes, framed by deep hollows, knitted brows, and high cheekbones, which suggest considerable underlying tension. This disquieting aspect is intensified by the agitated convolutions of the hair that surrounds the face. The resulting psychological intensity of this superb head is rarely equaled in sculpture of the period.

Although there are similarities in its psychological dynamics to sculptures at Strasbourg Cathedral, the technique, the naturalizing of facial features, and the emotive complexity all find their closest parallels in several sculptures at Dijon and, particularly, at Beaune, reinforcing the Burgundian attribution.

**Saints John the Baptist and
John the Evangelist**
c. 1500; North Netherlands,
Gelder or Cleve
Oak; h. 62½ in. (158.7 cm) and
h. 60 in. (152.4 cm)
Gift of Mrs. Oswald Brown in memory
of her husband, 58.68, .69

In their original setting, these two nearly life-size, high-relief sculptures almost certainly flanked the principal group in the central shrine of a large, carved altarpiece. The hands and attributes of both figures are replacements. The bearded figure of Saint John the Baptist is recognizable by the hair shirt worn underneath his mantle. The keys are the attribute of Saint Peter, who, in late medieval art, is invariably represented as an older man with a bald pate. The identification of the other saint is probably correct as John the Evangelist. Traditionally depicted as a beardless young man, his attribute is a eucharistic chalice.

The attenuated figure style, the narrow chiseled faces, and the broad, smooth passages of drapery interrupted with sharply creased, angular folds stylistically relate these figures to sculpture from the eastern reaches of the North Netherlands, although a German or nearby lower Rhineland origin is also possible. Like most altar sculptures from this region, the figures were probably never intended to be polychromed.

The Judgment of Paris
c. 1516—18; German
Lucas Cranach the Elder (b. 1472,
Kronach (Bavaria); d. 1553, Weimar)
Oil/tempera on wood; 25 x 16½ in.
(63.5 x 41.9 cm)
LeRoy M. Backus Collection, 52.38

Midway through his long career, Lucas Cranach became interested in portraying the nude figure and turned his attention to appropriate biblical and mythological subjects. The Judgment of Paris was a favorite theme, one that he painted at least ten times.

Jupiter sent Mercury to have Paris, second son of Priam of Troy, designate the most beautiful among Juno, Minerva, and Venus. Paris was to present his choice with a golden apple inscribed "To the Fairest." Each goddess offered him a bribe: Juno promised earthly wealth, Minerva offered victory in battle, and Venus promised the love of any woman he chose. She then described Helen, the wife of the king of Sparta. Paris gave the apple to Venus and would later sail to Sparta to abduct the beautiful Helen, thus setting in motion the Trojan War.

Cranach has northernized a classical scene by depicting the three goddesses as dainty blonde maidens, by dressing Paris in contemporary armor and setting the action in the rugged landscape around the Elbe, where the artist worked.

This painting is among his earliest versions and lacks the narrative clarity of later works. The golden apple is absent, and the goddesses are not individually identified by attributes. The sleeping Paris is oblivious to the charms of the goddesses, who look coquettishly out of the painting, inviting the viewer to decide.

Knight, Death, and the Devil
1513; German
Albrecht Dürer (1471–1528)
Engraving; 10¹⁄₁₆ x 7¹³⁄₁₆ in.
(25.5 x 19.9 cm)
Gift of Mrs. Leo Wallerstein, 64.52

This engraving shows the intrepid Christian knight striding on horseback through a dark, craggy landscape. He gazes resolutely ahead, unaware of the two fantastic figures who try to get his attention. Death, shown not as a skeleton but as a decaying corpse with hair and flesh still clinging to his face, holds up an hourglass as a reminder of the shortness of life. Behind the knight, the Devil is a grinning, powerless, comical creature with the face of an animal.

Saint Paul originated the image of the soldier girding himself for battle as a symbol of the devout Christian facing a hostile world; this vivid metaphor remained popular throughout the medieval period. In Dürer's own time the humanist writer Erasmus revitalized the idea of the Christian soldier, exhorting the reader to stay steadfastly on the path of virtue and renounce the evils of the world so that they might be rendered harmless.

Dürer's knight is amply prepared: he wears marvelously delineated armor and displays erect posture, an alert expression, and a firm grip on the reins. His splendid horse has a determination and steadiness to match his own, and his faithful dog strides alongside. All three figures march purposefully across the picture plane. The dangers that lurk in the darkness will be quickly passed and put behind them. In one sense, the print can be seen as an expression of the enlightened spirit of humanism striding into the dark forests and fortified towns of northern Europe.

This print demonstrates Dürer's mastery of the technique of engraving that won him a reputation as Europe's supreme printmaker in the first quarter of the sixteenth century. Within the confines of an inherently linear technique, he created an image rich in tonal variations and with a brilliant sense of different textures. This impression is a particularly fine one, with deep, velvety blacks and crisply delineated forms.

Plate, Saint Francis Receiving the
Stigmata
c. 1520; Italian, Deruta
Maiolica, tin-glazed earthenware;
diam. 16⅝ in. (42.2 cm)
Eugene Fuller Memorial Collection,
47.79

The secret of producing white, translucent porcelain was carefully guarded in the East. Chinese Tang porcelain arrived in the Middle East via the sea routes crossing the Indian Ocean and greatly influenced the early Islamic potters who attempted to imitate these wares. They perfected a white, opaque glaze by adding tin oxide to a clear lead glaze, which gave their buff-colored pottery a white surface, suitable for enameled decoration.

With the Arab conquest of Spain in 711, Moorish cultural and artistic elements were introduced into existing Spanish-Christian traditions. Two of the most important techniques of Islamic potters, the art of making a white tin glaze and the secret of lustre painting, were used to create pottery with a golden iridescent quality coming from layers of fired copper or sulfide of silver.

Trade carried the tin glaze and lustre tradition to Italy by way of Maiolica (the island today known as Majorca). Italian pottery, called maiolica, based on the newly arrived Islamic techniques, developed about 1500 in Deruta. Wares from Deruta are generally characterized by designs outlined in blue and filled in with large areas of straw-yellow lustre. The cavetto, or well, of the plate is painted in a pictorial style influenced by the humanistic spirit of the Renaissance. The border retains overlapping scale motifs and other geometric designs from the Islamic tradition combined with symmetrical acanthus scroll and abstract vegetal motifs of the European tradition.

Depictions of Francis of Assisi, the early thirteenth-century saint and founder of the Franciscan order, were popular throughout the Renaissance. The theme of Saint Francis Receiving the Stigmata, the wounds of the crucified Christ, while at prayer on a mountainside, is traditionally portrayed by fine blue lines connecting the kneeling saint and the cross.

Maiolica techniques of tin glazing and enamel decoration, derived from Moorish Spain, continued to spread as potters traveled throughout Italy. Many settled in and around Urbino, where a decorative style called *istoriato* (literally, storied) developed. *Istoriato* pieces treat the entire plate as a canvas, covering the surface with finely painted historical, biblical, or mythological scenes.

The story of Cain and Abel is portrayed in two parts on this plate. These brothers, the first two children born to Adam and Eve, are depicted on the left before sacrificial altars, where Cain, a farmer, has brought an offering from his harvested crops. God the Father is seen bursting from the clouds, rejecting Cain's sacrifice in favor of Abel's offering of one of the first offspring of his flock. In his role as the just shepherd, Abel served as an early prototype, in the Christian tradition, of the Messiah, and

sacrifice of Jesus, the Lamb of God. On the right, we witness the moment when, in a fit of jealous rage over his rejection by God, Cain raises his clublike axe to kill Abel.

This scene is an intriguing combination of painting traditions. The drama and violence of the brothers' gestures, overseen by a Zeus-like patriarchal deity, is rendered in accordance with Renaissance values and preoccupations with classical Greece: the modeled, heavily muscled bodies in dynamic postures and the plain, architectural altars drawn in perspective. On an island across the water (right), a few columns rise, suggesting classical ruins.

But in the left background stands a large Romanesque villa bordered at water's edge by an orderly planting of shrubs. Such contemporary landscapes appear frequently in European paintings of religious subjects, from the thirteenth through the fifteenth century. They provide a serene and harmonious counterpoint to the stirring acts, miracles, or portents of the main theme, serving to anchor them, for the viewer, in a familiar present.

The Origin of the Cornucopia
c. 1619; Flemish
Abraham Janssens (1575-1632, Antwerp)
Oil on canvas; 42⅜ x 67⅜ in. (108.6 x 172.8 cm)
Purchased with funds from PONCHO in honor of Dr. Richard E. Fuller's
75th birthday, 72.32

According to Ovid's *Metamorphoses,* when Hercules and the river god Achelous were competing for the hand of Deianeira, the two rivals fought, with Achelous first assuming the shape of a snake, then of a bull. In overcoming him, Hercules snapped off one of the bull's horns, which was retrieved by a group of river nymphs who filled it with fruit and vegetables. It is this latter episode that Janssens presents in the foreground.

On one level the picture can be seen as an allegory of abundance. It may also have been part of a decorative series; Janssens is known to have painted cycles devoted to both the Life of Hercules and the Four Seasons, and the prominence of harvest symbols makes the latter possibility especially attractive.

During an early trip to Italy, Janssens became the first Antwerp painter to see the works of Caravaggio, whose influence can be seen here in Janssens's use of strong lighting, crisp modeling, and clarity of design. The compressed horizontal format and heavy, slow-moving figures give the work a monumental effect. In his time Janssens's paintings were prized for their classicism, and they offered patrons in Antwerp an alternative to the dynamic compositions of his famous contemporary Peter Paul Rubens.

The Triumph of Neptune
c. 1692–1702; Italian
Luca Giordano (1632–1705, Naples)
Oil on canvas; 78 x 101 in. (198.1 x 256.5 cm)
Eugene Fuller Memorial Collection, 54.161

During his long and prolific career, Luca Giordano treated virtually every subject available to artists. Stories from the Old and New Testaments, portraits, allegories, hunting scenes, mythological episodes, saints, and still lifes all found easy expression in his brush. His versatility and energy led to numerous commissions throughout Italy; toward the end of his career he was invited to Spain by Charles II, whom he served as court painter from 1692 to 1702.

The Triumph of Neptune is treated in Giordano's most exuberant manner, with swirling forms and quick, fluid brushstrokes. The sea god Neptune, after unsuccessfully wooing Amphitrite, has finally sent dolphins to bring her back to him. She rides a dolphin alongside his chariot as tritons and putti joyfully attend them. Although the pyramidal arrangement is essentially stable, the twisting, tumbling figures and the billowing drapery convey a sense of motion of the wind and waves.

Because of his mastery of many different styles, it has been difficult to determine a chronology for Giordano's works. Nevertheless, because this painting was recorded as being in the possession of Charles II of Spain, it is logical to assume that it was painted during the ten years the artist was active at the Spanish court.

Pastorale
c. 1627; Dutch
Gerrit van Honthorst (1590–1656, Utrecht)
Oil on canvas; 43⁹⁄₁₆ x 39¹³⁄₁₆ (110.6 x 101.1 cm)
Gift of the Samuel H. Kress Foundation, 61.156

As a young man Honthorst studied in his native Utrecht with the painter Abraham Bloemaert, but his artistic personality fully emerged during an extended sojourn in Italy from 1610 to 1620. There he was strongly influenced by the dramatically lit compositions of Caravaggio, and when he returned to the Netherlands, he brought the new style back with him. While this sunny *Pastorale* has none of the brooding quality of the works Honthorst produced in Italy, the strong illumination of the forms, the crisp drapery, and the smooth brushwork recall the technique of Caravaggio and his followers.

Pastoral themes became popular in the visual arts and in literature in seventeenth-century Holland. Though this scene, in which a young shepherdess is bedecked with flowers, may not derive from a specific literary source, wreaths of flowers were a common symbol of fidelity in both poetry and painting and were a popular means of designating a bride.

Paintings showing shepherds and shepherdesses relaxing or making music were in great demand among the elite of Honthorst's time. Such works decorated permanent living quarters as well as summer houses and hunting lodges. This work may have hung above a mantle in the residence of Frederick Hendrick, Prince of Orange.

Riva degli Schiavone
c. 1710; Italian
Luca Carlevaris (1665–1731)
Oil on canvas; 37¾ x 75¾ in. (95.9 x 192.4 cm)
Gift of Floyd A. Naramore, 50.70

Carlevaris is known as the first Venetian artist to paint *vedute,* or views, a genre of painting that became popular in the eighteenth century. This view of the famous Doge's Palace was one of the artist's most popular compositions; he painted at least ten versions. As in many *vedute,* the artist achieves a soaring, spacious effect by using an elevated viewpoint which displays more than the eye can naturally take in. The clear, even light at once focuses details and unifies the composition. The limited palette of pinks and blues also contributes to the unity of the whole.

The waterfront is populated by a lively assortment of noblemen, gondoliers, merchants, performers, and sailors. But the individual figures are ultimately subordinated to the light, atmosphere, and grandeur of architecture. Together these elements recreate the ambience of the Venetian scene, the true subject of this *veduta.*

Paintings such as this one helped to popularize the new genre, but Carlevaris promoted it in other media as well. A trained architect and mathematician, Carlevaris knew Venice intimately and made laborious drawings of each significant church and palace in the city. He then published a book of etchings of these views, which stimulated an interest in these sites and created a demand for *vedute,* which he and his famous followers Canaletto and Guardi were happy to meet.

Allegorical Figure of America
1752–54; French, Strasbourg factory
Modeled by Paul Hannong (1700–1760)
Hard-paste porcelain; h. 10 in. (25.4 cm)
Marks: impressed PH (five times)
Gift of Martha and Henry Isaacson, 81.8

Allegorical Tapestry of America
Late 17th century; Flemish, Brussels
Jacques Van der Borght, Sr., and Jan Cobus
Wool; 13 x 12 ft. (33 x 30.4 m)
Gift of the Hearst Foundation, Inc., 62.199.1

The European tapestry tradition developed in medieval times through the infusion of Arabic traditions and craftsmanship from Moorish Spain. By the sixteenth century, the Flemish city of Brussels was the center of European tapestry production. The museum's three tapestries, representing America, Africa, and Asia from the *Four Continents* series were created in the last great tapestry atelier of Brussels, the factory of Jacques Van der Borght. Van der Borght was often joined in the designing and production of tapestries by Jan Cobus, whose name appears in the lower right corner of Africa.

As the great European trading companies developed throughout the seventeenth century, European taste and fashion were shaped by the delectation of exotic new trade goods and fanciful images (paintings and engravings) of the Orient, Middle East, and the New World. Views of foreign landscapes, strange animals, and unusual plant life were popular sources of inspiration for artists of the seventeenth and eighteenth centuries, the Age of Reason and exploration.

The source for the Native American featured in both the tapestry and porcelain figure was a watercolor by John White (fl. 1585-93), who accompanied Sir Walter Raleigh on several expeditions as a commissioned artist to depict life in the New World. Theodore de Bry, a Flemish engraver and publisher working in Germany, produced twenty-five engravings after John White for inclusion in his collection of travel books, *Great Voyages,* published in the 1590s. This Native American image comes from an engraving produced for the Florida edition.

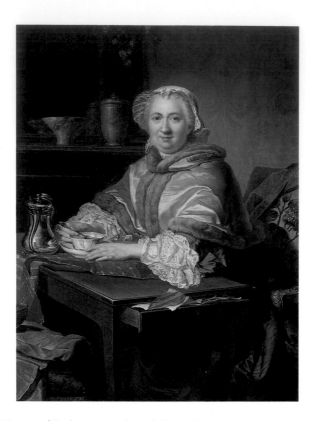

Portrait of Madame Brion, Seated, Taking Tea
1750; French
Jacques-André Joseph Aved (1702–66, b. Flanders)
Oil on canvas; 50⅝ x 38³⁄₁₆ in. (128.6 x 97 cm)
Purchased with funds from the Frederick Pipes Estate Fund, General
Acquisitions, Mary Arrington Small Estate, and Eugene Fuller Memorial
Collection, by exchange, 87.99

Among French painters of the eighteenth century, Jacques-André Joseph Aved remains less well known than his contemporary François Boucher or Jean-Baptiste Siméon Chardin. During his lifetime, Aved enjoyed a reputation as one of Paris's finest portrait painters. Born in Douai in 1702, he traveled to Amsterdam for his early training before settling in Paris in 1721, where he concentrated his efforts in portraiture. In 1734 he was admitted to the Académie des Beaux-Arts, and he first exhibited in the Salon of 1737.

This painting of Madame Brion is an example of the new candid style of portraiture that Aved first introduced to Paris in the 1740s, and which soon earned him the patronage of the city's bourgeoisie. Pausing momentarily from her work, Madame Brion turns to engage the viewer as she stirs a cup of tea (or coffee) poured from the steaming pot on the table. The directness of her gaze and the informality of the moment recall portraits by Chardin, who had earlier painted his wife with her afternoon tea. While the two men shared a lifelong friendship, Aved celebrated the details of reality in a way contrary to Chardin's; hence Madame Brion's obvious comfort in an environment that is lovingly recorded by the artist.

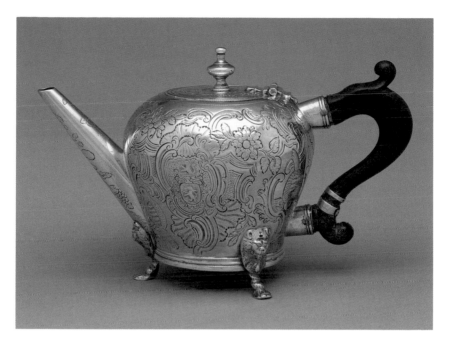

Teapot
c. 1740; Irish, Cork
George Hodder (first mentioned in 1738, d. 1771)
Sterling silver; 6¼ x 9¼ in. (15.9 x 23.5 cm)
Marks: maker's mark and hallmark for the City of Cork
Gift of the Decorative Arts Council in honor of the museum's 50th year,
84.18

A distinct Irish rococo decoration, which developed during the second quarter of the eighteenth century, reveals the strongest national characteristics in Irish silver. Stylistically, Irish silver followed the broad trends of English silver; the apple form of this provincial teapot as well as its straight spout, baluster finial, and double scroll handle are inspirations from the earlier English Queen Anne style. But the whimsically chased foliated scrolls and exotic bird and floral motifs proclaim the resourcefulness and great technical skill of the Irish silversmiths, as they developed a rococo decorative style quite distinct from their English counterparts.

Dublin was the largest silver center of Ireland, but the provincial towns of Cork and Limerick also supported a lucrative silver trade. George Hodder served a provincial apprenticeship and became one of the leading silversmiths of Cork. In 1754 he was made Mayor of Cork. His teapot combines romantic and fantastic elements of foliate decoration with natural wildlife motifs supported on three lion mask-and paw feet, an asymmetrical confluence of design that embodies the Irish soul in silver.

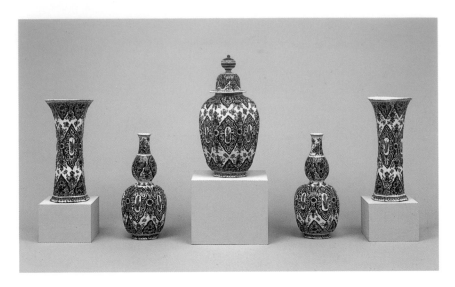

Garniture of Five Vases
Late 17th century; Dutch, Delft
Delftware, tin-glazed earthenware; h: 17, 16¾, 19¾, 16¾, and 17 in.
(43.2, 42.5, 50.2, 42.5, and 43.2 cm)
Marks: painter's mark of Lambertus van Eenhoorn (d. 1721),
The Metal Pot factory
Margaret E. Fuller Purchase Fund, 58.41

The development of a tin-glazed earthenware industry in Holland in the late sixteenth century was stimulated by the arrival of Italian ceramic artisans and by the China trade. The gradual decline in the art of maiolica-making in Italy throughout the second half of the sixteenth century led to a large-scale migration of ceramic artists north into the low countries. They injected new, improved glazing and firing techniques into the fledgling Dutch industry, which greatly increased productivity as a result.

This influx of artisans coincided with the development of the Chinese porcelain trade by the Spanish, Portuguese, and the Dutch East India Company. Chinese porcelain made in the late Ming period, called *kraak porselein* by the Dutch, was greatly admired for its pure white color and vibrant underglaze blue decoration. The secret of porcelain production was locked in the East, and the warm, white, tin-glazed ceramic body and rich cobalt blue decoration of Dutch Delftware was a successful attempt to achieve a resemblance to Chinese porcelain.

The Chinese vase forms and high-temperature blue decoration in the Far Eastern style of these vases was popular at the Metal Pot factory of Lambertus van Eenhoorn, proprietor from 1691 to 1721. This garniture by van Eenhoorn would have been proudly displayed on a chimney piece or atop a high cupboard of the type known as a *kast*.

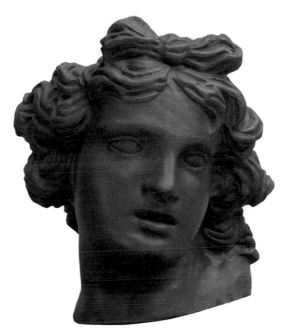

Head of Apollo
c. 1710–15; German, Dresden or Meissen factory
Modeled by Paul Heermann (c. 1673–1732)
Steinzeug (red stoneware); h. 4⅛ in. (10.4 cm)
Gift of Martha and Henry Isaacson, 69.179

The secret for producing a white, translucent hard-paste porcelain had for centuries been locked in the Far East. This revered ware was coveted by royalty in Europe—their search for a European porcelain formula led to countless experiments with varied materials (permeable clays and pulverized stone for fusing) and high-fire kiln techniques. In 1706 or 1707 an alchemist, Johann Friedrich Böttger (1682–1719), and a physicist/mathematician, Ehrenfried von Tschirnhaus (1651–1708), working under the aegis of Augustus the Strong, Elector of Saxony and King of Poland, achieved a hard, impermeable stoneware. Work with this ware brought them ever closer to the secrets of porcelain.

Early Böttger stoneware pieces were simple cups and vases. When the Saxony court goldsmith J. J. Irminger (1635–1724) joined the factory staff in 1710, new imaginative shapes based on Chinese models and silver designs were perfected, and the unique qualities of the stoneware, such as the ability to polish the surface to a gleaming mirror finish, were utilized. Gradually a German style, influenced by the baroque, developed. Tall graceful vases, octagonal-shaped teapots, and sculptural busts and figures in this style were elegantly rendered in Böttger stoneware. The hollow stoneware *Head of Apollo* (first listed in the Meissen inventory of 1711) was formed in a low-fired clay mold created from a model by Paul Heermann. The concept for this model came from the baroque marble *Apollo and Daphne* (c. 1622-24) in the Palazzo Borghese in Rome by Bernini, who in turn was inspired by the great classical sculpture the *Apollo Belvedere.*

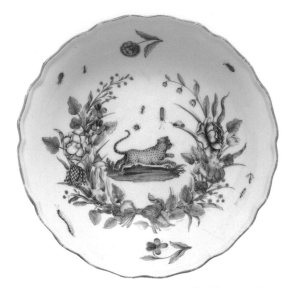

**Dish from the Duke of
Northumberland Service**
c. 1740–45; German, Meissen factory
Hard-paste porcelain;
diam. 9⅛ in. (23.1 cm)
Mark: crossed swords in underglaze
blue and impressed numeral 20
Gift of Martha and Henry Isaacson,
55.99

The European quest for the secrets of producing porcelain was finally successful when, in March 1709, after years of experimentation, Johann Friedrich Böttger announced to Augustus the Strong of Saxony that he could produce a good white porcelain with a very fine glaze. On the strength of his discoveries, the first hard-paste porcelain factory in Europe was established in Meissen in 1710. European porcelain was so highly valued that it was promptly termed "white gold." As the secret formula leaked from Meissen, new factories were established throughout Europe.

When the English Duke of Northumberland ordered two great table services in the 1740s, he looked to the Meissen factory, which was esteemed throughout Europe. The wares from the great period of Meissen are considered by many to be the finest European porcelain ever produced. Meissen dominated European porcelain production from 1710 to the period of the Seven Years' War (1756–63), when Saxony was ransacked by invading Prussian troops, plunging the manufactory into financial and artistic decline.

The duke's dinner services were the work of Johann Joachim Kändler (1706–75), a Saxony court sculptor appointed chief modeler of the factory in 1733. Kändler's mastery of the pliant porcelain paste inaugurated a new era of sculptural rococo design. A fascination with nature, prevalent in all cultural arenas of the day, inspired Kändler to create animal and bird forms. He studied the beasts and birds in the Royal Menagerie of Augustus the Strong and used many of the different bird models as finials and handles on the Northumberland serving pieces. The same interest in nature inspired wares depicting scenes with botanical and zoological specimens. The two services, one of which numbered 129 pieces, were decorated by the Meissen painters with a fantastic array of exotic animals amid rococo-styled *deutsche Blumen* (German flowers) primarily inspired by engravings of the period. The animal racing across this plate has come down through time catalogued as a panther, but it is a leopard. Records from the eighteenth century often reveal confusion concerning the actual names for foreign animals, many of which were so newly known in Europe.

Figure of Columbine
c. 1750; Italian, Capodimonte factory
Soft-paste porcelain; h. 6 in. (15.2 cm)
Mark: impressed fleur-de-lis
Dorothy Condon Falknor Collection of
European Ceramics, 87.142.65

The finest porcelain wares produced in Italy were manufactured at the Capodimonte factory of Naples between 1743 and 1759. The factory was the prestigious possession of the Bourbon King Charles IV of Naples and his queen, a granddaughter of Augustus the Strong, the great porcelain collector and patron of the Meissen factory. The porcelain body of Capodimonte is highly prized for its translucence and warm, milky white color. The swirl of rococo modeling seen in this commedia dell'arte figure features the luscious Capodimonte porcelain articulated by reserved, well-placed enamel decoration.

The Italian commedia dell'arte was widely popularized as a farcical theater form in the sixteenth and seventeenth centuries, but its stock characters — lovers, villains, buffoons — go back to late Roman times. It developed as scenarios with improvised dialogue performed by groups of strolling players, usually under the patronage of a nobleman.

The most important characters were the *zanni,* or servants. It was their task to weave elaborate plots and arouse laughter. Harlequin was the primary *zanni* character and, with his beloved Columbine, acted as servant to the aristocratic stock-characters, the Lovers. Columbine was witty, bright, and full of intrigue. She is often portrayed dancing. Depictions of characters from the commedia dell'arte were popular in all forms of the decorative arts of the late seventeenth and eighteenth centuries, and figures of its stock characters, who gained enormous popularity, were produced in most European porcelain factories.

Crayfish Salts
c. 1745–50; English, Chelsea factory
Soft-paste porcelain; 2⅞ x 4⅜ in. (7.3 x 11.1 cm)
Marks: one has an incised triangle on base; the other is unmarked
Gift of Evelyn Clapp, 54.132.1, .2

Porcelain production in England was underway by 1745, thirty-five years after the founding of the first European porcelain factory at Meissen, Germany. The tradition of establishing and supporting the manufacture of porcelain, in vogue on the Continent, did not take hold among the English nobility. Except for a moderate financial interest held by Sir Everard Fawkener (1693–1758), secretary to the Duke of Cumberland, in the first English porcelain factory at Chelsea, the English companies were private enterprises owned and operated by artisans and middle-class businessmen.

The artistic director and manager of the Chelsea factory was Nicholas Sprimont (1716–71), a Huguenot silversmith. His skills in drawing and modeling plastic designs for silver were wonderfully transposed into porcelain models for the new factory.

Extremely complex in design and requiring complicated molds, rococo motifs of swirling sea life and shells were beautifully rendered in porcelain. This pair of rococo crayfish- and shell-decorated salts would have held a prominent position at the table. Salt was a commodity that had become more accessible by the eighteenth century, but continued to be esteemed as an essential element for good health and as an important ceremonial part of dining.

Tobacco Jar (*pot à tabac*)
c. 1745–50; French, Vincennes factory
Soft-paste porcelain, silver-gilt mount; h. 8 in. (20.3 cm)
Marks: unidentified painter's mark in blue on bottom of jar and
inside rim of lid
Dorothy Condon Falknor Collection of European Ceramics, 87.142.30

In the eighteenth century, soft-paste porcelain produced from a fine clay and glass frit (powdered glass) was an ultimate luxury, a prime manifestation of French taste. A porcelain manufactory established during the late 1730s in an abandoned royal chateau at Vincennes captured the fancy of Louis XV and his mistress, that great patroness of the arts Madame de Pompadour. In the early years of their sponsorship, Vincennes developed a refined rococo style famous for its soft, winsome appeal, seen here in the form and painting of this tobacco jar. Beautifully drawn floral decoration — a rose, a stem of iris, violets, pinks, and a lily — playfully share the surface of this piece with a caterpillar, butterfly, and other insects. The naturalistic style of painting is both delicate and spontaneous.

French porcelain wares in the eighteenth century were predominantly useful rather than figural, but with the passage of time and the changes in their use dictated by subsequent generations, the original function of many pieces has been lost. Such is the case with this Vincennes jar. Formerly catalogued as pomade pots, tea canisters, or jam jars, these large jars with tight-fitting lids have been revealed by recent research to be storage containers for the exotic weed from the New World, tobacco.

Pair of Miniature Orange Tubs
1756; Vincennes or early Sèvres factory
Soft-paste porcelain; h. 3¹¹⁄₁₆ in. (9.3 cm) (each)
Marks: one pot with interlaced L's enclosing the date-letter D for 1756
and the painter's mark for Pierre-Antoine Méreaud (Méreaud ainé,
active 1754–91); the other bearing an incised numeral 8
Purchased with funds from the estate of Mary Arrington Small and the
Decorative Arts Council, 85.215.1, .2

Madame de Pompadour, the mistress to the French King Louis XV, was so enthralled by her almost daily participation in the Vincennes porcelain factory that after she built her new chateau, Bellevue, she longed for the factory to be close by. In 1756 the factory moved to a new site at Sèvres; wares produced after the move are known as Sèvres porcelain.

Sèvres became very important during the Seven Years' War (1756-63), when Saxony was occupied by Frederick the Great of Prussia. Because of the war, the Meissen factory, which had dominated porcelain manufacture since its founding, was in great disarray. Sèvres, stepping into the breach, led the fashions and ceramic market throughout Europe until the last decades of the century.

Vincennes and Sèvres were known for a pure white porcelain paste of the finest quality. This pair of small flower pots, in the shape of miniature orange tubs, were listed in the factory records as *"caisses carrées"* (square boxes). They feature the vibrant green ground color and characteristic floral painting, highlighted with rich, tooled gilding; both famous features of Vincennes/Sèvres porcelain. *Caisses carrées* (sometimes called *caisses à fleurs)* were produced in three sizes; this pair is of the smallest size. They were made to contain flowering plants (they have holes in the bottom for drainage) and probably sat on small trays arrayed along the grand banquet tables of an earlier age.

ART OF THE UNITED STATES

Peonies in the Wind with
Kakemono Borders
c. 1893; United States
John La Farge (1835–1910)
Leaded stained glass; 56 x 26 in. (142.2 x 66 cm)
Purchased with funds from the Kreielsheimer Foundation, Thomas W.
and Ann M. Barwick, the Virginia Wright Fund, Ann H. and John H.
Hauberg, the Margaret E. Fuller Purchase Fund, and the 19th- and Early
20th-Century American Art Purchase/Deaccession Fund, 87.143

John La Farge was among the most versatile of late nineteenth-century American artists. Worldly, well-traveled, and highly sociable, he produced a remarkable range of paintings, watercolors, drawings, and, with the greatest innovation and impact, pictorial stained glass, for which he had his own factory and developed new technology.

From La Farge's watercolor studies, artisans executed his pictorial windows in the opalescent glass he developed. Its flecked, multitoned shading created prismatic effects accentuated by the depth of individual glass fragments and their multilayered construction. The dutchmen, the lead supports around the glass elements, made possible the use of interconnected glass sections (rather than the earlier method of painting or drawing on glass) to realize the designs.

This vivid floral view was made by the artist to lend when an example of his glass work was requested for public exhibition. At least three earlier versions were commissioned for private residences and are now in public collections. The Seattle version was retained by the artist throughout his life.

Framed with a glass border imitating silk on a Japanese scroll (kakemono), La Farge's design demonstrates the interest in and influence of Japanese art at the turn of the century in the United States and Europe.

A Country Home
1854; United States
Frederic Church (1826–1900)
Oil on canvas; 31⅞ x 50 in. (81 x 127 cm)
Gift of Mrs. Paul C. Carmichael, 65.80

Frederic Church captured the United States's panoramic expanses of undeveloped nature as masterfully as any late nineteenth-century American artist. Based in New York, Church and other painters of the so-called Hudson River School are credited as generating the first significant art movement in the United States. In both quaintly descriptive and epically grandiose compositions, they celebrated the national paradise of their already rapidly industrializing country.

In the early 1850s, moving on from the spiritualized landscape visions of his mentor Thomas Cole (1801–48), Church combined carefully observed details from his numerous sketches and studies into a small series of pastoral views of the northeastern United States. In *A Country Home,* mountains, lake, streams, and light-soaked clouds dwarf a house, three figures, and a field of grazing cows. The front windows glow with the reflected sunset as a woman carries a bucket of lake water to the house, and two men succeed at fishing. Church later traveled to and painted bigger and more dramatic terrains, but in this landscape, he achieved one of his most complete and definitive views of a still young, agrarian country.

Mount Rainier
1875; United States
Sanford Gifford (1823–80)
Oil on canvas; 21 x 40½ in. (53.3 x 102.9 cm)
Promised 55 percent fractional interest gift of an anonymous donor and
45 percent fractional interest gift, by exchange, of Mr. and Mrs. Louis
Brechemin, Max R. Schweitzer, Hickman Price, Jr., in memory of
Hickman Price, Eugene Fuller Memorial Collection, Mr. and Mrs.
Norman Hirschl, and the estate of Louise Raymond Owens, 90.29

Sanford Gifford visited Washington Territory in the summer of 1874. On September 1 of that year he produced the drawing of Mount Rainier that served as the model for this painting, which he executed in the winter of 1875 in his New York studio. The back of the picture is inscribed "Mount Renier [sic], Bay of Tacoma, Puget Sound, S. R. Gifford, Pinxit 1875. New York."

In the same year the picture was sold to a Mr. Fowler living in London. It subsequently found its way to collections in Connecticut and California before being acquired by the Seattle Art Museum in 1990. Gifford's view of Mount Rainier and the surrounding countryside from Commencement Bay in Tacoma not only celebrates the majesty of the Cascade Mountains but also evokes the details of daily life in the southern reaches of Puget Sound. The large, long-prow canoes of Native design ply these waters in search of trade or seasonal work in the hops fields before returning to communities farther north.

Suffused with the radiant light that Gifford brought to many of his finest works, Mount Rainier is also a brilliant technical demonstration of the interplay of underdrawing and thin layers of color applied with a rapidly moving brush.

Portrait of Alexander J. Cassatt
1888; United States
Mary Cassatt (1845–1926)
Pastel on paper; 35¾ x 25½ in.
(90.8 x 64.7 cm)
Gift of Mr. and Mrs. Louis Brechemin,
by exchange, 88.154

Mary Cassatt painted this portrait of her older brother at the height of her artistic power. His composure and formal reserve belie the warmth of Cassatt's relationship with him. Affluent and successful, Alexander Cassatt (1839–1906) was the subject of four of the approximately twenty identifiable male portraits Cassatt created during her long and productive career. Alexander's dark formal clothing and his pose looking to the right are common to all four. Recent scholarship traces the execution of this portrait to the June 1888 visit of Alexander and his wife, Lois, to Paris. He posed at his sister's new apartment, and Lois reported in June in a letter to America, "Mary has painted a very good portrait of Aleck for which he has been posing every morning for two hours for two weeks" (Lindsay, *Mary Cassatt in Philadelphia*, 1985).

This portrait's gravity is balanced by the looseness of the background and the vague intimation of interior space, suggested by the black, incomplete line to the right of his face along with the swiftly delineated book and pen or page cutter lying before him on a sharply angled table.

Mary Cassatt, best known for her depictions of women and children, portrayed family life and the domestic scene in a careful impressionist style. She conferred a meditative calm on all her subjects. Cassatt showed at the French Salon in 1873, was invited by her friend Edgar Degas, another great practitioner of the medium of pastel, to exhibit with the independents in 1877, and in 1879 exhibited with the impressionists: upon no other American artist were such honors bestowed.

Black Lion Wharf
1859; United States
James Abbott McNeill Whistler (1834–1903)
Etching; 5^{15}⁄$_{16}$ x 8^{15}⁄$_{16}$ in. (15.2 x 22.9 cm)
Manson F. Backus Collection, 35.262

After James Whistler's exotic, migratory upbringing and unlikely first professional foray (he made two attempts at a career in the army at West Point), he turned in his early twenties to printmaking following a brief employment etching coastal and topographic maps for the United States government. By the late 1850s, as part of his study of art in Paris, Whistler was etching regularly. *Black Lion Wharf* was completed in London as part of a set of sixteen etchings of the River Thames. Its sign missing the "k," the Black Lion wharf office is visible to the right at the back of the print. Detail, empty space, and loose line exist simultaneously without any compromise of representation. As Elizabeth Luning observed in 1975, "All lines are uniform in depth and appear to have been etched in a single bite."

The series brought Whistler his first acclaim as a printmaker. *Black Lion Wharf* was among the fifty prints Whistler chose for his 1893 print exhibition at the Columbia Exposition in Chicago. An early work within Whistler's production of nearly 450 prints, it hangs on the wall behind the figure in Whistler's most famous painting, *Arrangement in Green and Black: Portrait of the Painter's Mother,* 1871.

Alabama, #3828
1914; United States
Lewis Wickes Hine (1874–1940)
Gelatin silver print; 4⅝ x 6¹¹⁄₁₆ in. (11.8 x 17 cm)
Gift of Chuck Kuhn, 87.82

Lewis Hine left a career as a school teacher in 1908 to pursue "interpretive" photography, as he called it, and research into American labor and social issues. A university-trained sociologist, Hine counted artists such as Paul Strand among his social reform-minded friends and was aware of the rhetorical power and aesthetic conventions of photography. Between 1908 and 1916 he collected evidence for the National Child Labor Committee. He became a master of what was later called documentary — the addition of analysis to neutral record. While his photographs and notes were intended for publication in the *Survey Graphic* and other periodicals aimed at reforming labor laws, his skill as an artist was also recognized during his later life by the New York Photo League. Not until recently has the true breadth and depth of his understanding of the language of photography been fully appreciated.

We are engaged by the even, fatigued gaze of the young women in the cotton mill and cannot escape the erosion of their youth and beauty by the strain of long hours at work. Hine has positioned them tightly together—they are pressed between the spinning machinery, the light of the window, and the camera. Their slender bodies and closed faces, both sullen and vulnerable, are reminiscent of massed workers in woodblock prints by Hine's contemporary Käthe Kollwitz. The placement of the camera below eye level, and the eye contact with the viewer — most of the women have obeyed his instruction to look directly at the lens—implies both sympathy and respect on the part of Hine. For the industry of the time, these young workers were as anonymous, numerous, and expendable as the bobbins on the machinery.

Tobadzischini — Navaho
1904; United States
Edward S. Curtis (1868–1952)
Photogravure; 7⅜ x 5⅜ in.
(18.7 x 13.6 cm)
Purchased with funds from the estate of
Mary Arrington Small, 85.261

This image is from the first volume of Edward S. Curtis's lifelong project, *The North American Indian,* published from 1907 to 1930. The huge undertaking was intended to document, through photography and text from field notes, as many groups of Indians as Curtis could find who still followed their traditional lifestyle. It served two barely compatible ends: the production of more than two thousand photogravure art prints, then and now admired for their deep and subtle beauty, and the ethnographic study of a "disappearing" people.

In the sacred Yebechai dance of the Navaho, men in traditional masks first represent and then become living embodiments of specific supernatural beings. This man is dressed as the god

Tobadzischini, one of seven main dancers that Curtis photographed. Curtis was able to convince the Navaho of the importance of recording the dancers in the face of very strong proscriptions against outsiders seeing, let alone photographing, the ritual (as much of the significance of the dance as was revealed to Curtis is explained in the text of his first volume).

Even with its context missing, there is unavoidable charged power in the dramatically lit masked figure. It is tempting to see this as residual of the original dance and the sophisticated world view of the Navaho — so strong that it can survive the monochrome abstraction of the photographic portrait and the subsequent generation into the intaglio gravure. The copy in the museum's collection is the first approved pull from the plate, called the *bon à tire.* As evidenced by the fingerprints and the pinhole at top center, it was used by the printers to match the complete edition.

Elizabeth, Paris
1931; United States
André Kertész (1894–1985, b. Hungary)
Gelatin silver print; 9¹¹⁄₁₆ x 7½ in.
(24.6 x 19.1 cm)
Gift of Jerome D. Whalen, 86.232

At the time of this portrait of his second wife-to-be, Elizabeth Sali, André Kertész was in the middle of the most exciting time of his life. As a freelance photographer in Paris, he was in the process of inventing a new language of journalistic photography using the new small Leica and other fast, hand-held cameras. Along with Felix Mann and Erich Saloman, and later Cartier-Bresson, Brassai, and Robert Capa, Kertész freelanced for the new picture magazines including the *Berliner Illustrierte Zeitung, Vu,* the *Münchner Illustrierte Presse,* and the *London Sunday Times.* The design discoveries of the surrealists, in whose social circle he traveled, and the need for eye-catching images in a highly competitive market, pushed Kertész into areas of formal innovation that bridged commercial and expressive or art photography.

The portrait of Elizabeth is an example of the influence of cubism on the new surrealist photography. The carefully placed edge of the photograph causes an oscillation to set up between a profile and frontal view that adds mystery to an already sensuously self-confident face. The hand on the woman's shoulder provides tension from an unseen source, but remains below and in submission to the single dangerous eye. The new photography created by Kertész and his circle used radical cropping to imply whole worlds by showing only parts of images. This print, for example, is made from less than one-third of the original negative, which also contains the image of Kertész and reveals that the hand is his.

In the Bridgeport War Factories
1941; United States
Walker Evans (1903–75)
Gelatin silver print; 9¹¹⁄₁₆ x 7¹³⁄₁₆ in.
(24.6 x 19.8 cm)
Purchased with funds from the Margaret
E. Fuller Purchase Fund, 90.57

Walker Evans fused a love of the complex ambiguities of literature, a firsthand knowledge of the new art in Europe at the beginning of the century, and his own unconventional, pragmatic social attitudes into a genuinely original American art photography. This photograph, made to illustrate an article in *Fortune* magazine on the frenetic industry that built rapidly during the first year of the United States's involvement in the Second World War, contains all of the elements of Evans's art that so strongly influenced his two most important followers, Robert Frank and Lee Friedlander.

This picture seems like a casual snapshot but contains unusual layers of information created by reflection, transparency, and frames within the primary frame of the image. Like a good lyric poem, it contains meanings that change in relation to each other and our understanding of them—they may conflict or combine. Is the child yawning or grimacing? What is she doing in this unusual place of display? It also functions like a cubist collage, juxtaposing snippets of mundane visual experience — advertising, common entrances, gestures, conventional clothing — things we glance at without concentrating.

When Evans was hired in 1936 by Roy Stryker of the Farm Security Administration, a federal program, to make documents of the Great Depression, he didn't last long because of his conviction that complex social upheavals could be easily trivialized by merely descriptive images. He sent back photographs that might best be described as darkly felt impressions of the damage being done to individual American people, including himself, rather than collective despair or quick-fix economic recovery. He believed that the human consequences of the Depression and the subsequent war that turned it around could best be communicated with the subversive strategies of art. The editors of *Fortune,* unlike his former government employers, had the wisdom to encourage his views.

Message
1943; United States
Morris Graves (b. 1910)
Tempera and ink on paper; 27½ x 53 in. (69.8 x 134.6 cm)
Gift of Marion Willard Johnson in honor of the museum's 50th year,
83.209

In a secular century Morris Graves has managed to infuse his art with a profound and ecumenical spirituality and mysticism. Based in Seattle in the 1930s and 1940s, Graves, with Mark Tobey and a few other artists, forged a distinct Northwest artistic vision of light and nature. From his landscapes of the 1930s to his still lifes of the late 1970s and 1980s, Graves has conferred a tantric consecration upon the natural environment, animals, and still lifes. In *Message* his incisive line weaves webs of light against dark background. It was painted in the aftermath of two of the most influential experiences of Graves's life: his traumatic enforced military induction, and the acclaim he received upon the first public exhibition of his art at the Museum of Modern Art in New York in 1942. Shortly after it was completed, *Message* was sent as a gift to Marion Willard Johnson, his longtime New York dealer and friend. The image, as Graves's biographer Ray Kass has written, is "intended to represent the progress of the self toward the goal of higher consciousness." One bird hovers in the darkness. The other, larger creature, armed with four sharp horns, stands in the light, experiencing, in Graves's words, "divine self-realization." The work used the same title as Graves's 1937 series of tempera and wax paintings on paper inspired by Northwest Native Americans' trail markers.

Sea Change
1947; United States
Jackson Pollock (1912–56)
Oil paint and pebbles on canvas;
57⅞ x 44⅛ in. (147 x 112.1 cm)
Gift of Peggy Guggenheim, 58.55

Over forty years after their completion, such Jackson Pollock drip paintings as *Sea Change* still have the capacity to astonish viewers with their energy, seeming abandon, and nonobjectivity. Made between 1947 and 1953, this series of arabesque linear paintings and drawings changed the direction of much subsequent art. Pollock's often mural-sized unions of color and line, abstract form and content, process and results challenged the hegemony of cubism as they altered traditional Western artistic concepts of perspective and form. In the late 1940s and the 1950s, Pollock and other abstract expressionist painters and sculptors built upon the automatism and exploration of the subconscious of French surrealists. The frontal black and then aluminum webs of color in *Sea Change* float above a multicolor, pebble-studded underlayer

of seemingly more representational images. Suggestive of his symbol-laden forms of the mid-1940s, these quasi-representations and Pollock's paint skeins read as equivalents of the subconscious and the complex processes of thought itself.

While Pollock's later drip paintings were for the most part simply titled numerically, *Sea Change* and the other paintings in his January 1948, New York gallery exhibition were, with the aid of friends, given descriptive designations. *Sea Change* came from Ariel's song in William Shakespeare's *The Tempest* in which death is evoked as a "sea change into something rich and strange." Pollock gave most of the paintings in this 1948 exhibition to his patron and former gallery dealer Peggy Guggenheim, to whom, for several years, he had relinquished work in return for monthly financial support. A decade later, at the instigation of Seattle art dealer Zoë Duzanne, from her palazzo in Venice Guggenheim sent *Sea Change* to the museum along with four works by other artists.

Electric Night
1944; United States
Mark Tobey (1890–1976)
Tempera on board; 17½ x 13 in. (44.5 x 33 cm)
Eugene Fuller Memorial Collection, 44.78

The jangling intensity of city streets has been a subject of modern artists since the rapid increase in urbanization in the mid-nineteenth century. Mark Tobey found in the city a view of contemporary life seen in terms of light, energy, and dense interlocking patterns of human activity. A master draftsman, Tobey expressed this perceived unity of people and place by means of a rhythmic white line. The line, or "white writing" as he called it, had its source in the fluid rhythms of pressure and release practiced in Asian calligraphy and provided Tobey a new formal means to express spatial unity without the Western conventions of perspective and volumetric construction.

Tobey lived in Seattle during the 1940s, where he sketched the throngs of people who filled the streets and marketplace in wartime. *Electric Night* evokes the experience of not one but several cities — Hong Kong, San Francisco, New York, and Seattle. Like this painting's network of woven line, Tobey himself seemed to draw energy from changing locale, from a pattern of discovery and recapitulation as he traveled from place to place.

How My Mother's Embroidered Apron Unfolds in My Life
1944; United States
Arshile Gorky (1905–48, b. Armenia)
Oil on canvas; 39⅝ x 44⁹⁄₁₆ in. (101 x 113.2 cm)
Gift of Bagley and Virginia Wright, 74.40

Arshile Gorky initiated abstract expressionism but did not live to see its flowering in the 1950s. In the late 1920s and 1930s Gorky had served extended apprenticeships to the styles of Cézanne, Picasso, and Miró before developing his own fluid, personal approach early in 1944. This painting, completed at the end of 1944, is a classic example of Gorky's mature art and the abstract expressionists' capacity to combine spontaneity and careful execution. In such sinuous inter-lockings of colorful, organic shapes, Gorky's art bridged from French surrealism of the 1930s to color-field painting of the 1950s and 1960s. Recent scholarship has explained his curving forms in auto-biographical terms, seeing in these interlocking shapes the outlines of figures and relationships. Gorky himself wrote with passionate inten-sity about his feelings. The embattled history of his native Armenia, his beloved mother's death by starvation there in 1919, his exile to the United States and subsequent illnesses, marital strife, and emotional dysfunction have been seen as the matrix of his abstract designs. Whatever can be detected in his interlocking forms, Gorky's haunting title transforms maternal devotion and harsh realities into lyric memory.

Obos I
1956; United States
George Tsutakawa (b. 1910)
Teak; 23¼ x 9¾ in. (59 x 24.7 cm)
Gift of the Seattle Art Museum Guild, 79.7

From wood of a two hundred-year-old English schooner, which was dismantled in Seattle in the mid-twentieth century, George Tsutakawa has carved a sculpture inspired by an ancient act of thanksgiving and imbued with both a modernist and a traditional Japanese aesthetic of adorned natural materials. *Obos* is the Tibetan word for the ritually placed piles of rocks left by passersby at auspicious sites in the Himalaya Mountains. These cairns are built at mountain passes in thanks for safe passage and at sites such as water sources, where the spiritual energy of the earth is believed to be potently expressed. As a sculptural form, Tsutakawa's *Obos* is concerned with balance and the relationship of solid form to space; its tactile surface and the irregularity of the stacked elements enliven the inert material. Like much advanced painting and sculpture in the United States after World War II, it uses a totemic configuration to invoke a message of universality. Tsutakawa, born in Seattle and educated in Japan and the United States, intends that the sculpture express spiritual as well as physical balance, a harmony of form and content that surpasses specific cultural references.

Fifteen Planes
1957–58; United States
David Smith (1906–65)
Stainless steel; h. 113¾ in. (289 cm)
Gift of the Virginia Wright Fund, 74.1

Beginning in the 1930s, David Smith established himself as the most influential twentieth-century American sculptor. The three themes of Smith's numerous metal sculptures are the landscape, the figure, and geometric abstraction. He first worked as a cubist painter and continued to conceive sculpture two-dimensionally. *Fifteen Planes* started in March 1957 as a small drawing with its rectangular elements positioned in cut-out collage. In the sculpture's tall, two-legged grouping of fifteen planes, geometric abstraction and figuration were even more drolly combined. This work was among Smith's first sculptures made entirely of stainless steel, a material particularly suited to the outdoor installation he favored at his upstate New York studio-residence. The surfaces of his stainless steel plates were brazed in swirling lines to better reflect light, suggest depth, and make them appear less weighty. His freeform drawing mimics the drip motifs of Jackson Pollock's paintings such as *Sea Change* (p. 120). *Fifteen Planes,* both in material and composition, anticipates Smith's final, most famous series of *Cubi* sculptures. As with many of the best *Cubis,* its geometric juxtapositions are strengthened by its sly figurative reference.

Waters
1962; United States
Agnes Martin (b. 1912)
India ink on paper; 8⅛ x 7⅝ in. (20.6 x 19.3 cm)
Gift of Margaret Smith, 84.186

Despite the geometric simplicity of her work, Agnes Martin describes herself as an expressionist. When she talks about lines, it is clear that her inspiration is emotional, not structural, and that the feelings she associates with them are expansive, even ecstatic. Here is Martin's description of emerging from the mountains onto a vast plain that she likened to a straight horizontal line:

> I sort of surrendered. ... I thought there wasn't a line that
> affected me like a horizontal line. Then I found that the more I
> drew that line, the happier I got. First, I thought it was like the
> sea ... then, I thought it was like singing!
> *(ARTnews,* September 1976)

This drawing has the subtlety and refinement of her large, delicately penciled works on canvas. The title states the natural analogy for the work and the clear rhythm of bold and fragile lines pulses like a wave. The mass of horizontal lines has indefinite ends, like a frayed cloth or a retreating tide. The evidence of the human hand is everywhere, creating regularity without forcing an impossible exactitude; creating the intimation of perfection, while acknowledging the human origin of this spiritual abstraction.

Parnassus
1963; United States
Mark Tobey (1890–1976)
Oil on canvas; 82⅛₆ x 46¹⁵⁄₁₆ in.
(208.5 x 119.3 cm)
Gift of the Virginia Wright Fund, 74.41

Mark Tobey's spiritual concerns, linked to his Bahai faith and studies in Eastern philosophy, are evident in his progression from the particular (street scenes, portraits) to the cosmic. In *Parnassus,* titled after the Greek mountain visited by the Muses of poetry and song, the vibrant line of *Electric Night* has become unlinked from its association with the urban scene. The dense linear webs represent a universalization of life force, equally applicable to the city, to man, and to nature. They have the quality of the Chinese calligraphy that Tobey first studied and wrote about in the 1930s: "There is pressure and release. Each movement, like tracks in the snow, is recorded and often loved for itself.... wisdom and spirit vitalized."

While the American art scene exploded with the activity of abstract expressionist painters in the 1940s and 1950s, Tobey lived in Seattle, poised between Asia and New York. He shared the New York School's heritage of European surrealism and primitivism, and with them abandoned illusionistic perspective, cubist grids, and a riveting central focus. But his sensitive cursive line is finely controlled, and his painting and his personality are distinct from the full-bodied bravado of Jackson Pollock, with whom he shares the achievement of transforming line into mass.

Self-Portrait on Geary Street
1958; United States
Imogen Cunningham (1883–1976)
Gelatin silver print; 8 x 6½ in
(20.3 x 16.5 cm)
Purchased with funds from the
Photography Purchase Fund through Mr.
John H. Hauberg, 88.11

Imogen Cunningham lived in Seattle from 1889 to 1917, where she graduated from the University of Washington, worked in the studio of Edward S. Curtis, started her own business as a professional photographer, and gave birth to the first two of her four children. Cunningham made her first photograph, a nude self-portrait, in 1906, and her last shortly before her death in 1976. Her seventy-year career spanned and contributed to many changes of taste and convention in American photography. While she is best known for her voluptuous close-ups of plants and flowers, the archive of thousands of her prints and negatives contains a depth and diversity of experimentation not yet fully appreciated.

In this self-portrait, which suggests in its ominous self-analysis Robert Frost's *Stopping by Woods on a Snowy Evening,* Cunningham layers her own seventy-five-year-old image into a scene of dissolution and chaos. However, even though the lights are literally out in the transparent interior of this old store front, the San Francisco sun streams in, driving out the darkness. This photograph was made at the end of a period of depression and doubt: Cunningham had just received belated recognition with an exhibition at Limelight Gallery in New York and was about to sell a major body of her work to the International Museum of Photography at George Eastman House.

Cunningham worked at the frontier of her art. The collaging of information with shadow and reflection and the splintered, centrifugal composition of this image refer to contemporary abstract expressionist painters and look forward to Lee Friedlander's *Self Portrait* series of the 1960s.

New Orleans, 1968
1968; United States
Lee Friedlander (b. 1934)
Gelatin silver print; 7⅜ x 11⁷⁄₁₆ in.
(18.7 x 28.1 cm)
Purchased with funds from Pacific
Northwest Bell, the Photography
Council, the Polaroid Foundation, Mark
Abrahamson, and the National
Endowment for the Arts, 83.31

All forty-two photographs in Lee Friedlander's 1970 book *Self Portrait* contain unmanipulated combinations of his direct image, his shadow, or his reflection. As a witty continuity, this device purposefully breaks the composition rules of good snapshots and makes the viewer aware that those rules are intended to keep photographs anonymous — these are not anonymous pictures. The lamination of the maker onto the found world in front of the camera also opens questions about how aesthetic decisions are made both in the mind and by the eye.

Most first-time viewers of *New Orleans, 1968* assume that it has been made by means of darkroom trickery. A second look reveals a series of real reflections and ricocheting lines of sight that can be unsettling. It is very hard to begin trying to explain what the flat piece of film and the flat print made from it actually record, and where the viewer must be to read that record. Friedlander is standing on the sidewalk in front of a plate glass window. His camera is held at his chest. Beyond the window, inside the storefront, is a mirror that reflects his image. The cabinet doors and the false brick pattern are also in the room, seen through the window. Everything else is behind Friedlander, reflected in the glass of the window.

Layering information into pictures with the use of reflection and transparency is a way to subvert the easily held belief that the photograph is a mechanical slave to what is simply found. Superficial analysis is difficult, however, when the surface keeps disolving. The front of this photograph has been made to coincide with the surface of the window—it reflects the artist and his tricks that let our vision selectively and slowly pass through to another kind of reflection.

Thermometer
1959; United States
Jasper Johns (b. 1930)
Oil on canvas; 51¾ x 38½ in.
(131.4 x 97.8 cm)
Promised gift of Bagley and Virginia
Wright

Jasper Johns's art begins in the mid-1950s with depictions of commonplace subjects — the American flag, the target, numbers, and alphabet letters. From the start, his selection of images mixed factuality and ambiguity. Johns painted by building up encaustic (warm wax) upon a smooth layer of newsprint paper adhered to stretched canvas. His controlled application of color evolved from abstract expressionism and also signaled its demise. At the end of the 1950s his painting strokes turned more agitated and were more broadly applied. His style moved closer to the gestural abstraction of the abstract expressionists Willem de Kooning and Philip Guston.

Also around 1960, Johns produced a small group of sculptural replications of objects (light bulbs and flashlights) which make up, to this point, the bulk of his output of sculpture. In *Thermometer* he placed a functioning gauge of temperature down the center of his degree-enumerated patches of color. Just as it divides the canvas, Johns's thermometer might be said to measure the heat of abstract expressionism. Johns made a careful graphite drawing of the painting the following year, which was enlivened with a red thermometer gauge that hovered permanently around 76 degrees. In the painting and subsequent drawing of *Thermometer,* Johns's self-referential art achieves one of its most ambiguous yet functionally representational expressions.

Double Elvis
1963; United States
Andy Warhol (1928–87)
Acrylic on canvas, silkscreen;
82¼ x 59⅛ in. (208.9 x 150.2 cm)
Purchased with funds from the National
Endowment for the Arts, PONCHO, and
the Seattle Art Museum Guild, 76.9.1, .2

The parent of pop art, Andy Warhol presides over an era when popular culture and high art have increasingly merged. Beginning with his career in advertising and fashion illustration in the 1950s, Warhol sought means to replicate and stimulate glamour and consumerism. In 1962 he first employed photo silkscreen, and his imagery quickly moved from products to people. With studio assistants, he fabricated serial images and multiple portraits of such "superstar" actors and actresses as Troy Donahue, Warren Beatty, Natalie Wood, Marilyn Monroe, Elizabeth Taylor, and Marlon Brando. Unlike many other celebrities he was to depict, Warhol never met the singer-entertainer Elvis Presley (1935–77). But when Warhol was preparing for his second Los Angeles exhibition in 1963 (his first

public exhibition, of depictions of Campbell's Soup cans, had been held there the year before), he selected the leading stars of the day, Presley and Elizabeth Taylor, as his subjects.

The Elvis paintings were silk-screened on a silver ground and accompanied in many cases with equal-sized blank canvases (suggestive of death and nothingness, film clips, and the process of photography itself). The doubled, silkscreened image was the idea of Warhol's studio assistant Gerald Malenga; Warhol proposed the blank canvases. Presley's over-life-size cowboy image came from his critically successful 1960 film, *Flaming Star,* in which Presley played a half-white, half Native American caught between two cultures. Representative of Warhol's knack for selection, this view of Elvis mixes death and sex, past and present, and American myth and reality. When Warhol sold the painting in 1974, it had just the one imaged panel; a second blank silver panel was made with Warhol's approval in 1976 in Seattle and has been subsequently displayed as part of the work.

The Studio
1977; United States
Jacob Lawrence (b. 1917)
Gouache on paper; 30 x 22 in.
(76.2 x 55.8 cm)
Gift of Gull Industries; John H. and Ann
H. Hauberg; Links, Seattle; and by
exchange from the estate of Mark
Tobey, 90.27

Self-portraits are rare in Lawrence's art, which sprang from the social realism of the 1930s and the vigor of the Harlem Renaissance. Other than a small sketch from 1965, there are two paintings from 1977, the year the artist was elected to the National Academy of Design. One, a smiling, seated half-figure, brushes in hand, Lawrence gave to the Academy. *The Studio,* pictured here, he kept.

This painting depicts the red-orange stair rail, art tacked to the walls and stacked on the floor, carpentry tools, and sculptures by Augusta Savage and Lawrence's wife, Gwendolyn Knight, in their usual places in Lawrence's Seattle studio. But the wall of the neighboring house has been replaced with a cityscape — the New York that remains Lawrence's spiritual home although he moved to the Northwest in 1971.

Lawrence imagines himself ascending a staircase, a pose derived from Charles Wilson Peale's *Staircase Group* (1775). Like Peale's son in the eighteenth-century portrait, Lawrence holds the brushes of his calling in one hand. In the other he balances a compass, symbol of physical labor and metaphysical creativity. The artist's hands, pointing earthward and heavenward, are echoed in a half-hidden painting against the rear wall of the studio, Lawrence's *Human Figure After Vesalius* (1968).

The artist paints himself surrounded by evidence of his history and his production, placing himself in the company of laborers through references to their tools, and of other artists. The work affirms a life made rich and whole through artistic vision.

White Squad II
1982; United States
Leon Golub (b. 1922)
Acrylic on canvas; 119⁷⁄₁₆ x 151¹⁵⁄₁₆ in. (303.3 x 385.9 cm)
Purchased with funds from the Virginia Wright Fund, Camille McLean,
the Contemporary Art Council, Anne Gerber, and anonymous donors,
85.291

In historical paintings depicting war and violence, nobility of cause is often assumed. The painter and the patron identify with the victor, who fights bravely against a strong foe and whose assured triumph is desired.

White Squad II is a painting in the opposing tradition of *Guernica,* Picasso's shattering tribute to the victims of the Spanish town destroyed by a Fascist bombing raid in 1937. Golub presents a coarse and nameless assassin whose victim is helpless and whose triumph, while sure, is abhorrent. The figures are squeezed against the edges of the canvas, with dominance and subjugation as clear as their vertical and horizontal poses. The space between them is focused on a trigger finger poised to shoot. The vast surface of the canvas has been painted, scraped raw, and painted again to create an eroded backdrop that, like Golub's earlier *Napalm* series, appears burnt.

Golub worked consistently in this politically committed, figurative style in the post-World War II years when abstract, formalist, and conceptual art were in the ascendancy. His painting achieved a new prominence in the 1980s when European and American artists returned to the human form and loose brushstroke of expressionism. In comparing his work to that of the German expressionist Georg Grosz, Golub equates their desire to create pictures that are "not contemplative, that could not be assimilated to a comfortable point of view" and to present "an obdurate image, a report—some bad news, perhaps—but so ferocious in style that it couldn't be brushed away, dismissed as mere art" (*Art in America,* December 1982).

Untitled
1984; United States
Susan Rothenberg (b. 1945)
Charcoal on paper; 50⅛ x 38¼ in. (127.3 x 97.1 cm)
Purchased with funds from the estate of Mary Arrington Small, 85.58

Following nearly fifteen years of minimalist art in the United States, around 1974 Susan Rothenberg, along with other artists in Europe and the United States, turned to representational, personal imagery. Rothenberg's initial theme was the horse, outlined and shown in full side view. She employed a gestural paint application to realize a severely reductive motif. Over the next five years she engaged in a formalist autopsy of her chosen prop. Around 1980 she shifted her perspective to a head-on view of the horse and began fragmenting her motif. She then moved on to the human figure and the landscape. Throughout this evolution, drawing was a partner and spur to Rothenberg's fusion of image, process, and variation. In this large-scale work on paper she takes a frontal view of what is likely a male torso (a necktie floats to the left). As with her earlier works she makes the represented motif a pretext for the act of mark-making. She shows the figure's head in front and side view and in two colors. Coalesced, agitated linear strokes can be read as both abstraction and as a portrait of creative and existential frenzy, anxiety, and isolation.

Portrait of a Dwarf, Los Angeles, 1987
1987; United States
Joel-Peter Witkin (b. 1939)
Gelatin silver print, toned; 20 x 16 in.
(50.8 x 40.6 cm)
Photography Purchase Fund in memory
of Garry Wiggs, 89.75

One of the most controversial and innovative photographers of the late 1980s, Joel-Peter Witkin appears to have carefully identified the accepted limits of art photography and systematically violated them all, technically and spiritually. His human subjects are generally well outside conventional norms of physical beauty. He explains:

I want to celebrate the uniqueness of each individual, the part that is invisible. I usually set up a fictional situation that is both new to me and new to them. I try to create the most strongly evocative image possible and then work on the negative and the print to increase its power. The subject sees the final print first. If they say that it rings true about them, especially in ways they hadn't thought of—then it is a good one and I release it. My object is not to demean or exploit but to reveal something new about myself *and* the person.

—From a conversation with the author

Many of Witkin's pictures refer to events in world literature and art and are often religiously oriented. *Portrait of a Dwarf,* however, began as a staged marriage between a twenty-seven inch high woman and a six-foot nine-inch tall man. The original concept was suggested by the Eugene Atget photograph *Fête du Trone* (1925) which contains portraits of a giant and a dwarf, and their respective chairs and shoes. During the course of setting up this portrait, Witkin became fascinated with the intensity and character of the dwarf— an actress who played the character E. T. — and concentrated on her. The addition of the wand, the toy horse, and the vandalized, blindfolded statue provide doorways for our imagination. The emotional uneasiness we may feel when confronted by Witkin's images serves to define with great precision our individual limits of taste and propriety and occasionally reveals how those boundaries were established.

Thicket
1990; United States
Martin Puryear (b. 1941)
Basswood and cypress; 67 x 62 x 17 in. (170.2 x 157.5 x 43.2 cm)
Gift of Agnes Gund, 90.32

Since the early 1970s Martin Puryear has created a series of beautifully crafted and simple, enigmatic objects, mostly fashioned in wood. His art starts with natural forms and the functional essence of basic tools and shelters. It transcends minimalism in its insistence on handcraft and its fusion of form and feeling. In Seattle, Puryear is best known for *Knoll* (1983), his site-specific installation at the National Oceanographic and Atmospheric Administration, Western Regional Center, on Lake Washington.

The form of *Thicket* derived from Puryear's fascination with the shape and mass of a small rock he found on a pivotal trip into the Alaskan wilderness in summer 1980. Here he makes the stone's interior visible, letting "the 'bones' be what the piece was about." He chose basswood for its base and interwove this lightly grained, quite soft, and easily carved wood with cypress. Its dowelled accretion and interpenetrating and proliferating structure give tangible form to one of Puryear's strongest memories of Alaska, an area of low Arctic vegetation he encountered on the 1980 trip. From above, this growth looked quite solid, but beneath, as Puryear studied it on his knees, it was an open, passaged labyrinth and nesting place for the snowshoe hare. This covered haven, with "its thrusts and counter thrusts, its beams, struts, posts, structures upon structures," became, a decade later, *Thicket*.

ART OF THE NEAR EAST

Bowl with *Kufic* Writing
10th century; Iranian
Red clay; diam. 10¼ in. (26 cm)
Eugene Fuller Memorial Collection, 57.18

This handsome bowl is an unusual example of tenth-century ceramic wares from northeastern Iran. Ceramic wares displaying writing in Arabic were produced during the rule of the Samanids, from the late ninth to the early eleventh century. All of the wares with writing on them are red bodied with a white slip ground, on which writing in Arabic is displayed, usually in aubergine-black letters, sometimes in red. The formats for the writing vary, as does the ornamentation of the letters. Phrases run around the rim, cut across the surface; letters are tall and simple, leafed, and highlighted in red. Many of the phrases are general aphorisms, but as recent scholarship shows, many sayings can be attributed to the prophet Muhammad and Imam 'Ali, as well as others of the Imami Shi'a Imams.

What is unusual about this bowl is that the letters are not connected to form words, but are written as individual letters of the alphabet. Because the script is *kufic,* which represents the twenty-four letters of the alphabet by only eighteen different shapes, one letter shape can stand for several different letters. Thus, reading the inscription presents a challenge for us today. Several combinations of these letters form words, but the most probable reading of the phrase on this bowl is: *ya huwa,* Oh God!

Qur'an Page
Early 10th century; North African
Vellum, blue dye and gold; 9¾ x 13⅝ in. (24.7 x 34.6 cm)
Eugene Fuller Memorial Collection, 69.37

This blue vellum page is from an early tenth-century Qur'an pro-
duced in Qairawan (Tunisia). Colored vellum Qur'ans are rare; the
austere *kufic* script of this gold writing in Arabic provides an example
of exceptionally splendid calligraphy. Visual interest and balance is
created on the page by the design which results from the periodic
lengthening of the horizontal letters.

Displayed here are verses from *surah al-baqarah* (The Cow), 2:
109-(part of) 113. This *surah,* one of the most normative ones in the
Qur'an, proclaims the essential elements and actions of Muslim life.
The lines displayed here encourage Muslims to remain faithful to
their submission (Islam) to God, confirming their right to Paradise. It
translates:

> How many of the followers of the Book having once known the
> truth desire in their hearts, from envy, to turn you into infidels
> again even though the truth has become clear to them. But you
> forbear and overlook until God fulfills his plan. God has power
> over all things. Fulfill your devotional obligations and pay the
> *zakat.* What you send ahead of good, you will find with God, for
> He sees all that you do. And they say, "None go to Paradise but
> the Jews and the Christians," but this is only wishful thinking.
> Say, "Bring the proof if you are truthful." Only he who submits
> *(aslama)* to God with all his heart and also does good will find his
> reward with the Lord, and will have no fear or regret. The Jews
> say, "The Christians are not right," and the Christians say . . .

Candlestick
12th or early 13th century; Iranian
Bronze, silver; h. 8¼ in. (20.9 cm)
Eugene Fuller Memorial Collection, 49.156

Produced in Iran, probably in the twelfth or early thirteenth century, this bronze candlestick with silver inlay displays an unusually specific narrative imagery. The images in the large cartouches around the center of the base highlight the trial of courage by which Bahram Gur became king.

Bahram is shown seizing the Sasanid crown from between two lions, an event recorded in the *Shahnameh* as pivotal in the succession dispute following the death of King Yazdgerd, circa 420. In one cartouche Bahram holds the round crown while facing a rampant lion; in another he spears a lion rearing behind his mount. In yet another, he tramples a lion while a bird, representing *farr,* or kingly strength, perches behind him.

Above and below this central episode, enclosed in smaller cartouches, are images of individual musicians playing a variety of string and percussion instruments. These figures probably allude to another incident for which Bahram Gur is famous, namely ordering ten thousand musicians to be brought from the East to play throughout Iran. This famous act was his response to the common people in his empire, who had complained that although the nobles and wealthy could enjoy music, they had none. Bahram Gur is credited with fostering music in Iran, and his image is often associated with those of musicians.

Bird and Scene of Lovers with an Attendant
c. 1629–35; Iranian, Safavid period, c. 1629–35
Riza 'Abbasi (d. 1635)
Colors and gold on paper; 13⁵⁄₁₆ x 8¾ in. (33.8 x 22.3 cm)
Gift of Mrs. Donald E. Frederick, 50.111

This exquisite album page is an assembly of two paintings framed by a separate border. Each of the individual paintings is signed by Riza 'Abbasi, master painter in the atelier of the Safavid shah 'Abbas I. The color intensity and fine brushstrokes manifest in these paintings suggest they were the work of the artist's early career, perhaps from the first decade of the seventeenth century. Collections of album pages rather than illustrated manuscripts were a significant art form for members of seventeenth-century Safavid society. Some album pages were single compositions, whereas this page suggests the influence of the owner in the assembly of the individual paintings and border elements.

The border is composed of ten rhymed couplets from the *Shahnameh,* the epic poem of the mythological and historical kings of Persia. Written in *nastaliq* script, the full couplets, separated by colored ornamental space, begin at the top of the painting. The first two couplets form the top border and then continue sequentially — with one irregularity — clockwise around the painting. The story told is of young Faridun approaching the castle of the evil ruler Zahhaq. The juxtaposition of these couplets with the depiction of a prince suggests an association of the image with the youthful Faridun of the *Shahnameh.*

ART OF INDIA
AND SOUTHEAST ASIA

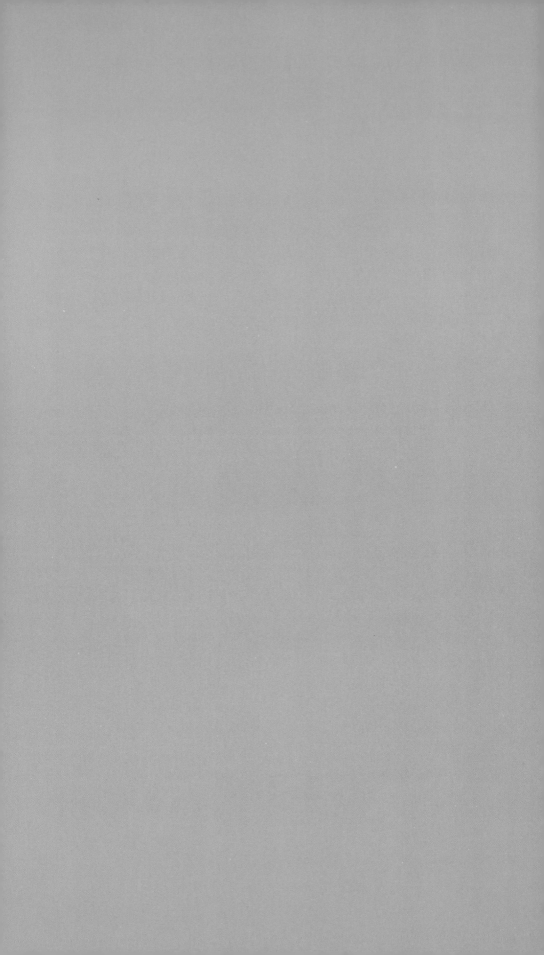

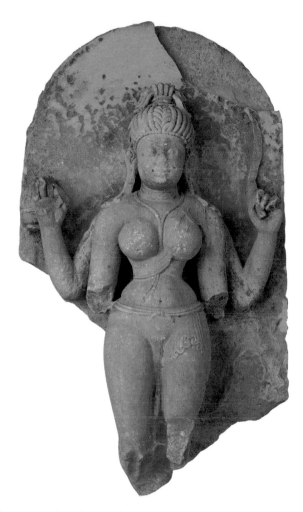

Four-Armed Goddess (perhaps Durga)
c. late 6th century; North-central Indian
Sandstone; 53¾ x 22 in. (136.5 x 55.8 cm)
Eugene Fuller Memorial Collection, 69.23

This voluptuous four-armed goddess is probably a form of Durga, whose ascetic nature is indicated by her coiffure of matted locks, the antelope skin over her left shoulder, and the string of recitation beads she holds in her upper right hand. Sensuous in spite of her asceticism, her body is curvaceous and fleshy, her breasts round and full. Clad in a garment that clings nearly invisibly to her body, except where it falls in delicate pleats across her left thigh, she is adorned with a necklace and a sash, which crosses her torso diagonally. Extremely important in the Indic religious scheme, goddesses are popularly portrayed as consorts of male deities. As a couple, the divine pair represents the universal unity that transcends the apparent duality of the physical world. Some goddesses, such as Durga, attain a status equal to or beyond that of their male counterparts and are the focus of cults in their own right.

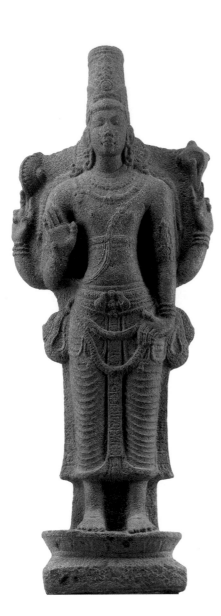

Vishnu
c. 8th century; Southern Indian,
Tamilnadu region
Granite; 68 x 23½ in. (172.7 x 59.7 cm)
Eugene Fuller Memorial Collection,
69.13

Vishnu, the Pervader, functions in the Hindu cosmic scheme as the Preserver of the Universe. In this role, he appears in many forms and incarnations. Here Vishnu is depicted as a royal figure bedecked with jewelry and a crown. Befitting the original function of this image as an icon to be worshiped, Vishnu stands frontally, with no flexion to his body or legs. The four-armed Vishnu can be recognized by two of his well-known attributes. His proper right hand holds the discus and his proper left hand holds the conch. The discus, believed to be a solar symbol, is also a deadly weapon that Vishnu hurls at the enemies of universal order and with its sharp blade destroys them. The conch, Vishnu's war trumpet, is sounded at the start of battle. Vishnu's lower right hand performs the gesture of reassurance or protection to his devotees, while his lower left hand rests against his hip.

Typical of this south Indian stylistic idiom, Vishnu's body is slender, particularly through his torso. The narrowness of the waist is accentuated by the band worn above it and by the contrast of full hips and broad shoulders. The elongated crown is also typical of this southern style.

This figure's nearly life-size proportions suggest that this image may have been a main object of worship in a Hindu shrine or temple. Its schematically rendered back further suggests that in its original setting, the image would have been placed against a wall.

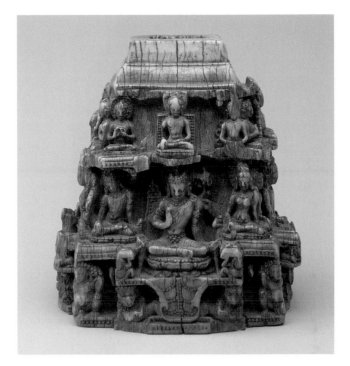

Buddhist Cosmic Diagram (mandala)
c. 9th century; Eastern Indian, probably Bihar, probably Pala period,
c. 8th–12th century
Ivory; h. 4½ in. (11.4 cm)
Eugene Fuller Memorial Collection, 48.166

Although ivory was a popular artistic medium in India, ancient ivory objects rarely survive due to their fragility. This precious example is the only known surviving ivory carving from eastern India from the pre-Pala or Pala period.

The carving is in the form of a three-dimensional mandala. While the term "mandala" literally means "circle," in the broader religious context in India, a mandala is a schematic cosmic diagram and may also be square in shape. This mandala is not only four-sided, but each side is arranged in three vertical tiers. Conceptually, the carving represents a three-dimensional diagram of the cosmic Mount Meru that rises at the center of the Buddhist universe. In its original, complete state, the work may have had a base and would have had some type of finial or crowning element.

At the top center of each side a Jina Buddha presides over one of the four directions. The fifth Jina Buddha may have been implied at the center of the mandala, or may have appeared in the now lost superstructure of the piece. Other figures include additional Buddhas, members of the Buddhist pantheon, and a prominent bodhisattva (Buddha-to-be) in the center of each side.

Although much original detail has been lost over the centuries due to surface wear and damage, the carving displays the richness and elaboration typical of eastern Indian art during the pre-Pala and Pala periods.

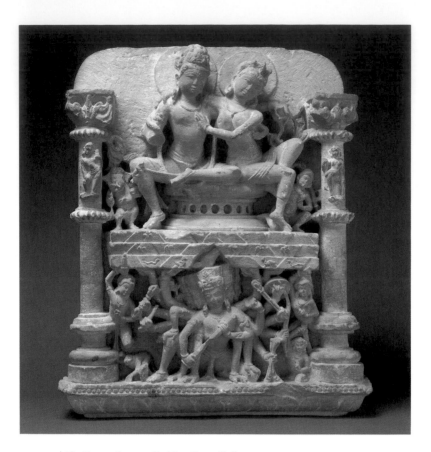

The Demon Ravana Shaking Mount Kailasa
c. 9th century; North-central Indian, possibly Rajasthan
Stone; h. 21 in. (53.3 cm)
Eugene Fuller Memorial Collection, 67.134

The multi-armed, multi-headed demon Ravana crouches beneath the mountain abode of the god Shiva. Shaking the mountain, shown here as a three-tiered crystalline form, Ravana frightens Shiva's consort Parvati. Clinging to her lord for protection, Parvati takes refuge in Shiva, symbolizing the asylum every devotee seeks through devotion to the deity. Shiva's serenity, even when threatened by the forces of evil, demonstrates his omnipotence. Ravana's multiple heads and arms and the powerful weapons he holds indicate that he is a formidable adversary.

Standing at Shiva's knee is the divine couple's elephant-headed son, Ganesha. A youthful-looking male figure near Parvati's legs may be their other son, Karttikeya. The children appear here not as part of this narrative but to emphasize Shiva's harmonious domestic life.

Crisply carved and deeply undercut, the figures and other elements reflect north Indian carving at its best. The tapered, slender limbs create lacelike patterns against the voids in the relief, and the delicate facial features punctuate the composition's multiple centers of interest. The image's rectilinear shape and small size suggest it was probably part of the wall decoration of a Hindu temple dedicated to Shiva rather than a main icon.

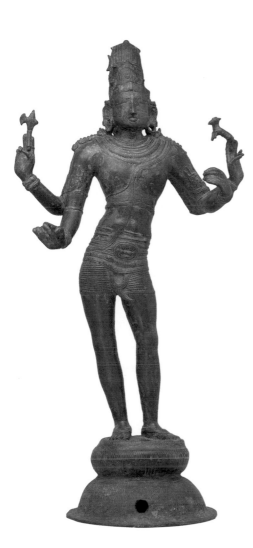

Shiva as Teacher of Music
(Vinadhara-dakshinamurti)
c. 10th or 11th century; South Indian,
Tamilnadu region, Chola period,
c. 9th–13th century
Bronze; 26½ x 8¼ in.
(67.3 x 20.9 cm)
Purchased from the bequest of Charles
M. Clark, 64.55

Portable metal images were important in the increasingly elaborate religious rituals of south India during the Chola period and after. Carried in processions, they served as surrogates for the immovable images enshrined in Hindu temples, allowing devotees the opportunity to gain merit by seeing the deities and having the deities return their glance. In their original contexts as the focus of worship, metal images like this would have been bathed and then clothed and ornamented with jewelry and flowers on a daily basis. Cast of solid metal, the images reflect a sophisticated technology.

Shiva, one of the major deities of Hinduism, is best known in his role as Destroyer of the Universe, a task he performs periodically in order that the universe may be constantly recreated. The god also appears in many other forms. Here Shiva stands atop a lotus pedestal, with his hip thrust to his right. His two front arms are posed as if holding a *vina,* a stringed, lutelike instrument. His back left hand holds a deer, and his back right hand holds a small axe, both common attributes of Shiva in South Indian imagery. As bearer of the *vina,* Shiva is the patron of learning and the arts.

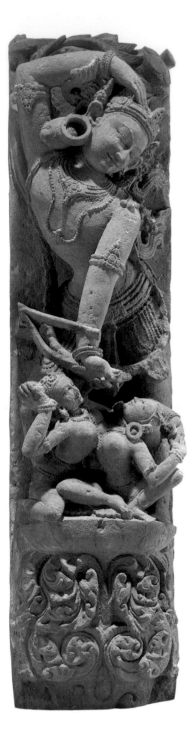

Kama, God of Love
c. 11th century; Indian, Orissa region,
possibly Bhubaneswar
Sandstone; 36½ x 9 in.
(92.7 x 22.9 cm)
Purchased from the Alma Blake and
General Acquisitions Funds, 74.17

Kama prepares to shoot his passion-inducing arrow from the bow in his left hand, while two women, perhaps the objects of his aim, already seem to writhe with passion. His left arm serves as an axis for the composition, linking the foreground and background elements and accentuating the downward thrust of his bow. Smiling serenely, the god gazes down not only at his victims but also at whoever would have seen the image from below its original position, high on the exterior of a temple. Characteristic of the Orissan style are the wide face with pointed features, the broad shoulders, and smooth contours of the body. The elaborate foliate motif at the bottom, the tree behind Kama, and the lavish jewelry create a richly textured surface, which contrasts with the smooth areas of the composition.

As god of love, Kama serves a dual purpose in Hinduism. On the one hand, he is a reminder of the powerful ties to the physical world experienced by all living beings. Thus he is associated with sexual passion and also with life giving and the seasonal renewal of vegetation. At the same time, the passion Kama induces may be understood on a metaphorical level to represent the individual's longing to attain union with the divine, thereby transcending the physical realm.

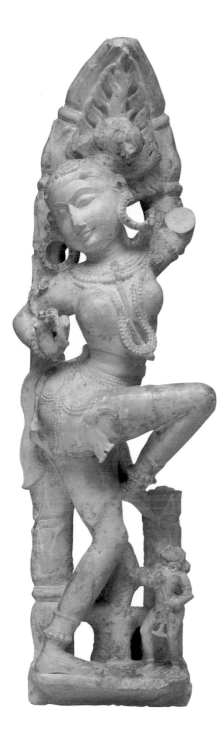

Dancing Girl
c. 11th century; Indian, probably Rajasthan
Marble; h. 39⅝ in. (100.6 cm)
Eugene Fuller Memorial Collection, 64.24

This bracket panel probably once decorated the upper portion of a pillar in a lavishly ornamented temple. Twisting in space so that her body seems to revolve around a spiral axis running from her grounded foot to her turned head, this dancer's joyous movements were intended to honor the divinities of the temple in perpetuity. Her limbs are rodlike cylinders, and the components of her body are juxtaposed in an angular, geometric fashion. Her downward gaze reflects her original position near the ceiling of the temple interior, indicating that the proper vantage point for viewing the composition is from below and slightly to the left.

Beautiful women, richly garbed and sensual in appearance, are commonly depicted as adornments on India's myriad temples. Representing an assertion of life, prosperity, and well-being, such figures express the Hindu religion's joyous acceptance of the physical world.

Conqueror at the Gate of a City
c. 1567–82; Indian, Mughal period,
reign of Akbar, 1556–1605
Page from the *Hamza-nama*; composition
probably by Mir Sayyid Ali and Abd us
Samad
Black ink, water-based pigments, and gold
on gold-flecked paper; 28⅛ x 21¾ in.
(71.5 x 55.3 cm)
Gift of Dr. and Mrs. Richard E. Fuller,
68.160

In about 1567, the ruler Akbar commissioned a vast manuscript devoted to the semi-apocryphal adventures of the prophet Muhammad's uncle. Consisting of twelve unsewn volumes with 1,400 paintings, the work took about fifteen years to complete. This painting is one of about two hundred which survive. The text is written on the back so that the pictures could be displayed while the text was recited.

Mir Sayyid Ali and Abd us Samad, two Persian artists brought to India by Akbar's father, directed the work, but the paintings were executed by artists from diverse backgrounds and trained in both the Indian and Persian traditions. Working together, they laid the foundation for the hybridized Mughal painting idiom. Indian features include bright primary colors and occasional profile faces. Persian elements predominate, including the high, rising ground plane, three-quarter view faces, intricate detail, and rich palette. The typically Persian composition is divided into foreground, middle ground, and background, but there is little pictorial depth. Both text and painting read from right to left: the viewer enters the pictorial world with the visitor at lower right. Even though Indian and Persian stylistic elements are readily identifiable, the *Hamza-nama* paintings display an extraordinarily well-integrated and homogeneous appearance.

Radha Inviting Krishna to Her Bedchamber
1634; North-central Indian,
Malwa School, Rajgarh
Page from an album illustrating the
Rasikapriya by Keshava Das
Water-based pigments on paper;
7¼ x 5½ in. (18.4 x 13.9 cm)
Eugene Fuller Memorial Collection, 51.55

Krishna, the eighth incarnation of the Hindu god Vishnu, was born to destroy his evil uncle, whose tyrannical rule threatened the order of the universe. However, Krishna is most beloved in Indic art and literature for his childhood escapades and the romantic liaisons of his youth. His principal consort, Radha, symbolizes every devotee's adoration of the god, and Krishna's love of Radha demonstrates the god's requited love for his devotees. The late sixteenth-century poem *Rasikapriya,* composed by Keshava Das in 1591, explores the concept of divine love through the para-

digm of the love affair between Radha and Krishna. This painting belongs to a dispersed set of album pages illustrating the poem. The text appears against a yellow ground at the top and bottom and is an integral part of the scheme.

Radha beckons the blue-skinned Krishna to her bedchamber. A peacock perched on the roof symbolizes passion, and the closed lotus bud Krishna holds signifies male sexuality. The lovers gaze intently at one another. Their profile faces with full-front, heavily outlined eyes are characteristic of the Indian style. Also purely Indian is the use of flat, unmixed colors in a limited palette emphasizing red, yellow, blue, green, black, and white. No effort is made to convey the three-dimensionality of the material world. Elements of the composition are simplified and extraneous details eliminated so that nothing distracts from the mood of the lovers.

Buddha
c. 7th century; Mon, Dvaravati period
Stone; h. 43⅞ in. (111 cm)
Thomas D. Stimson Memorial
Collection, with a partial donation from
Hagop Kevorkian, 46.47

Although Buddhism originated in India, the religion quickly spread throughout Asia, where it was widely adopted and practiced in many variant forms. Works of art produced in many regions of Asia were often closely modeled on their Indian prototypes, although local features and aesthetic preferences were also displayed strongly. Although reminiscent of the Indian Gupta style from which it derives, this image epitomizes the Dvaravati School. The downcast eyes and full lips recall Indic models, but the broad face and flat nose reflect local ideals of beauty. The clinging drapery falls smoothly across the body, recalling Gupta prototypes, but the unflexed, frontal stance indicates a departure from the Indic source.

Bodily marks indicating the Buddha's special nature include the protuberance atop his head and the three rings around his neck. His hair is coiffed in neat rows of spiral curls. Unadorned by jewelry, he wears the simple robes of a Buddhist monk. Although the body is abstractly rendered, the softly modeled abdomen suggests a lifelike fleshiness. The broken hands were probably raised to chest level in mirror-image gestures indicating discourse. The gently smiling expression and downcast eyes convey the peaceful, introspective mood.

ART OF CHINA

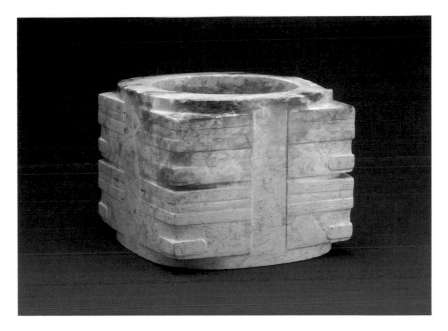

Cong
Chinese, Liangzhu culture, late Neolithic period, c. 2800–1900 B.C.
Jade (nephrite); 2⅜ x 3 x 3 in. (6 x 12.7 x 12.7 cm)
Gift of the Foster family in memory of Albert O. Foster, 88.112

The majority of the Neolithic jades found along the lower reaches of the Changjiang (Yangzi) River are associated with the Liangzhu culture. These jades are frequently decorated with masks, birds, human figures, or abstract designs, which may be cut through the surface, fashioned in relief, or incised on the surface; cut or relief designs are also frequently enhanced by incised lines.

Typical of many Liangzhu *cong*, this piece is decorated with masks arranged on the four corners of the piece. Each corner has two bands of design for a total of eight masks. The eyes of each mask are indicated by a smaller circle cut inside a larger one; two short horizontal lines are cut at the outside edge of each of the larger circles. The nose of the mask is indicated by a slightly raised area below the eyes; additional details of the nose are indicated by fine lines cut into the surface of this raised area. The jade of this *cong*, originally a light and translucent green, has altered in the course of its long burial to a soft white with some green and yellow inclusions.

Traditionally the *cong* has been described as the symbol of the earth, and the *bi*, a flat disk with a circle cut from the center, the symbol of heaven. Recent studies of the *cong* have suggested that the masks may be associated with the four intermediary directions, thus supporting the traditional association of this object with earth. However, not all Neolithic objects of this shape have four masks; some examples have three, and some are round rather than square. There is evidence that some of these objects were bracelets.

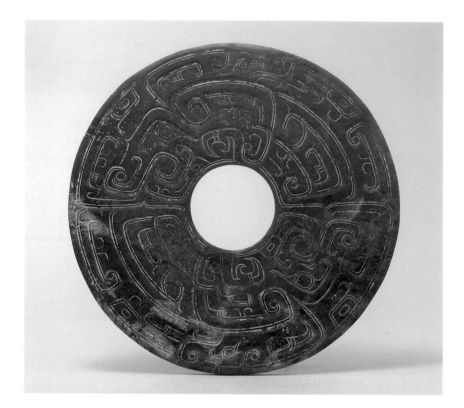

Disk *(bi)* with Dragon Designs
10th–8th century B.C.; Chinese, Western
Zhou dynasty, mid-11th century-771 B.C.
Mottled opaque green and brown jade
(nephrite); diam. 9⅝ in. (24.5 cm)
Eugene Fuller Memorial Collection,
39.11

Jade is a hard stone that cannot be carved; it is worked by abrasion, mainly with saws and drills. Even in later times, after the development of tools which employed diamonds, hardened steel, or corundum, working jade was complex and time consuming; in the Neolithic and Bronze ages the process was extraordinarily difficult. In these early periods, abrasive sands hard enough to cut jade, such as crushed garnets, were applied to string saws and bamboo drills, and the surface of the stone was slowly shaped. Many lengths of string and sections of bamboo were consumed to finish a single piece. Despite such difficulties and limitations, the evolution of surface decoration on jades followed closely similar developments in other media.

This large *bi* is decorated on both sides with paired dragons. Similar to decoration on contemporary bronzes, these design elements are scattered and abstracted, and it is difficult to recognize the animals' forms. The dragons are placed head to tail: the head of each is indicated by a long curling snout, a hooked lower jaw, and a large round eye, followed by a single claw and the creature's tail. They also have large plumes, which appear mainly as elaborate abstract designs along the outer ring of the *bi*.

String saws were used to cut this thin disk from a larger piece of jade. All designs are cut below the level of this original cut. Their three-dimensional quality is achieved through a technique unique to the Western Zhou period. One side of each design is cut away with a beveled edge that ends abruptly at the motif; the line formed by this edge is paralleled by a second, thinly cut line, creating the impression that the design exists in three dimensions.

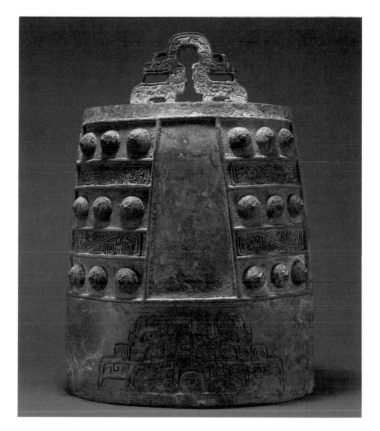

Bell (bo zhong)
Late 7th–early 6th century B.C.;
Chinese, Eastern Zhou dynasty, mid-
Spring and Autumn period, 771–480 B.C.
Bronze; h. 15⅜ in. (39 cm)
Purchased with funds from the Asian Art
Council of the Seattle Art Museum and
friends, the Margaret E. Fuller Purchase
Fund, and the Eugene Fuller Memorial
Collection, by exchange, to honor
Henry Trubner, Senior Curator Emeritus,
87.43

The bronze ritual bells of the Zhou dynasty were suspended by a handle from a frame and were played by striking the bottom section with a wooden mallet or pole. Because of their elliptical cross section, each bell produced two distinct notes, one when struck near the center of the lip and the second when struck near the outer edge. By the late Western Zhou (9th-8th century B.C.), these notes were generally separated by a major third. Sets of bells ranged in number from five to as many as sixty-four and had a musical range as great as five octaves. The difference in notation from bell to bell was determined by size: the smaller the bell, the higher the two notes it produced. As part of an orchestra that included drums, various zithers, pan pipes, and stone chimes, such bells played a major role in the court and ritual music of the time. Literary evidence indicates that these instruments were also played purely for pleasure.

Function dictated the form and placement of decoration on these bells. To avoid interfering with the playing surface and to allow for proper tuning, only the bosses, which influence the duration of the note and the range of overtones, and the suspension system are in high relief; other decoration is limited to low relief or intaglio. The decoration on this large flat-bottomed bell is largely abstract but retains recognizable dragons and felines. Stylistic comparison with similar examples from datable tombs places this piece in the late seventh to early sixth century B.C.

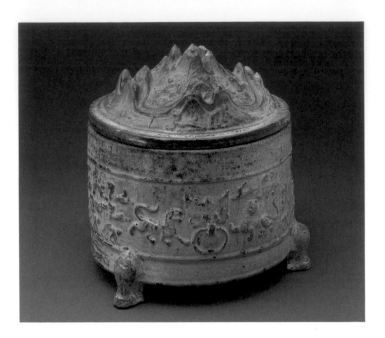

Covered Vessel
Chinese, Eastern Han dynasty, 20-220
Pottery with lead glaze; h. 8½ in. (21.5 cm)
Eugene Fuller Memorial Collection, 51.199

The Five Elements Theory was a major feature of the cosmology of the Han dynasty. This pseudoscience/religion divided the universe into the four cardinal directions and the center; an animal and an element was associated with each. A precise knowledge of astronomy and a working compass were necessary to make prognostications and to interpret the portents indicated by the alignment of stars and the relationships of the elements and directions. These prognostications and portents determined diverse activities, ranging from the proper orientation of palaces or even individual rooms to guarantee luck, health, and fortune, to the loss of the Mandate of Heaven and the end of a dynasty. Included in the Five Elements Theory were the Five Sacred Mountains, one associated with each of the cardinal directions and one in the center. It has been suggested that the theme of the top of this type of covered vessel, which consists of four groups of smaller mountains flanking a large central peak, is the Five Sacred Mountains. Another suggestion is that the top represents one of the Mountains of the Immortals, in particular Mount Penglai or Mount Hua.

Firing upside-down has caused the thick green lead glaze on this vessel to run and pool on the peaks of the mountains, accentuating their forms and partially covering the many animals and trees found on their sides. The vessel's body is also decorated with animals, including tigers, monkeys, rabbits, and deer as well as a mounted archer. Animal masks with rings in their mouths appear on each side of the vessel, indicating that it is made in imitation of a bronze form. Green-glazed ceramic vessels of this type were made for burial in the tombs of the Han dynasty.

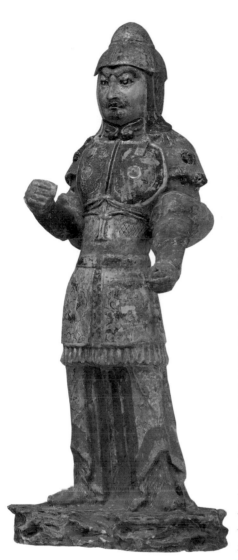

Warrior
Late 7th century; Chinese, Tang
dynasty, 617–906
Pottery with straw-colored glaze,
polychrome, and gilt; h. 27½ in.
(69.8 cm)
Eugene Fuller Memorial Collection,
35.6

This warrior belongs to a group of Chinese ceramic funerary sculptures. The white-bodied figures are all of about the same size and have considerable amounts of pigment applied over the glaze. Representing a distinct non-Chinese racial type, these figures have the typical heavy frowning brow, rounded

eyes, and mustaches and beards of certain Central Asian nomadic groups living on the northwest border of China during this period.

The competence of these foreign warriors and their strange and often menacing demeanor made them ideal guards, both in real life and as sculptures in funerary and Buddhist arts. Armored foreign guardian figures were standard in art of the Six Dynasties and the Tang (4th–5th century). In funerary sculpture, guardians were generally placed in niches along the passageway leading to the coffin and served to protect the spirit of the deceased, and perhaps acted as envoys, leading the spirit to paradise.

Datable to the late seventh century by comparison with recently excavated examples, this warrior has the heavy furrowed brow, fierce eyes, high cheek bones, and beard of the people from the vast deserts, grasslands, and mountains west of China. The nomadic or semi-nomadic people from these regions were among the fiercest warriors of the time, possessing advanced armor and fighting techniques evolved from their own lifestyle and their contacts with other cultures. This warrior's armor reflects the height of contemporary development. The helmet appears to have a metal frame combined with flexible mail. The body is protected by plaques in front and back as well as a combination of mail and lamellar armor which provided protection and flexibility. The epaulets are in the form of two tigers, with a tiger skin at the back, indicating this sculpture may represent a member of a particular guard.

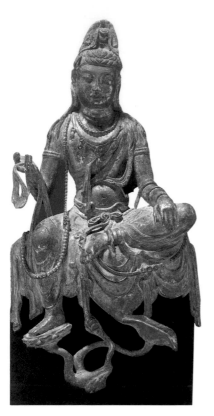

Seated Bodhisattva Avalokitesvara
8th–9th century; Chinese, Tang
dynasty, 617–906
Gilt bronze; h. 10⅜ in. (26.4 cm)
Purchased with funds from the bequest
of Mr. and Mrs. Archibald Stewart
Downey, 53.79

During the Tang dynasty, a period of great cultural confidence in China, foreign people with their religions and philosophies, artistic styles, music, and dance were readily accepted; their influences were woven into the fabric of Chinese life. Buddhism, a religion that had entered China from India some centuries earlier, flourished during the early and middle Tang, and monuments ranging from the enormous stone Buddha and attendants at the Longmen caves near Luoyang to this intricate bodhisattva in gilt bronze were created in great numbers. The sensuous styles of Gupta India were the ultimate source for the soft, feminine body and its relaxed pose, the large areas of exposed flesh, tight-fitting garments, and extensive jewelry of this bodhisattva.

The bodhisattva is a figure of divine mercy in Buddhism. Although male in their original Indian form, many bodhisattvas took on feminine characteristics in China, partly in response to the sensuous quality of the Indian prototypes, but also in response to the desire of the Chinese to depict a figure of compassion. The most popular bodhisattva in China was Avalokitesvara (*guanyin*), an attendant of the Amitabha Buddha. The front of this figure's elaborate headpiece is flattened and has two sockets, indicating that it perhaps once held an additional attribute. Sculptures of Avalokitesvara frequently have a small figure of Amitabha in this position, and it is likely that this figure represents this bodhisattva.

This sculpture is a remarkable example of the bronze casters' art. Very fine surface details such as the curling hair, long flowing ribbons, and bead necklaces as well as sensuous qualities of the face, hands, and feet are carefully rendered. Small sockets in the necklaces once held inlays of colored glass or stone. A certain stiffness in the depiction of the chest and torso of this figure and an emphasis on the rhythmic surface ornamentation indicate a date in the late eighth or ninth century, characteristics that prefigure developments seen in Buddhist sculpture of the Song dynasty.

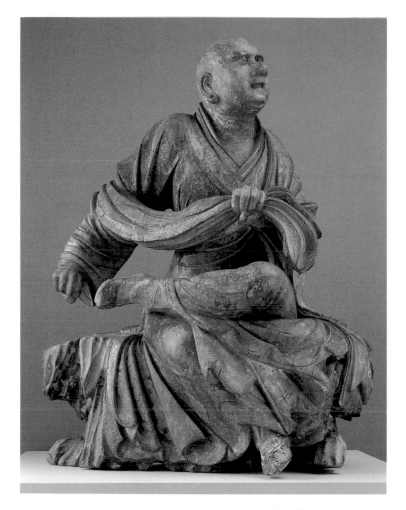

Monk at the Moment of Enlightenment
c. 14th century; Chinese, late
Yuan–early Ming dynasty
Wood with polychrome decoration;
h. 41 in. (104.1 cm)
Eugene Fuller Memorial Collection,
36.13

Largely aniconic, Chan (Zen) Bud dhism emphasizes meditation and other religious practices that offer an escape from the often-threatening mundane world. Ink painting was considered an aid to Chan meditation, and therefore such works have survived in some numbers. There was no established sculpture tradition in Chan, however, and surviving Chan sculpture is extremely rare. The content of such sculptures is often surprising and dates and iconogra- phy are unclear. This polychrome wood sculpture of a monk is an example of such a piece. The monk's figure is won- derfully dynamic, with a strong twist in the body, an out-thrust arm, and flowing drapery. The face is very expressive but physically unattractive, particularly from the standpoint of Chinese aesthet- ics. Its large broad nose, heavy eye- brows, protruding eyes, and thick lips must represent a non-Chinese and also reflect a lack of concern with physical beauty, a tenet of Chan. No other figure of this type is known, and therefore it is difficult to determine its exact signifi- cance or date. Based on comparison with other wooden sculptures, this piece has tentatively been dated to the thirteenth or early fourteenth century.

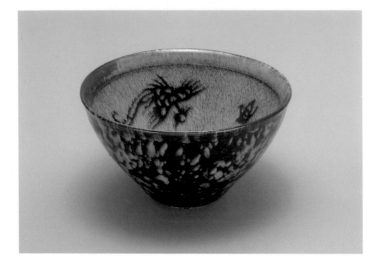

Tea Bowl
Chinese, Song dynasty, 960–1279
Jizhou ware, stoneware with iron glaze; diam. 5⅛ in. (13 cm)
Thomas D. Stimson Memorial Collection, 36.6

The potters at the Jizhou kilns in Fujian province during the Song dynasty freely experimented with new techniques in glazing and design. The wares they created have warmth and spontaneity combined with a high degree of technical virtuosity. The artist placed paper cutouts of a phoenix, butterfly, beetle, and plum blossoms on this bowl's interior before applying the glaze. When fired, these designs emerged in black. The exterior is covered in a "tortoise shell" pattern, which was accomplished by applying a very thick iron-rich glaze over an iron-rich body. The iron precipitated irregularly during firing to form the mottled brown and black appearance.

The Jizhou kilns specialized in bowls, which were commissioned in large numbers by the practitioners of the tea ceremony in the Chan temples of southern China during the Southern Song dynasty (1127–1279). These bowls are still highly treasured by collectors of tea implements in Japan. Connoisseurs valued the slight roughness at the edge of the rim of the bowl; the warm, rich outer glaze; and the sudden appearance of the designs as the tea was drunk.

Buffalo and Herdboy
12th–13th century, Chinese, Song dynasty, 960–1279
Album leaf, ink, and slight color on silk; 11 x 11⅛ in. (27.9 x 28.2 cm)
Thomas D. Stimson Memorial Collection, 48.208

This small album leaf contains many of the elements that typify Chinese painting of the Southern Song dynasty (1127–1279). During this period it was common for painters to suggest space by placing the majority of the elements of their work to one side of the painting, allowing untouched, or a slightly inked surface to suggest empty, misty space. In this album leaf, the trees, buffalo, and herdboy are all in the right two-thirds of the painting, and all are moving toward the space at the left. Psychologically this composition provides a sense that the work continues into the space beyond the painting.

By the Song dynasty, painters had a range of appropriate brushstroke techniques and ink effects available to suggest the nature of the various parts of a painting. In this album leaf, a minimal number of strokes develops the ground line yet preserves a believable sense of grass, small plants, and continuing space. The background trees are cursorily done in broad strokes and wet ink, with a few quick strokes for leaves, but effectively suggest a grove of willows or other deciduous trees.

Close observation of natural detail was also an important aspect of Song dynasty paintings of animals and flowers and birds, here shown in the sense of solid mass and slow plodding movement in the ox. Each hair and detail of this animal is carefully developed in fine brushstrokes. In contrast, the herdboy and his bird are done in rough, choppy strokes, an effective depiction of the boy's ragged garb and the aggressive nature of the bird.

Large Plate
Mid-14th century; Chinese, Yuan
dynasty, 1279–1368
Porcelain with underglaze blue and
molded decoration; diam. 18½ in.
(47 cm)
Purchased in memory of Elizabeth M.
Fuller with funds from the Elizabeth M.
Fuller Memorial Fund and from the
Edwin W. and Catherine M. Davis
Foundation, 76.7

The final overthrow in 1279 of the moribund Southern Song court by the Mongols of the Yuan dynasty led to a period of rapid development in many Chinese arts and crafts. Nowhere is this more apparent than in the development of underglaze blue-and-white decorated porcelains from the Jingdezhen kilns in Jiangxi province. At these kilns there was the happy coincidence of an industry that was well developed but had yet to be fully challenged, a ready supply of raw materials including porcelain stone (a form of decayed granite used in the body), and imported supplies of cobalt for the underglaze blue decoration. In addition, a vast market for large-scale works decorated in underglaze blue was already established, and governmental structure encouraged this enterprise.

Although underglaze decorated blue-and-white wares are often regarded as the quintessential Chinese porcelain, their first major market was the Muslim merchants living in various cities in southern China. These merchants commissioned the pieces and shipped them to markets in the Middle East; they also arranged for a continuous supply of high-quality cobalt. These underglaze painted porcelains were a departure from early ceramic traditions. Early porcelains had relied on form, carved or molded surface patterns, and the colors of glazes for decoration; painterly effects were limited, appearing largely on the northern Cizhou and southern Changsha stonewares, and had not been seen at all in porcelains. These new underglaze-blue decorated wares thus had the potential of changing the emphasis of ceramic design from shape and form to surfaces for painting. However, this transition did not exclude earlier techniques; the strongest of fourteenth-century and later porcelains have a harmonious blend of form and painting.

This large plate is typical of a group dating to the mid-fourteenth century. Its large scale and elaborate foliate rim indicate it was created for the Middle Eastern market. The decorative scheme, however, is largely Chinese in content. The underglaze painted designs are combined with molded flowers and vines, creating a rich and varied surface typical of pieces of this period.

Box
Early 15th century; Chinese, Ming
dynasty, 1368–1644
Lacquer on wood base; diam. 5¼ in.
(13.3 cm)
Eugene Fuller Memorial Collection,
51.102

Lacquer is a durable, impervious finish refined from the sap of the treelike shrub *Rhus verniciflua*. It has been employed by the Chinese to protect and decorate containers and furniture of wood, fabric, and other fragile materials from at least as early as the Hemudu culture of approximately 3000 B.C. Raw lacquer is highly caustic; thus only a limited number of very stable pigments can be used with it. The vast majority of lacquers are red, black, or yellow.

Lacquer, applied in a viscous state, can be used to coat objects with elaborate shapes or carved surface decoration. From very early times the Chinese fully exploited its plastic quality. The carving of built-up lacquer (rather than the wood substrate), however, presented challenges that were not resolved with complete success until the Song or Yuan dynasty (12th–14th century). In order to cure properly, lacquer must be applied in thin layers; each must set and then be dressed with an abrasive before adding the next layer. In the most complex examples, such as this box, as many as two hundred layers were applied before carving could begin.

The length of time and amounts of material required to create carved lacquer wares restricted their use to an elite few. Many of the finest Ming carved lacquers have imperial marks indicating that they were made in workshops under imperial supervision or were intended for imperial consumption. Four gold-filled characters carved into the black lacquer base of this box identify it with the Xuande emperor (1426–35) of the Ming dynasty. This mark almost completely obscures a smaller four-character mark of the Yongle emperor (1404–24). Therefore we can assume that this box was created during the reign of the Yongle emperor and was so treasured that the Xuande emperor applied his mark as well.

River Landscape with Towering Mountains
Dated 1561; Chinese, Ming dynasty, 1368–1644
Wen Boren (1502–75)
Hanging scroll, ink and slight color on paper; 50⅝ x 15⅛ in. (128.6 x 38.4 cm)
Eugene Fuller Memorial Collection, 51.133

The full development of the literati schools of painting was one of the principle art movements in China during the Ming dynasty. Painting as an avocation rather than a profession, literati artists were in general well educated scholars who sought careers in the official bureaucracy or who lived in retirement. Their paintings were usually created in ink, or ink and slight color, on paper and were interpretations of styles of admired masters of the past.

The major literati school of the early and middle Ming dynasty was centered in the wealthy and sophisticated city of Suzhou. Known as the Wu School (after Wuxian, the Ming dynasty name for the area around Suzhou), this group of artists was most influential during the late fifteenth and the sixteenth centuries, when painters such as Shen Zhou (1427–1509) and Wen Zhengming (1470–1559) were active. Wu School artists are noted for paintings done in fine and detailed brushwork, a subtle use of color, a shallow spatial development, and, in hanging scrolls, a narrow vertical format. Eclectic in their borrowing of past styles, the finest of these artists were able to create powerful works through synthesis and individual interpretation.

In later generations Wu artists tended to be overly reliant on a set vocabulary of styles and forms. Wen Boren was one of these later-generation artists. The nephew of Wen Zhengming, Wen Boren is reported to have been a difficult young man and was once jailed over a lawsuit with his uncle. This event seems to have sobered him, and he matured to become a respected artist. Typical of many of Wen Boren's paintings, this landscape has a narrow vertical format and is crowded with detail, making it difficult to read as a unified work. Rather, the artist has assembled a group of images—the foreground scene with the scholar's hut, the body of water, the tall background mountain — into a single painting. In keeping with Wu School traditions, the brushwork is very fine with a light touch, and the colors are gentle and subdued.

Pair of Round-Cornered Cabinets
16th–17th century; Chinese, Ming
dynasty, 1368–1644
Yellow rosewood *(huanghuali)*;
72 x 37 x 20 in. (182.8 x 93.9 x 50.8 cm)
Sarah Ferris Fuller Memorial Collection
and an anonymous donor, 89.20.1,.2

Although lacquered softwoods, fruit-woods, bamboo, and other materials were used extensively for furniture during the Ming dynasty, the majority of surviving examples were made of varieties of exotic hardwoods found in southern China or imported from Southeast Asia. Due to strict trade regulations, these exotic woods were rare in China during the early part of the Ming. Contemporary accounts indicate that supplies increased dramatically following the relaxation of trade regulations and continued to be plentiful until the confusion of the final years of the Ming.

This fine pair of cabinets can be dated stylistically to this period, or perhaps slightly earlier. Made of one of the most valued of the imported hardwoods, *huanghuali* (literally, yellow pear wood, actually a rich honey-colored rosewood), these cabinets are masterpieces of joinery and design. Their sides taper slightly from bottom to top, making for complicated joinery where the angled sides meet the horizontal top and bottom, and requiring precision in designing the doors to hang properly and to meet perpendicular in the center. The cabinet frames are constructed with mortise-and-tenon joins; some of the tenons are exposed. The panels are suspended in the frames by means of tongue-in-groove construction. This joinery combination has the advantage of strength and allows the wood to expand and contract with changes in temperature and humidity without splitting or checking. Because this construction did not require gluing, it was quite simple to disassemble even large pieces for easy moving.

The Chinese house did not have closets, and cabinets of various sizes took their place to store clothing, art, books, and other materials. The central stile in these cabinets made it possible to lock them securely; in place, the stile prevented rolled paintings and calligraphies from falling out, and it could be temporarily removed to allow for ease in storing large garments. A single shelf and a pair of drawers in each cabinet provided additional flexibility.

The kilns at Yixing produced a fine reddish brown, high-fired pottery which was found to be perfect for the type of tea preferred by the Chinese scholar gentry of the late Ming and Qing dynasties. Slightly porous, the bodies of these ceramics absorb the essence of the tea, adding to the subtle depth of flavor of successive brews. Whereas earlier forms of tea in China and the teas commonly used in the tea ceremony in Japan were finely powdered and mixed into hot water, the tea used by the Chinese literati was cured and steeped in a teapot. In keeping with the tastes of the scholar gentry and the way in which they were used, the majority of Yixing teapots tend to be small in scale and naturalistically shaped.

Shi Dabin, one of the best known of the late Ming potters at Yixing, was said to have been an elegant man of severe tastes, traits reflected in his tea vessels. He reputedly visited the city of Songjiang during his early career and there discussed the use of tea with the literati artist Chen Jiru. Following these discussions, Shi Dabin began to make small teapots that suited literati taste and use. Much of his personality and the requirements of his patrons are displayed in the small-scale elegance of this melon-shaped teapot, which he signed and dated the spring of 1596.

The teapot by Chen Mingyuan is elaborately sculpted yet perfectly balanced. It shows the extremes to which the Yixing potter was able to take his craft in order to satisfy the desires of his patrons to have tea wares in naturalistic shapes.

Bowl
Chinese, Qing dynasty, reign of the Yongzheng emperor, 1722–35
Guyuexuan type, porcelain with overglaze enamel decoration;
diam. 6⅜ in (7.6 cm)
Eugene Fuller Memorial Collection, 33.55

Imperial supervision of the porcelain kilns at Jingdezhen in Jiangxi province was re-established during the Kangxi reign (1672-1722) after a hiatus at the end of the Ming dynasty and the early years of the Qing. The Kangxi emperor reorganized the imperial kilns with two levels of production: those producing high quality goods made for court use were directed by a supervisor appointed by the emperor, while others made wares for domestic use or for export. There was a distinct difference in the quality of materials produced at these kilns. By the end of the Kangxi reign and the following Yongzheng reign (1722–35), the groups of talented craftsmen, gathered under the inspired leadership of three successive superintendents, Cang Yingxuan (1682–1726), Nian Xiyao (1726–28), and Tang Yin (1728–53), were producing refined wares which many consider the height of Qing-dynasty porcelain design and decoration.

Many of the finest imperial wares of the Qing dynasty were decorated in overglaze enamel, and this is certainly true of those of the Kangxi and Yongzheng periods. During the reign of the Yongzheng emperor a new enamel palette was introduced. Known as "famille rose," these enamels included a range of pinks created by the use of colloidal gold as well as the use of an opaque white mixed with other pigments, providing a broad range of subtle differentiations in color; both techniques were introduced through European influence.

Among famille rose enamels is a smaller group known as *guyuexuan,* which are perhaps the ultimate in refinement. In this group, enamels are delicately applied to the finest of porcelain bodies. Designs include flowers and birds as well as landscapes and frequently reveal European influence. Landscape scenes are usually accompanied by poetic inscriptions in black followed by seals in red, as seen in the individual scenes on this bowl. This bowl has a four-character mark of the Yongzheng emperor in blue enamels on the base and is a fine early example of the type.

Bowl in the Form of a Lotus
Late 18th century; Chinese, Qing dynasty, 1644–1911
Jade (nephrite); diam. 6⅜ in. (16.1 cm)
Eugene Fuller Memorial Collection, 33.79

Jade has been valued by the Chinese since the Neolithic period, but it is rare in China proper; the vast majority of this material was either imported or found in alluvial flood plains. During the reign of the Qianlong emperor (1736–95) of the Qing dynasty, sections of Central Asia, including areas in which there were substantial deposits of jade, were brought under Chinese control. Direct access to these sources led to an enormous increase in the supply of jade in China, and the Qianlong reign is justly recognized as a period when jade-working flourished.

Along with this new supply of jade came an influx of Muslim craftsmen, many trained in the styles of the Mughal court of India. The Qianlong emperor was favorably impressed with their talents and placed them in positions of responsibility in the imperial workshops. Their influence on the decorative style of jades can be seen in vessels such as this bowl in the form of a lotus blossom.

Lotus-shaped bowls are known in Chinese art from the Tang dynasty (617–906), where they appear in silver and ceramics. The form continued to be popular in the decorative arts of the Song dynasty (960–1279) and later. The highly detailed sculptural quality of this lotus bowl makes it difficult to determine where it was actually carved. Although the outer petals are not pointed like real lotuses, layers of petals of various sizes and thickness are depicted with veins like the blossom itself. This degree of naturalism is not common in Qing vessels and may suggest the hand of Muslim craftsmen. Yet certain stylistic details, such as the way the foot is cut, suggest Chinese workmanship, and it is likely that this bowl was fashioned at the Qing palace workshops under Muslim influence.

ART OF KOREA

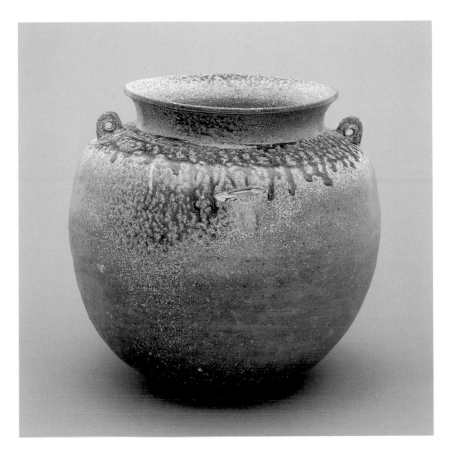

Globular Jar with Two Lugs
c. 5th century; Korean, Three Kingdoms
period, 57 B.C.–A.D. 668, Kaya
Kingdom
Gray stoneware with splashes of
natural ash glaze; h. 11½ in. (29.2 cm)
Gift of Frank S. Bayley III, 89.180

A container for foodstuffs, this jar was made for use by the living but might well have been included in a tomb as part of a funerary offering. Made in southeastern Korea, the pot is unglazed, though it displays generous splashes of accidental ash glaze around the shoulder, and it is devoid of surface decoration except for the fortuitous potting marks that appear throughout. Its aesthetic appeal derives from its immediacy, its robust proportions, and its full, taut forms. The two lugs at the shoulder enliven the shape, though they are too frail to have functioned as handles; perhaps they once anchored a cord that secured a cover, or

perhaps they served simply to ornament the rather austere form. The rounded bottom, which slumped a bit in firing, suggests that this well-preserved archaeological specimen most likely rested in a depression in the soil or stood on a ceramic stand made expressly for it.

Although the first great wave of Chinese influence reached the Korean peninsula during the Three Kingdoms period, Korean ceramics of the time show little if any Chinese influence. Buddhist painting, sculpture, and architecture of the period reflect strong Chinese influence, however, doubtless because the Koreans borrowed the forms from China and preferred to work in the Chinese idiom. Perhaps because Korea had a long and vibrant ceramic tradition, Three Kingdoms-period potters and their patrons saw little need to seek inspiration from abroad.

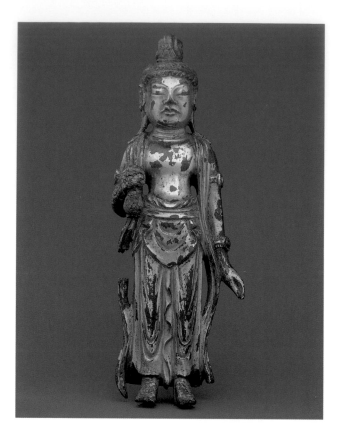

**Standing Bodhisattva Holding a Vase
(probably Avalokiteśvara)**
8th century Korean, Unified Silla dynasty,
668–935
Gilt bronze; h. 7½ x 2⅝ in. (19 x 6.6 cm)
Eugene Fuller Memorial Collection,
56.116

This image represents a Buddhist bodhisattva, a benevolent being who has attained enlightenment but who has postponed entry into final nirvana in order to help other sentient beings gain release from the *samsara* cycle of birth and rebirth. The vase in the figure's right hand suggests that the image may represent Avalokiteśvara (Korean, Kwanseŭm posal), the bodhisattva of compassion and one of the most widely worshipped Buddhist deities in East Asia. Bodhisattvas were typically presented in the guise of an Indian prince wearing a long *dhoti* (a rectangular piece of cloth wrapped about the waist and legs), a silken scarf, a wealth of jewelry, and an elegant coiffure, sometimes

with a crown; this bodhisattva doubtless originally had a removable crown that encircled the high chignon. Very much in the Chinese idiom, this image reflects the Tang-dynasty (618–907) interest in idealized, naturalistic forms, seen here in the well-modeled torso, in the beautifully serene face, in the articulation of individual strands of hair above the forehead, and especially in the tendency of the drapery to reveal the structure of the body it covers. With its large head set atop a short, narrow-shouldered body, the proportions, more than any other element of style, identify this image as Korean rather than Chinese. The sculpture is hollow and, in typical Korean fashion, has a circular opening in the back of the head and a larger, almond-shaped one in the back of the torso. Above and below the larger aperture are small tenons that originally secured a mandorla, now lost. The pinkish color of the gold may have resulted from modern cleaning.

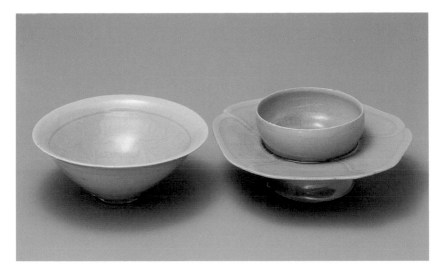

Bowl
Late 11th-early 12th century; Korean, Koryŏ dynasty, 918–1392
Light gray stoneware with celadon glaze over incised decoration;
diam. 4¾ in. (12 cm)
Gift of Douglas J. Stimson, 59.29

Cupstand with Foliated Rim
First half of the 12th century; Korean, Koryŏ dynasty, 918–1392
Light gray stoneware with celadon glaze over carved decoration;
h. 2⅛ in. (5.3 cm)
Thomas D. Stimson Memorial Collection, 48.58

Building on their highly sophisticated native stoneware tradition, Korean potters began to experiment with celadon glazes in the tenth century and had mastered the technique of producing such light bluish green glazes by the late eleventh. In shape, glaze color, and decorative scheme, their earliest wares reflect the strong imprint of Chinese Yue ware from northern Zhejiang province, a region with which Korea had carried on substantial maritime trade since at least the eighth century. Korean celadons from the period of this bowl typically have thin walls with a single register of boldly incised floral decoration. The individual floral elements tend to be large in proportion to the overall design and are rather freely rendered. The effect is one of controlled tension between the subtly colored glaze and the exuberant decoration.

During the first half of the twelfth century, Korean potters looked to a variety of other Chinese wares for inspiration. The splayed foot ring, perfectly colored glaze (which attains the desired pale blue-green hue), and naturalistic shape modeled on a five-petaled flower reveal the kinship of this refined cupstand to Chinese Ru ware, the most exalted ceramics at the court of the Emperor Huizong (r. 1100–1125). Celadons were used by people of various socio-economic classes during the Koryŏ period; the very finest examples, such as this cupstand, went to the court, wealthy nobles, or members of the powerful Buddhist clergy, but less exalted pieces were available to households of more modest means.

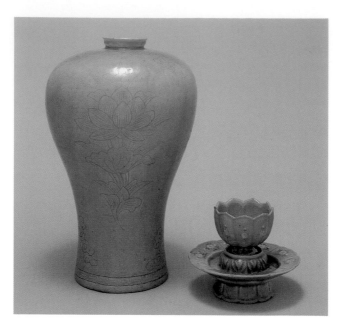

Maebyŏng Jar
First half of the 12th century; Korean,
Koryŏ dynasty, 918–1392
Light gray stoneware with celadon
glaze over incised decoration;
h. 12¹³⁄₁₆ in. (32.5 cm)
Margaret E. Fuller Purchase Fund, 71.45

Foliate Cup and Stand
Second half of the 12th century;
Korean, Koryŏ dynasty, 918–1392
Light gray stoneware with celadon
glaze over incised and molded deco-
ration and over decoration inlaid in
black and white slips;
h. 4¼ in. (10.7 cm)
Eugene Fuller Memorial Collection,
35.87

The Korean *maebyŏng* derives from the
Chinese *meiping* (literally, plum vase), a
tall jar with small mouth, short neck,
broad shoulders, and constricted waist.
The name is misleading, for these were
actually storage vessels rather than vases
for the display of blossoming plum
branches. The vessel would originally
have had a small, bell-shaped, celadon-
glazed cover, which would not only have
protected the contents but would have
resolved and balanced the strong curves
of the shoulder. The fluid lines and
elegant proportions of this extremely
handsome jar point to a date in the first
half of the twelfth century, as does the
delicate incising of the three graceful
lotus sprays that embellish its walls.
Both the decorative motif and the key-
fret border at the foot suggest influence
from Chinese Ding ware of the North-
ern Song period (960–1127).

In the mid–twelfth century Korean
potters soon began to explore new styles
and techniques of decoration. Most dra-
matic among their inventions was inlaid
decoration, a technique in which incised
decorative elements in the body were
filled with black and white slips (finely
ground clays), producing underglaze
designs in contrasting colors, as seen in
the chrysanthemum sprays of the cup
and stand. The simplicity of the deco-
rative scheme and the combination of
inlaid elements with incised and molded
ones suggest a date of manufacture in
the second half of the twelfth century.
The differing shapes and numbers of
foliations indicate that these two pieces
did not originally form a set.

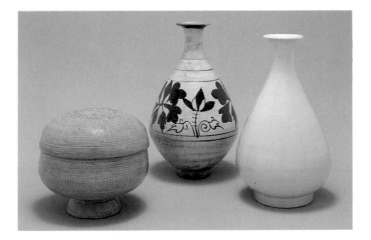

Covered Bowl
Late 14th–15th century; Korean,
Chosŏn dynasty, 1392–1910
Punch'ŏng ware, stoneware with
celadon glaze; h. 6 in. (15.2 cm)
Gift of Frank S. Bayley III, 87.140

Bottle
15th–16th century; Korean, Chosŏn
dynasty, 1392–1910
Punch'ŏng ware, Kyeryong-san type,
stoneware with celadon glaze;
h. 11¹⁄₁₆ in. (28.1 cm)
Gift of Frank S. Bayley III, 87.137

Bottle
Early 16th century; Korean, Chosŏn
dynasty, 1392–1910
White ware; h. 10⅝ in. (26.9 cm)
Gift of Frank S. Bayley III, 89.188

Korean ceramics of the Chosŏn dynasty fall into two basic categories, *punch'ŏng* stoneware and porcelain, both of which evolved from ceramic types of the preceding Koryŏ period (918-1392). Typical of fifteenth-century *punch'ŏng* ware, the covered bowl's abstract rope-pattern decoration was stamped in the still-moist clay body and then filled with white slip; the celadon glaze is much thinner than that on Koryŏ-period ceramics, so it appears light gray rather than bluish green. Probably used for rice, this covered bowl has identically shaped antecedents among later Koryŏ bronzes.

Punch'ŏng wares were produced at a number of kilns throughout Korea; vessels with painted decoration, like this pear-shaped wine bottle with floral sprays, are usually assigned to the sixteenth century and are often associated with kilns at the foot of Mount Kyeryong (near modern Taejŏn), where painted wares were produced. Such pieces were made of gray stoneware (visible at the lip), but were coated with white slip to make them resemble the more expensive porcelains; the floral decoration of this bottle was painted in brown slip on the white slip ground, but the bowstring-line borders were incised through this ground to reveal the gray body. The thin glaze is almost colorless.

Probably produced for court or official use, the undecorated white porcelain bottle is similar in shape to the slip-painted *punch'ŏng* bottle, underscoring their shared derivation from Koryŏ vessel types. Little is known about early Chosŏn porcelain kilns, but site excavations have revealed that some kilns specializing in the manufacture of *punch'ŏng* ware also produced porcelain, which could account for the unity of form.

Undecorated porcelain bottles were made in the fifteenth and sixteenth centuries; though strikingly similar in appearance, earlier examples tend to be a bit more squat in proportion; in addition, the exposed body clay (at the bottom of the foot ring) tends to be smoother in the earlier bottles.

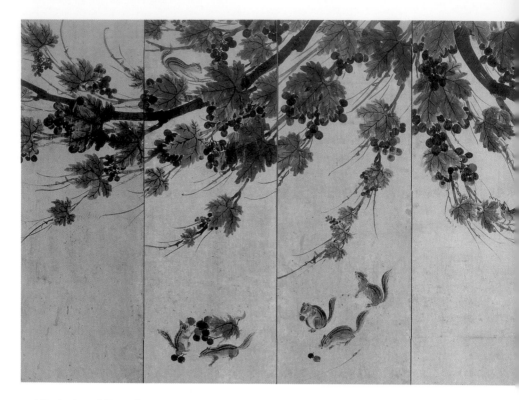

Squirrels and Grapevines
Early to mid-19th century; Korean,
Chosŏn dynasty, 1392–1910
Attributed to Ch'oe Sŏk-hwan (act.
early to mid-19th century; *ho* Yang-gok)
Eight-panel folding screen; ink on
paper; h. 61⅛ x 90 in. overall
(155.3 x 228.6 cm)
Gift of Frank S. Bayley III with
additional funds from Jeanne Nelson
and partial donation by the Kang
Collection, 90.41

This screen of eight panels — the usual number in Korean folding screens — features a unified composition depicting squirrels sporting amid fruiting grapevines. The work is unsigned, but the style suggests it might have been painted by Ch'oe Sŏk-hwan — an attribution that is here proposed. This prolific artist, active in the early to mid-nineteenth century, specialized in paintings of grapes and worked in Imp'i, North Chŏlla province (in modern South Korea). The screen shares a number of stylistic traits with his many extant paintings: the use of several bold and very dark brushstrokes for the grapevine's main branches to organize the

composition and establish its rhythms; the circular or semicircular configurations of selected branches, which impart a strong sense of movement and suggest that a gust of wind animates the scene; the pushing of the composition beyond the borders so that the painting focuses on details of the grapevine rather than on its whole; the construction of leaves through controlled ink washes, with veins detailed in darker ink; and the frequent overlapping of leaves and grapes, providing rich contrasts in texture and tonality.

The theme of squirrels and grapevines originated in China, probably in the Yuan (1279–1368) or early Ming (1368–1644). It quickly found its way to Korea, where it enjoyed great popularity during the late Koryŏ (918–1392) and Chosŏn periods. Tradition asserts that the grape *(Vitis vinifera)* was introduced into China in 126 B.C. from the Middle East. Doubtless inspired by designs on Sassanian metalwork and enticed by the calligraphic possibilities of the scrolling tendrils, Chinese crafts-

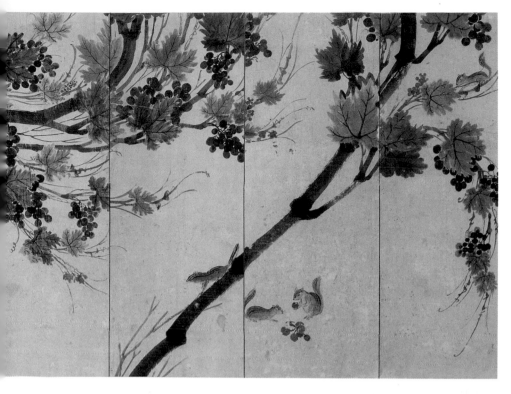

men adopted the grapevine as a decorative motif in the late Six Dynasties (220–581) and early Tang (618–907) periods; their bronze mirrors and gold and silver vessels frequently reveal designs of scrolling vines inhabited by a variety of animals and birds. Chinese and Korean potters occasionally embellished their wares with fruiting grapevines during the twelfth and thirteenth centuries, and painters began to explore the subject about the same time. The motif enjoyed its greatest popularity from the sixteenth through the nineteenth century in both China and Korea.

This slightly contrived motif forms a rebus, or visual pun, conveying wishes for longevity. The pun consists of the nearly identical pronunciations of "squirrel" and "pine," as well as a similar link between a character in "grape" and the word "peach," in both Chinese and Korean. Both "pine" and "peach" are symbols of longevity. Such rebuses became increasingly popular in the later painting and decorative arts of China and Korea.

Eight Branches of Blossoming Plum
c. mid-19th century; Korean, Chosŏn
dynasty, 1392–1910
Yi Kong-wu (b. 1805; *cha* Kong-yŏ; *ho*
Sŏk-yŏn)
Eight-panel folding screen, ink and
white pigment on lightly decorated
paper washed with light blue;
71¾ x 126 in. overall (182.2 x 320 cm)
Gift of the Asian Art Council, 90.1

Little is known about Yi Kong-wu save that he was born in 1805 in Yŏnan, Hwanghae province (in modern North Korea), that he served as a government official, and that he excelled in calligraphy and painting, especially in ink paintings of plum blossoms. In this screen, Yi depicts eight gnarled branches of blossoming plum in highly calligraphic brushwork against light blue backgrounds. Because the Chinese plum *(Prunus mume)* blooms in February, before donning its leaves, it is associated with winter and is regarded as a symbol of strength in the face of adversity. In addition, its blossoms symbolize feminine beauty and its weathered trunk the humble scholar. Because of its ele-

vated symbolism and expressive possibilities, the plum found great favor among literati painters of both China and Korea.

Metallic-decorated papers, colored grounds, and thick applications of pigment (seen in the white plum blossoms) attracted the interest of nineteenth-century Korean painters. In this case, the light blue grounds can stand for cloudy February skies, since the plum is associated with winter and is particularly revered when paired with snow, or for darkened night skies, since the plum is especially esteemed in moonlight. In typical literati fashion, the artist inscribed a fourteen-character poem extolling the virtues of the plum on each panel and also included his three-character signature on the last panel (far left); a seal of the artist follows each inscription. The wear at the edges of the outer panels resulted from frequent handling. This superb screen is one of only a handful of Korean literati paintings in the United States.

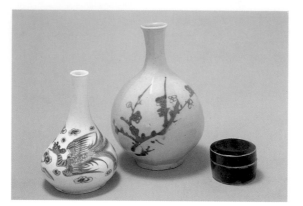

Bottle
Early 19th century; Korean, Chosŏn
dynasty, 1392–1910
Blue-and-white ware, Punwŏn type,
porcelain with underglaze cobalt blue
decoration; h. 8 in. (20.3 cm)
Gift of Frank S. Bayley III, 89.17

Faceted Bottle
18th century; Korean, Chosŏn dynasty,
1392–1910
Red-and-white ware, porcelain with
underglaze copper red decoration;
h. 10½ in. (26.6 cm)
Eugene Fuller Memorial Collection,
55.46

Covered Circular Box
Early 19th century; Korean, Chosŏn
dynasty, 1392–1910
Blue ware, porcelain with underglaze
cobalt blue decoration; diam. 3⅛ in.
(7.9 cm)
Gift of Frank S. Bayley III, 87.141

The small wine bottle sports decoration of a phoenix in flight amid scrolling clouds; the configuration of the clouds on the reverse resembles a playful dragon. Phoenix and dragon are the symbols of *ŭm* and *yang*—feminine and masculine principles (Chinese, *yin* and *yang*), the complementary opposites that give rise to the cosmos. The cobalt of the best Korean pieces is typically a light, silvery blue and has a quiet, ethereal character. The thin walls, meticulous painting, and smooth, glassy glaze suggest that this bottle may have been made at the government kilns at Punwŏn-ni (on the Han River near Kwangju, southeast of Seoul), established in 1752, which produced the very

finest porcelains during the later Chosŏn period.

The faceted bottle with plum decor relies upon underglaze decoration painted in copper red. Koryŏ potters of the twelfth and thirteenth centuries were the first to experiment with underglaze copper, which they used for touches of local color in combination with inlaid designs. Although Chosŏn-period potters favored copper pigment for its brilliant color, red-and-white pieces are relatively rare because of technical difficulties encountered in firing them, the copper often maturing to a dove gray instead of the desired pinkish red. The full rounded form suggests that this bottle most likely dates to the eighteenth or early nineteenth century, as does its "two-sided" decorative motif. Decorative schemes of both bottles lack formal borders, a characteristic of Korean porcelain decoration that likely reflects the Korean taste for simplicity as much as it reveals an attempt to conserve expensive materials.

Possibly produced at the Punwŏn-ni kilns, the small circular covered box was made for the scholar's desk to contain the cinnabar ink used to impress seals on letters, documents, and works of painting and calligraphy. Its rich, vibrant blue, doubtless resulting from two generous applications of cobalt, reflects the nineteenth-century preference for strong colors as well as the late Chosŏn tendency to cover entire vessel surfaces with decoration.

ART OF JAPAN

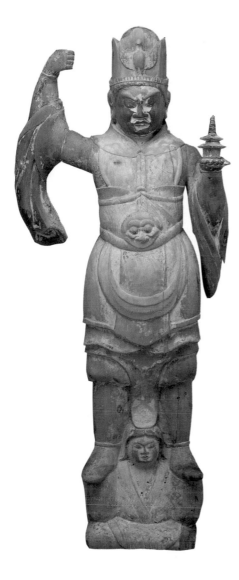

Tobatsu Bishamonten
Late 10th century; Japanese, Heian
period, 794–1185
Wood with polychrome traces;
h. 48½ in. (123.2 cm)
Eugene Fuller Memorial Collection,
48.179

Buddhism, born in northern India in about the sixth century B.C., was carried through Central Asia to China and Korea and was introduced to Japan by the ruler of the Korean kingdom of Paekche in the sixth century A.D. The imperial court adopted the new religion, which in time forged an accommodation with the native Shinto religion.

In Buddhist belief, each of the four cardinal directions is under the protection of a powerful guardian, and Bishamonten watches over the north. His iconographic attributes originated in India or Central Asia and include the small pagoda resting on the palm of his left hand, the tall cap or headdress with a bird crest, and the diminutive figure of Jiten, the earth goddess, beneath his feet. His right hand holds a trident or spear, now missing from this figure.

Earlier Japanese Buddhist sculpture relied heavily on Korean and Chinese prototypes. By the time this sculpture was carved, Japanese artists were developing their own iconographic vocabulary, and while there are distinct hints of continental relationships, such as his role of fierce armor-clad warrior, this figure, with its large head, small, compact body, and massive legs, reflects a native style developed in the previous century. Moreover, the figure of Jiten, which came originally out of India or Central Asia, reflects the accommodation between the two faiths in her close resemblance to Heian-period representations of Shinto deities.

Poems of Ki no Tsurayuki
12th century; Japanese, Heian period, 794–1185
From the *Ishiyama-gire,* calligraphy attributed to Fujiwara no Sadanobu (1088–1156)
Page from bound book mounted as a hanging scroll, ink, mica, and silver on paper; 8 x 6¼ in. (20.3 x 15.8 cm)
Eugene Fuller Memorial Collection, 51.210

This poem page brings together two of the most celebrated artists of the Heian period. Ki no Tsurayuki (868?-c. 946) excelled as a poet and is ranked among the thirty-six master poets of Japan. His poems here were transcribed by another courtier of two centuries later, Fujiwara no Sadanobu, who was renowned for the beauty of his calligraphy. The poems are transcribed in the flowing *sōsho,* or grass-writing style, a newly developed art form at the time. His brilliant brushwork expresses his taste in calligraphic style in its rhythmical variation of line width, the seeming spontaneity of the spacing, and the syncopated cadence of the brush movement.

This page symbolizes the opulent and elegant artistic traditions of the Heian period imperial court. It comes from one of thirty-nine volumes of poetry transcribed by twenty of the most celebrated calligraphers of the day as a birthday gift for the emperor Toba (r. 1107–23). Each page of this massive set was richly decorated; no two are the same. The paper for this page was first given a white sizing to mask any imperfections and to produce a blemish-free surface. It was then block-printed with diamond-shaped patterns enclosing stylized blossoms among a scrolling floral-vine motif. This design was highlighted with mica dust. Over the ground pattern, tiny blossoms, pine branches, and bird motifs were added by hand in silver ink.

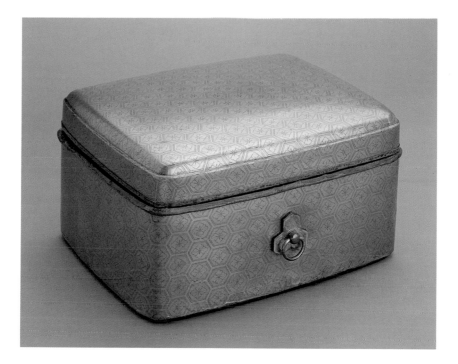

Cosmetic Box (tebako)
13th century; Japanese, Kamakura
period, 1185–1333
Maki-e lacquer on wood;
6¼ x 11½ in. (15.8 x 29.2 cm)
Gift of Mrs. Donald E. Frederick, 51.78

Maki-e is a uniquely Japanese technique of decorating lacquer. The process employs finely ground bits of gold and silver that are sprinkled onto damp lacquer surfaces to create patterns. Records indicate use of maki-e in the eighth century; the technique became highly refined during the Heian period (794-1185), when it was the predominant method of decorating lacquer wares. During the Kamakura period the three major types of maki-e were perfected, and this box is an example of togi-dashi maki e. In this type, the surface of the sprinkled gold design is smoothed with abrasives to create a clear, highly polished finish.

The exterior of the box displays an all-over design of connected hexagonal lozenges that enclose blossoms. The pattern is a stylized representation of a tortoise-shell pattern (kikkō) and symbolizes a wish for long life, an allusion to the legendary longevity of tortoises. As a further extension of this allusion, the underside of the lid carries a representation of the legend of the fisherman Urashima. One day this fisherman came to the aid of a wounded tortoise who was the disguised daughter of the Dragon King. As a reward for his kindness, he was invited to join her in an enchanted life under the sea as her husband.

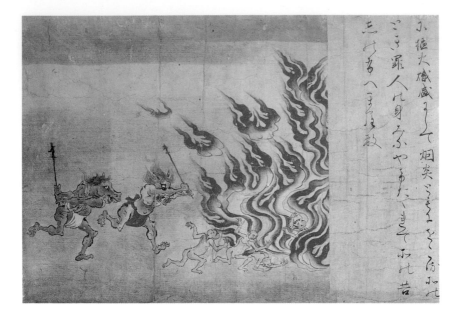

Hell of Shrieking Sounds (detail)
c. 1200; Japanese, Kamakura period,
1185–1333
From the *Jigoku zōshi*
Section of a handscroll, ink and color
on paper; 10¼ x 25⁹⁄₁₆ in.
(26.1 x 64.9 cm)
Eugene Fuller Memorial Collection,
48.172

Over the centuries, the handscroll format proved very popular with Japanese artists. The continuous flow of the scroll especially suited it to narrative uses, and the earliest remaining examples are scrolls illustrating the tenth-century novel *The Tale of Genji*. Between the twelfth and fourteenth centuries, during the late Heian and Kamakura periods, the handscroll became a highly favored format, which artists used to transcribe both sacred Buddhist texts and popular tales as well as to record the lives and travels of famous priests and the founding of important temples and shrines. This passage is one of seven fragments of a once much longer scroll. The scene is the treatment reserved for priests who tortured animals. The miscreants try to flee the searing flames, only to be beaten with iron rods by horse-headed demons and driven back into the fire. Depictions of a variety of hells and concern over the afterlife appeared frequently in Buddhist art of this time.

Art in the Kamakura period was characterized by an almost obsessive interest in capturing the likeness of the visible world, of life as it was experienced. The terror of a massive conflagration, a common experience during these times, is reflected in the drama of the roaring flames in the painting. The demons, shown with heavily muscled bodies, repeat in painting the concern for exaggerated musculature often encountered in Buddhist sculpture of the period. The naked priests, though shown in caricature, are given realistic touches: streams of blood spurting from the wounds on their heads, and one is shown raising a hand in a futile gesture to ward off the coming blow.

Indicative of the spread of popular Buddhist sects and the changing attitudes toward religion during this time is the use of the common literary form combining Chinese characters and Japanese syllabary, rather than the esoteric pure Chinese language, to transcribe the sutra text.

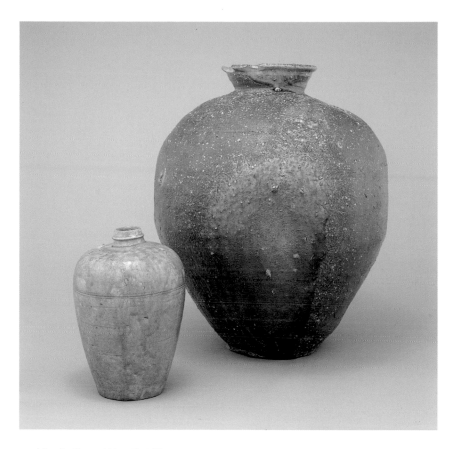

Bottle-Shaped Vase (heishi)
14th century; Japanese,
Kamakura period, 1185–1333
Ko Seto ware, stoneware with
intentional ash glaze; h. 9½ in. (24.2 cm)
Gift of the Asian Art Council in honor of
its tenth year and the museum's fiftieth
year, 84.11

Storage Jar (tsubo)
15th century; Japanese,
Muromachi period, 1333–1568
Shigaraki ware, stoneware with
accidental ash glaze; h. 18⅞ in.
(47.9 cm)
Gift of Drs. R. Joseph and Elaine R.
Monsen, 75.60

These two stoneware pieces represent the major ceramic traditions found in medieval Japan. The Ko Seto *heishi* reflects a taste for Chinese imported ceramics, while the Shigaraki tea jar was the product of centuries of development at native pottery centers.

The Seto bottle, destined for the elite and the clergy, is a nostalgic reflection of its older Chinese model, in which the slightly slumped shape and strongly modulated glaze are unknown. Quaint, incised Japanese motifs of chrysanthemums and pampas grass replace Chinese motifs, and native taste imparts a charm and personality quite lacking in the prototypes.

The coil-built, hand-finished Shigaraki jar stands boldly broad-shouldered, energetic and robust, reflecting the commercial vitality of the Shigaraki kilns and the lucrative tea market to which their fortunes were tied. The ruddy, high iron-content clay body contrasts pleasantly with the pale green accidental glaze formed during a prolonged firing period (a month or more), when ash floating in the kiln atmosphere settled on the piece, fluxing the feldspar in the clay. The pleasing spontaneity of these random effects reveals another aspect of Japanese aesthetic sensibility.

Landscape
Second half of the 15th century;
Japanese, Muromachi period,
1392–1568
Attributed to Tenshō Shūbun
(act. 1423–60)
Hanging scroll, ink and light colors on
paper; 35½ x 13 in. (90.2 x 33 cm)
Eugene Fuller Memorial Collection,
49.90

Ink painting *(suiboku-ga)* developed in Japan between the thirteenth and fifteenth centuries under the influence of Zen Buddhist monks. Landscape as a theme grew out of their practice of depicting an idyllic mountain retreat in monochrome ink. Japanese monks' interpretations of the subject differed somewhat from known Chinese prototypes; however, in both countries priests made these paintings for the pleasure of fellow priests and friends, who were invited to inscribe them.

Tenshō Shūbun was one of the most influential monk-artists among the early Japanese ink-landscape painters. He developed a style based on techniques made famous by the Song dynasty artists Ma Yuan and Xia Gui. This painting displays the characteristics and motifs usually associated with Shūbun's style, particularly the narrow vertical composition with prominent, rocky mountain forms and lakeside pavilions among twisted, ancient pines. "Axe-cut" strokes facet huge boulders and mountain faces are dotted with verdure. A frequently seen element is a waterfall descending from a great height and ending in the misty distance. Touches of light color were also added.

Tray
Early 17th century; Japanese, Momoyama period, 1568–1615
Mino ware, Oribe type, stoneware with green and transparent glazes
over painted decoration in iron oxide; 8 x 7¾ in. (20.3 x 19.6 cm)
Eugene Fuller Memorial Collection, 56.130

The tea ceremony of the fifteenth century relied on imported Chinese wares of the Song and Yuan dynasties. By the sixteenth century, under the influential tea master Sen Rikyū (1522–91), however, native Japanese potteries and humble Korean wares were preferred. After Rikyū's death, the mantle passed to one of his students, Furuta Oribe (1544–1615), who was of the daimyo class. Unlike Rikyū, Oribe enjoyed using newly made tea bowls. He sought to create a bright and lighthearted impression in the tea ceremony. Subsequently, Oribe's taste gained broad popularity and a new, but short-lived, daimyo-style of tea emerged, which reflected the contemporary incursion of the exotic Namban, or Western, influence of the period.

This square tray with its diagonally divided surface, the motifs scattered in casual informality, epitomizes Oribe's taste for eccentric patterns and exotic motifs. There is also a curious juxtaposition of a traditional *yamato-e* design of cart wheels submerged in the Kamo River with a totally nontraditional motif of "balloons" adrift in a starry sky. The rich copper-green glaze and the brown of the sketched designs against the pinkish body are hallmarks of Oribe ware.

Section of the Deer Scroll
Early 17th century; Japanese, Momoyama period, 1568–1615
Calligraphy by Honami Kōetsu (1558–1637)
Painting by Tawaraya Sōtatsu (act. 1600–1640)
Handscroll, ink and gold and silver paint on paper;
h. 13⅜ x 363¾ in. (34 x 923.9 cm)
Gift of Mrs. Donald E. Frederick, 51.127

In this handscroll, Sōtatsu painted a series of deer in a stylized landscape, and Kōetsu added poems from a medieval imperial anthology by the classical poets. The scroll was originally much longer, but someone in the past divided it into two long sections and a number of short pieces. This section is the longest, and in addition to the artists' painting and calligraphy, it contains at the end both Kōetsu's signature and personal cipher and the round seal of Sōtatsu, which reads "I-nen." Deer are a reference to autumn, and each of the poems relates to this season. There are twelve poems in this portion of the scroll.

The scroll blends poetry, calligraphy, and painting. The concept was an ancient one, but these artists wrought an imaginative reinterpretation of classical modes and imparted a lushness to their art that appealed to both the courtiers and aristocrats as well as to the newly affluent commoners of the late sixteenth and early seventeenth centuries.

Kōetsu's masterful calligraphy flows in effortless harmony with Sōtatsu's deer. The cadence of both the poems and the animals ebbs and flows in a rhythm that, among the deer, moves from the stags' majestic stance and balletic grace to the playful antics of youthful bucks.

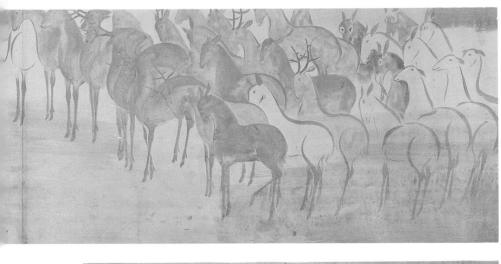

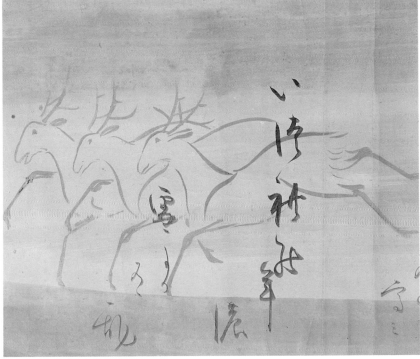

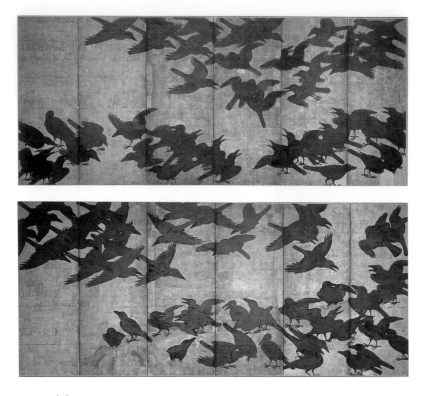

Crows
c. 1650; Japanese, Edo period, 1615–1868
Pair of six-panel screens, ink and gold on paper;
61¾ x 139 in. (156.8 x 353 cm) (each screen)
Eugene Fuller Memorial Collection, 36.21.1, .2

By the mid-seventeenth century, large urban centers such as Osaka, the mercantile capital, and Kyoto, the old imperial capital, were thriving metropolises. Edo, the newly established shogunal capital, was on its way to becoming the most populous city in the world. Strict feudal laws kept *shōnin,* the merchant class, politically powerless, but some merchants amassed great fortunes through brokering rice, timber, and other commodities. In general there was a great feeling of exuberance among the common people.

Denied the grand palaces, public ritual, and ceremony of the ruling classes, the *shōnin* thirsted to express their affluence. One such response was the pleasure quarter. Another was a type of commercial artist, or *machi-eshi,* who functioned outside conventional art schools. They were highly skilled, as many of them trained with established artists.

These screens were painted by a *machi-eshi.* The brilliant gold ground is borrowed from the dignified Kanō School painters of Kyoto. The motif, however, is highly original. Usually considered unlucky, crows seldom appear as a major motif. Equally original was the boldness of displaying a large number of these raucous, disruptive birds. Whatever the reason for his choice, the artist has closely observed crows and represented them here both in exacting anatomical detail and a true depiction of their typical behavior.

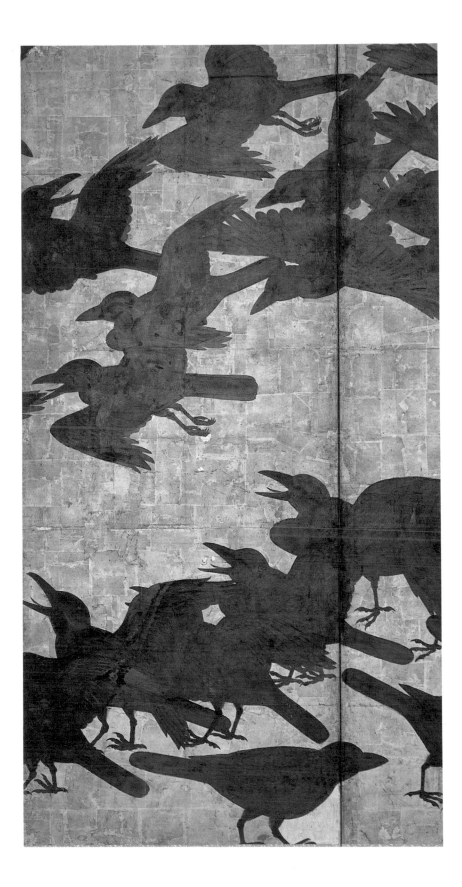

Before the seventeenth century, white-bodied, high-fired porcelain was known in Japan only through imports from China. After the close of the war in Korea in 1598, however, Japanese armies returned home with Korean potters, who soon discovered deposits of stone and clay needed for making porcelain in the southern island of Kyushu. By about 1625, a major porcelain center flourished there, and by the mid-seventeenth century, the palette for decoration broadened greatly with the addition of colored overglaze enamels.

In the early stages of development, porcelain manufacture was a monopoly of the Kyushu daimyo, and early wares are named after the town of Arita near which the most energetic branch of the new industry grew up. The deep dish is a type once thought produced at kilns at Kutani on the island of Honshu; however, the type is now known to have been produced at Arita, where, by the late seventeenth century, potters had learned the secrets of producing not only porcelain, but also overglaze colors.

The headrest displays a typically Japanese treatment of a motif of quail and wild chrysanthemums, in contrast to the landscape scene of the deep dish, which relies heavily on a Chinese painting style of the Ming dynasty. The circular motifs that ring the landscape relate to the so-called *shonzui* style of decoration of Chinese export porcelains of the Chongzhen era (1628–44), which were created for the Japanese market.

Travelers in a Winter Landscape
c. 1778; Japanese, Edo period,
1615–1868
Yosa Buson (1719–84)
Hanging scroll, ink and color on silk;
45⅜ x 17⁵⁄₁₆ in. (115.3 x 44 cm)
Purchased with funds from the estate
of Mary Arrington Small, 84.9

Yosa Buson, painter and poet, belonged to the literati artistic tradition that was based on Chinese ideals of the inspired amateur who combined poetry, painting, and calligraphy in his art. In China these traditions go back to the Song dynasty (960-1279), and they entered Edo-period Japan in the seventeenth century under the aegis of the Confucian philosophy and morality espoused by the feudal Tokugawa military government. Buson was among those most instrumental in transmuting the foreign tradition into a Japanese art. As one of Japan's greatest haiku poets, he perfected in his work a harmonious union of native Japanese poetry, calligraphy, and pictorial image.

This scroll reveals Buson's intense study of Chinese landscape-painting techniques with massive rock forms and distant mountains built up with a multitude of brushstrokes and deftly applied color washes. The glowing atmosphere enveloping the scene, Buson's interest in bringing the viewer into eye-contact with the attendant, and the ringing cadence of his brushwork throughout the surface of the painting are hallmarks that would become integral to his most mature artistic expression.

Mount Horai, Island of Immortality
Dated winter 1864; Japanese, Edo
period, 1615–1868
Hine Taizan (1814–69)
Hanging scroll, ink and light color on
silk; 74⅜ x 34⅝ in. (188.9 x 87.9 cm)
Gift of Drs. R. Joseph and Elaine R.
Monsen, 75.59

The subject of this painting is the fabled island known as The Mountain of Immortality. According to Chinese legend, it lies somewhere off China's eastern coast. This theme, popular in China at least as early as the third century B.C., inspired numerous Chinese and Japanese works of art. The craggy mountain, surrounded by crashing waves and partially blanketed in clouds, indicates an idealized location, as do the scholars tucked among the hills and dales. A pair of cranes bearing Daoist Immortals on their backs reveals that this is the Daoist paradise, for in Chinese legend cranes are said to carry the spirits of Immortals to this mountain.

This landscape, like the one by Yosa Buson (p. 197), is closely related to Chinese literati painting. The accuracy of the stylistic references indicate Taizan's probable direct access to Chinese works. The many small, round "alum clump" boulders repeated over the slopes of the mountain, a stylistic device attributed to the Five Dynasties painter Zhuran (act. c. 960–80), are a commonly used motif in literati painting. Taizan has captured the authentic Chinese taste in brushwork. The composition, with a tall central mountain built up in a number of layers, is based on paintings by literati masters of the late Yuan and Ming dynasties. This work, however, has a dramatic flair and dynamism not usually found in Chinese examples. Its crashing waves, swirling clouds, and unstable rock forms, now well established, reveal an individual artistic temperament that in its essence is purely Japanese.

Daimyo's Fire-Fighting Jacket
c. 1800; Japanese, Edo period, 1615–1868
Deerskin with paste-resist patterns and smoke-induced color
(fusube-gawa); 37 x 52⅛ in. (93.9 x 132.3 cm)
Gift of Virginia and Bagley Wright, 89.93

In crowded cities constructed largely of wood and paper, fire was the most feared urban disaster, and firemen were highly esteemed. Firemen were drawn from among all social castes, from daimyo to merchant-class commoners, and like other aspects of the feudal society of Tokugawa-period Japan, firemen's clothing reflected the person's social caste. Commoners customarily wore brightly decorated outfits comprising many layers of quilted cotton and, while among the daimyo class a number of different types were worn depending on the occasion, leather was the standard material for actually dealing with a conflagration. Clearly distinguishing them from the vulgar taste of the commoners, designs on the daimyo fireman's clothing were more refined but also characteristically bold, befitting the warrior class.

The all-over geometric design gives this coat a dynamic look with its white diamond patterns strung together with a line of indigo against a tawny background. An unusual touch is the broad, sweeping lapel, colored with indigo. The tawny background was created by a technique termed *fusube-gawa,* in which the deer hide was exposed to the smoke of smoldering pine needles. The areas to be left white or given other colors were initially covered with an opaque paste, later washed off, to prevent coloring during the smoking process.

CATALOGUE AUTHORS

In conjunction with selected distinguished scholars, the curatorial staff of the Seattle Art Museum has served as authors of and advisors to this publication.

Ancient Art of the Mediterranean and the Near East
Irene Bierman, University of California, Los Angeles: 23–25
Lawrence Bliquez, University of Washington, Seattle: 26–28
Emily Teeter, The Oriental Institute, The University of Chicago: 29–32

Art of Africa
Pamela McCluskey, Seattle Art Museum

Art of Oceania, Mesoamerica, and the Andes
Miriam Kahn, Burke Museum, University of Washington, Seattle: 55–58
Mary Miller, Yale University: 59–64

Native Art of the Northwest Coast
Steven Brown, Seattle Art Museum

Art of Europe
Timothy Husband, Cloisters Museum: 85–87
Chiyo Ishikawa, Seattle Art Museum and the University of Washington, Seattle: 88–89, 92–95
Julie Emerson, Seattle Art Museum: 90–91, 96–97, 99–106
Jay Gates, Seattle Art Museum: 98

Art of the United States
Patterson Sims, Seattle Art Museum: 108, 110, 112–13, 118–19, 121, 123, 128–29, 132, 134
Jay Gates, Seattle Art Museum: 111
Rod Slemmons, Seattle Art Museum: 114–17, 126–27, 133
Barbara Johns, Tacoma Art Museum: 120, 122
Vicki Harper, Seattle Art Museum: 124–25, 130–31

Art of the Near East
Irene Bierman, University of California, Los Angeles

Art of India and Southeast Asia
Susan Huntington, The Ohio State University, Columbus

Art of China
Michael Knight, Seattle Art Museum

Art of Korea
Robert Mowry, Harvard University Art Museums

Art of Japan
William Rathbun, Seattle Art Museum